ANTHONY
CARO

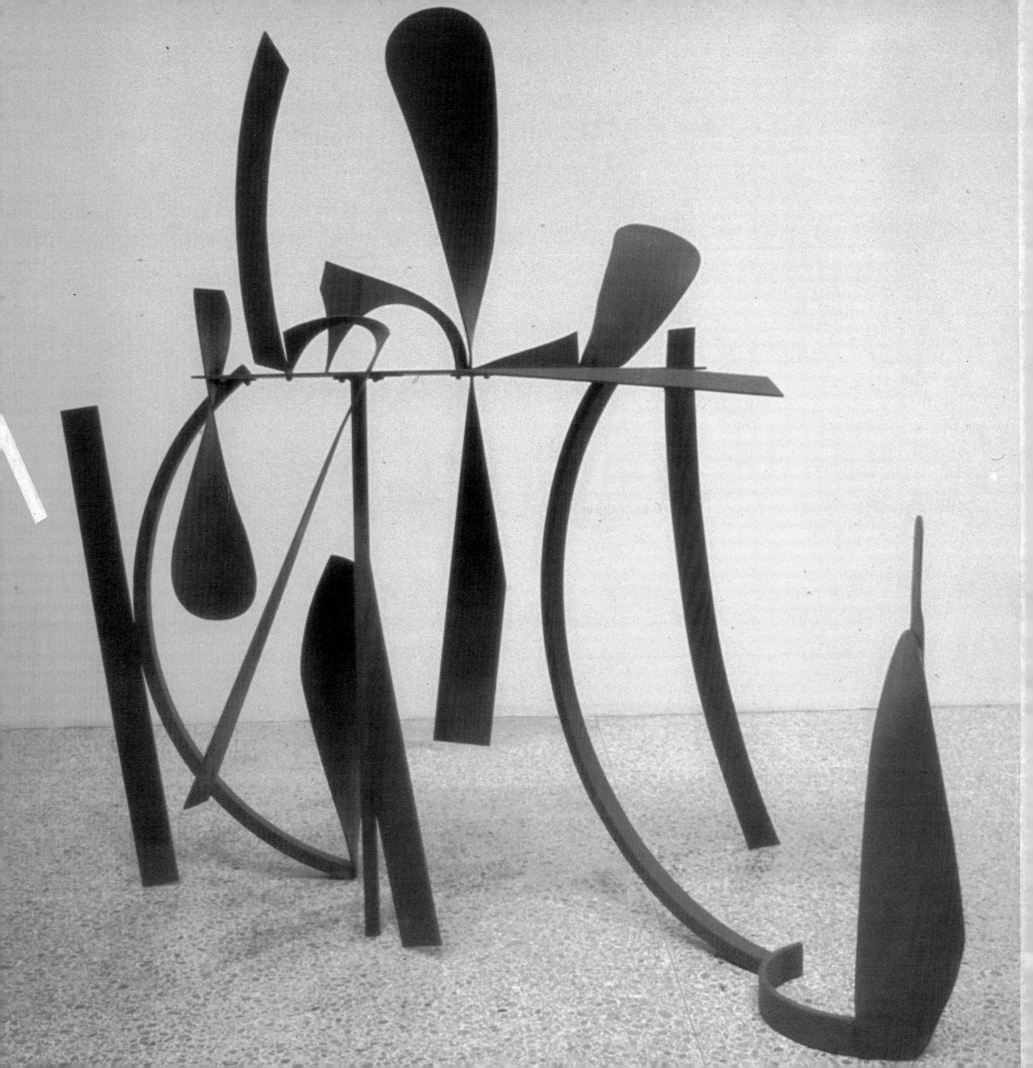

ANTHONY CARO

BY DIANE WALDMAN

PHAIDON · OXFORD

To my husband Paul

Phaidon Press Limited, Littlegate House,
St. Ebbe's Street, Oxford

First published in Great Britain 1982
First published in the United States of America
in 1982 by Abbeville Press, Inc.,
© 1982 by Cross River Press, Ltd.

British Library Cataloguing in Publications Data
Waldman, Diane
 Anthony Caro.
 1. Caro, Anthony 2. Sculptors — England
 I. Title
 730' . 92'4 NB497.C/
 ISBN 0-7148-2246-9

Printed and bound in Japan

Designer Roy Winkler

On the cover: *Yonge Street Flat.* 1974. Steel, rusted and varnished
7'6" × 9'1" × 3'3". André Emmerich Gallery, New York

Frontispiece: *Orangerie.* 1969. Painted steel. 7'2½" × 5'4" × 7'7"
Private Collection

Contents

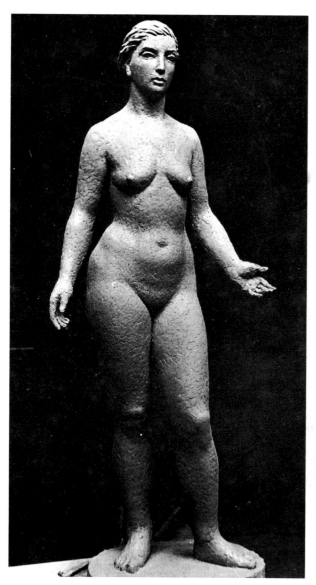

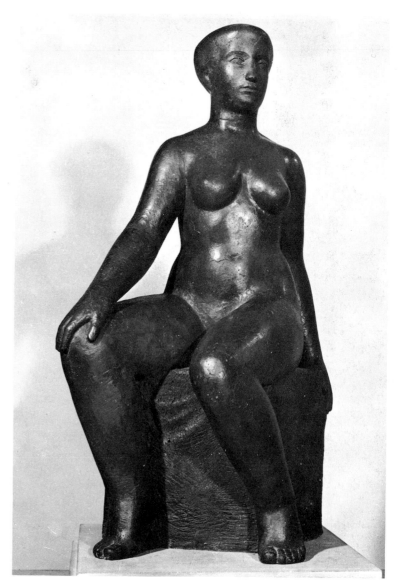

1. *Half Lifesize Figure*. June 1948 (destroyed)

2. *Seated Figure*. 1949. Terra cotta. Half lifesize

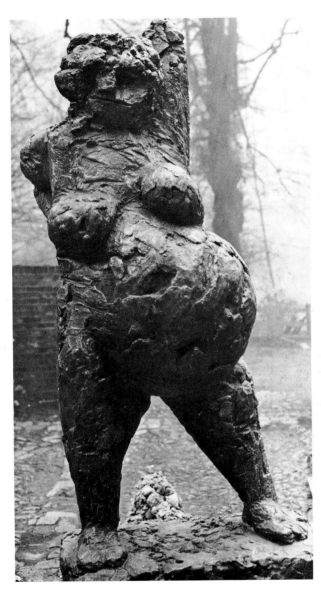

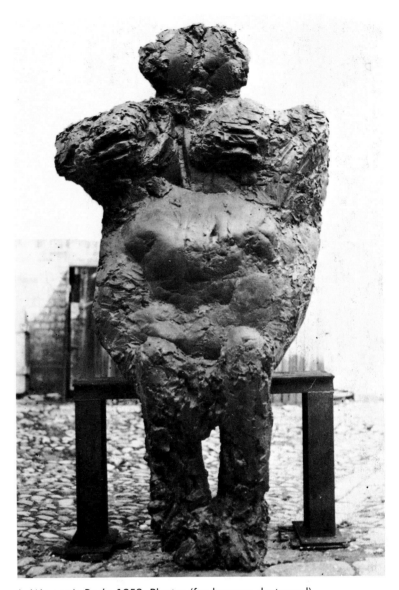

3. *Woman in Pregnancy*. 1955. Plaster. 6'3" h. (destroyed)

4. *Woman's Body*. 1959. Plaster (for bronze; destroyed)

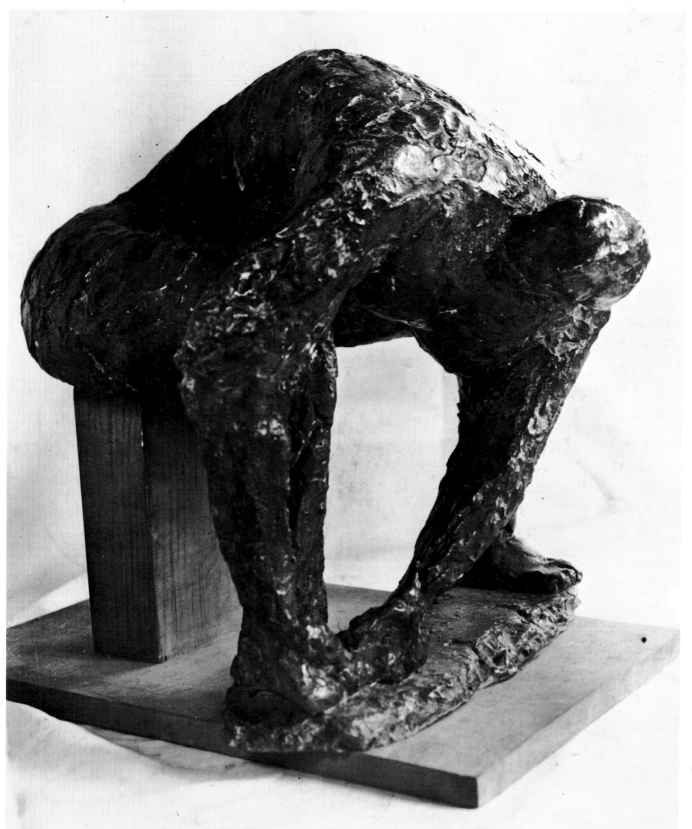

5. *Seated Figure.* 1955. Bronze. 1'3½" h.

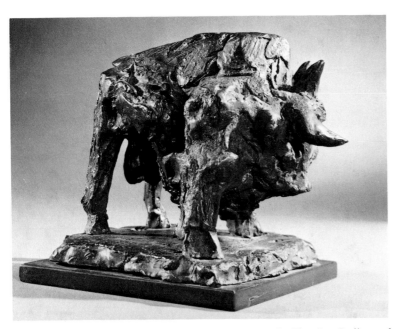

6. *Bull*. 1954. Bronze. 7¼ × 7½ × 6″. The Art Gallery of
Ontario, Toronto. Gift of Sam and Ayala Zacks, 1970

Western sculpture has traditionally been relegated to a minor role in the visual arts. From the Renaissance onwards, sculpture looked to painting for its example, reluctant to test its own limits, content to paraphrase old forms rather than invent new ones, performing its conventional function as public monument. If the invention of perspective gave the Renaissance painters the means of reconciling the known world and the perceived world, it failed to free sculpture from the prison of its own physicality. Where painting, no matter how earthly its subject, encouraged an unearthly, imagined, metaphysical reality, sculpture was forced into the role of miming the material world. Within the conventions of the sculpted figure there was no room for illusion, space, or atmosphere. In an otherwise bleak landscape of academicism, figures like Donatello, Michelangelo, and Rodin stand out as lonely sentinels among the many giants of painting.

With the change in the nature of patronage, resulting from the radical restructuring of society forged by the industrial revolution, sculpture began to come into its own. The costly and time-consuming process of making sculpture for public sites, the function of sculpture as appendage to or extension of architecture, and its secondary role in the visual arts were called into question; the power base was altered, and the forces that had combined to inhibit true creativity were eroded. The radical restructuring of the very concept of art, as well as the availability of materials less precious than bronze or marble, the change in the manner and methods of working, and the acceptance of a new role for sculpture in society, made it feasible for sculptors, as it had been for painters, to envision concept and object as one linked process. Sculpture became as intimate and individual as it had once been impersonal and monumental.

The revolution in sculpture in the twentieth century, as considerable and consequential as that in painting, stems primarily from two figures—Picasso and

Brancusi. Picasso's investigation of constructed sculpture and Brancusi's exploration of reductive form signal a dramatic reinvention of the basic tenets of sculpture. Picasso's constructions are made of unorthodox materials—fragments of everyday reality—which have been recomposed into structures that recall reality but that are in themselves independent of it. Brancusi's structures give us an idealized, more abstract concept of form. But although his forms are hermetic, self-contained, they are not remote or sealed off from the experience of the viewer. Instead, their relatively small scale, their intimacy and immediacy, their smooth yet sensual surfaces, and their delicate contours, endow them with a simplicity and humanity that evoke real form although they do not describe it.

If Brancusi's emphasis on the primacy of sculpture as an independent object influenced an entire generation of Minimalist sculptors, Picasso's influence has been broader still. An iconoclast in terms of imagery, materials, and methods, Picasso's wholesale restructuring of form created as dramatic an evolution in sculpture as his and Braque's investigation into Cubism created in painting. The very fact that Picasso felt free to cross the boundaries that had formerly obtained between painting and sculpture enabled him to invent a "hybrid" form that spoke of both and yet was neither. Following his example, subsequent generations of sculptors have contributed to the dialogue between painting and sculpture that has enriched the language of art. Whereas painting invites the viewer's entry into the domain of the two-dimensional illusion, sculpture had previously excluded that possibility, remaining monolithic in nature, intruding upon the space of the spectator. Despite its greater physicality

and its proximity to the size and space of the viewer, sculpture had traditionally seemed less accessible than painting. It was instead awesome, demanding and authoritative. No matter how skilled the portrayal, sculpture remained mere representation rather than illusion.

Once free of description, however, sculpture began to take on a life of its own. The independence of sculpture from a specific subject matter or function, the concerns with material and process, with abstract form and content as important ends in themselves, the concerns which originated with Brancusi and Picasso, have become the focus of much recent sculpture. As sculpture began to circumvent many of the restraints of traditional three-dimensional form, it began to admit illusion, frontality, color, and other purely optical effects that had formerly accrued only to painting. And as sculpture became more pictorial, it began to find the means of admitting the viewer into the monolith. It became more open, less formidable, more available. By the 1960s it was possible to speak not only of important individual sculptors but of schools of sculpture, as it had earlier been possible to speak of schools of painting. Anthony Caro has come to be identified in our time as both a major sculptor and a leader of a vital direction in the sculpture of our time.

The youngest of three children, Anthony Caro was born on March 8, 1924, in New Malden, a suburb of London, to Alfred Haldinstein Caro and Mary Rose Edith Haldinstein (his first cousin). His parents, both from Norwich, England, were of Jewish descent and could trace their origins back to the sixteenth century. Together with his brother Peter Jack and his sister Rachel Alice, Caro grew up in Churt, near Farnham, where, in 1927, his father had pur-

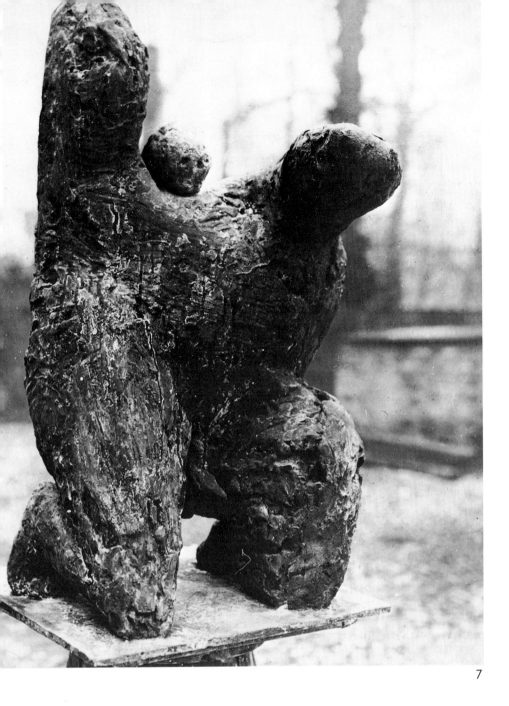

7

7. *Man Taking Off His Shirt.* 1955. Bronze. 2'5" h.
Private Collection

8. *Man Holding His Foot.* 1954. Bronze. 2'2½" h.
Private Collection

8

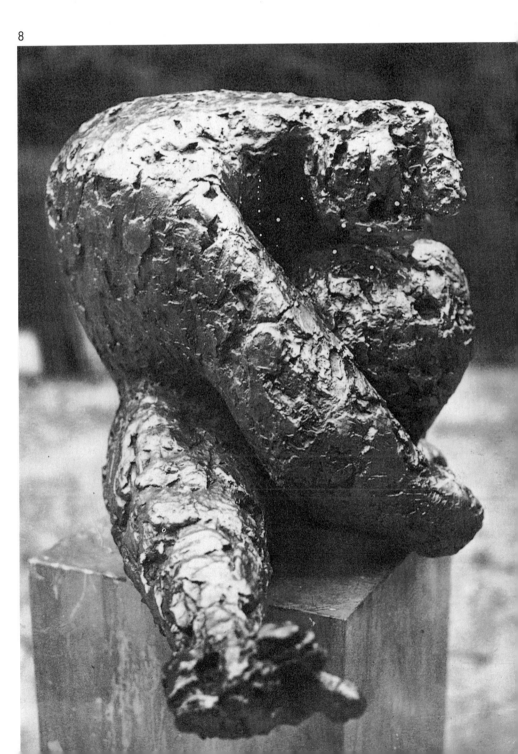

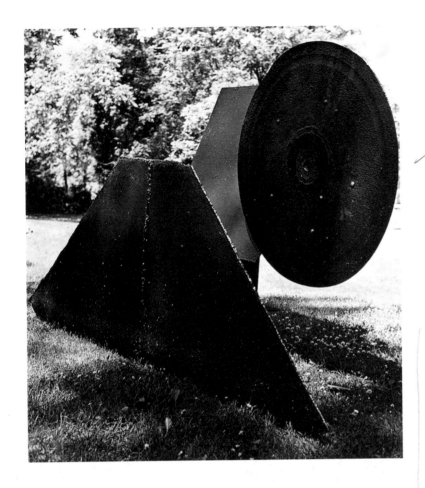

10. *Twenty-Four Hours*, another view

chased a farm. From 1933 to 1937 he attended Pinewood School, a preparatory school in Farnborough, Hampshire, and from 1937 to 1942 he went to Charterhouse School in Godalming, Surrey. At the age of fifteen, Caro sculpted in clay for the first time. At Charterhouse, the Housemaster introduced him to his friend, the traditional sculptor Charles Wheeler, who later became President of the Royal Academy (1956 to 1966). Wheeler later asked Caro if he would like to work for him during vacations and holidays, an offer he readily accepted. In the course of this apprenticeship Caro became acquainted with the technique of making armatures for clay sculptures as well as with the process of enlarging small-scale

models. He assisted in making maquettes for the human figures and dolphins that were to be part of a fountain Wheeler was making, and he became generally knowledgeable about the production of large-scale sculpture. Thus at an early age, Caro benefited from first-hand exposure to a professional working situation of a kind he could not have received in an academic setting. More important than this practical experience, however, Caro's contact with Wheeler gave him a taste of what a sculptor's life was like—offering him a hint of its many hardships and problems. His appetite whetted by this experience, Caro soon determined to become a sculptor, despite the strenuous objections of his family.

Caro's father, a well-to-do stockbroker, insisted that his youngest son follow in his footsteps or, failing that, that he become an engineer. Being an artist was considered an occupation fit only for a dilettante, "like doing nothing . . . like being a gambler." In the opinion of his family, art was a hobby, something one pursued for pleasure, for amusement. When Caro was finally free to "follow the thing I wanted to do, be an artist, . . . I had to show them that it could be

something serious and that you could make a living at it, and that you could take yourself seriously doing it."

Although Caro's parents were adamantly opposed to art as a professional goal, his mother's side of the family was artistic; her uncle was a professional painter, and she was an amateur painter. Nor was Caro's father insensitive to the arts, for he was a man of taste. Even though the younger Caro received "absolutely no encouragement to be an artist" he grew up surrounded by well-chosen objects and he feels that they probably reinforced his desire to be a sculptor.

In fact, Caro succumbed to family pressure to the extent that he attended Christ's College, Cambridge, from 1942 to 1944, attaining an M.A. in engineering. His art training was interrupted also by his service as a Sub-Lieutenant in the Fleet Air Arm of the Royal Navy from 1944 to 1946. But he utilized every free moment during furloughs to work at the local Farnham School of Art and at Wheeler's studio. At Wheeler's suggestion he enrolled full-time at the Regent Street Polytechnic where he studied, from 1946 to 1947, with Geoffrey Deeley, a friend of Wheeler's. Deeley was from Wolverhampton and belonged to the School of Wolverhampton, which was influenced by Carl Milles. His sculpture was naturalistic and, as Caro puts it, "sweet and decorative."

After his year at the Polytechnic, Caro enrolled in the Royal Academy Schools, once again at Wheeler's suggestion. Here sculpture was taught on a rotating basis by a different instructor each semester. Wheeler himself taught there, along with other sculptors, each of whom was an associate member or a full member of the Royal Academy. While Caro does not believe that they were particularly good artists, the instructors were thoroughly versed in their craft, and there was something of consequence to learn from all of them, especially in the area of technique. At the Royal Academy, Caro experimented with a variety of traditional materials, terra cotta, ivory, stone, wood, clay, and plaster, using traditional methods, making traditional sculpture. Caro says his experience there engendered mixed feelings: "I can't tell you how nineteenth century it was." There were long dark corridors lined with rows of plaster figures from the Acropolis, faceless models; the mustiness of an age-old tradition permeated the place. The Academy was imbued with a commitment to the past that created an atmosphere of activity outside time, without a compelling sense of the present, without a sense of the need for change. Rebellion on the part of the students was not imaginable; one accepted the Royal Academy for what it was.

In that sculpture room every morning we'd go and make a life model. . . . The model would be standing up there and round it would be, say, six people, copying the model half size or full size or making a relief of it, or whatever. I say it—it was a her or a he, but in fact it was an it, sexless. She was still, she was absolutely still. We were peering at her, taking measurements of her, making our model look as if it stood up, and not as if it were leaning, not as if it were weak at the knees. All these things were excellent . . . and a lot of younger artists now who haven't this tradition feel a . . . little deprived of not having had this basis from which to flower or to move out. On the other hand . . . I wouldn't suggest that anybody should do that again now. . . . It would be like learning to write Old English in order to be able to write modern poetry and I don't think you have to do that. But it did teach me a lot.[1]

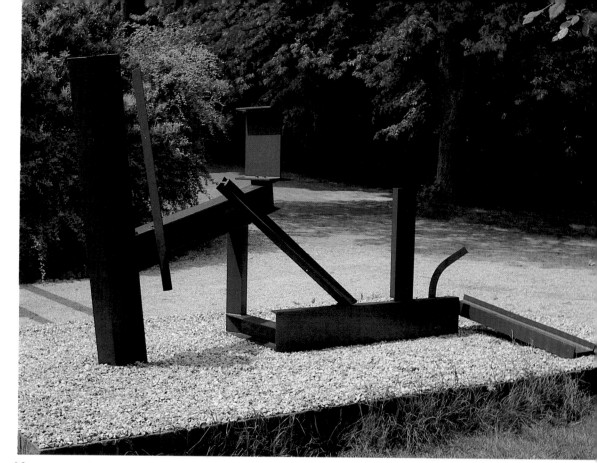

11. *Sculpture 3*. 1962. Steel painted red. 9′ × 15′1″ × 5′7″. Walker Art Center, Minneapolis

12. *Sculpture 2*. 1962. Steel painted green. 6′10″ × 11′10″ × 8′6″. Private Collection

13. *Second Sculpture*. 1960. Steel painted dark brown. 7′6′ × 8′5½″ × 1′4″

14. *Pompadour*. 1963. Aluminum painted pink. 9′ × 15′9″ × 5′8″. Rijksmuseum Kröller--Müller, Otterlo, The Netherlands

11

12

14

13

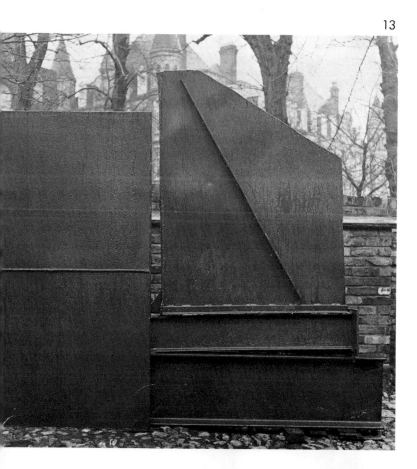

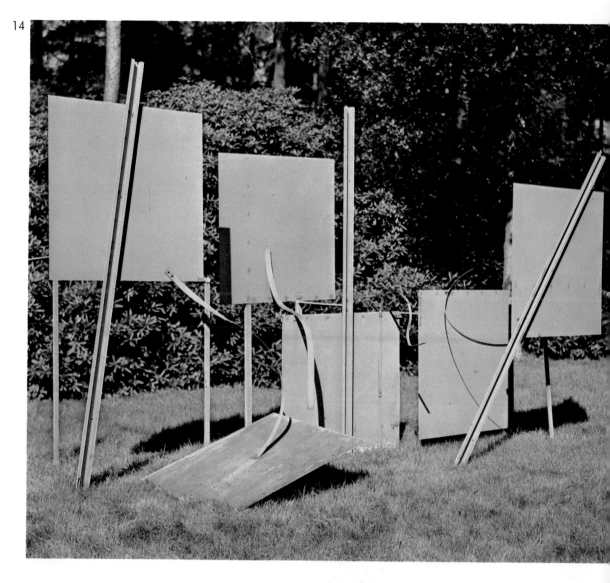

15–16. *Midday*. 1960. Steel painted yellow. 7'¾" × 3'1⅜" × 12'1¾".
The Museum of Modern Art, New York. Mrs. Bernard F. Gimbel Fund

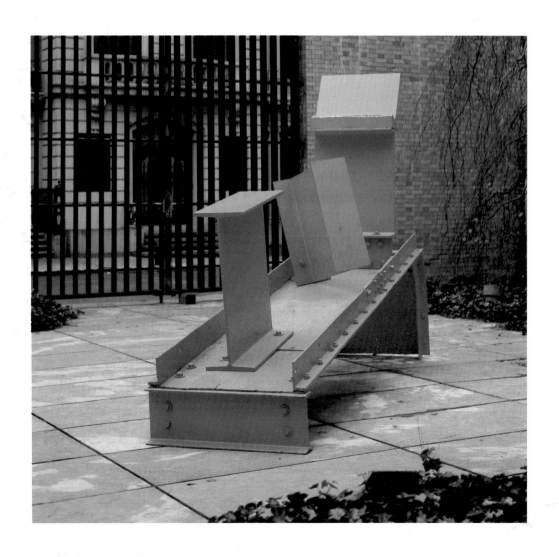

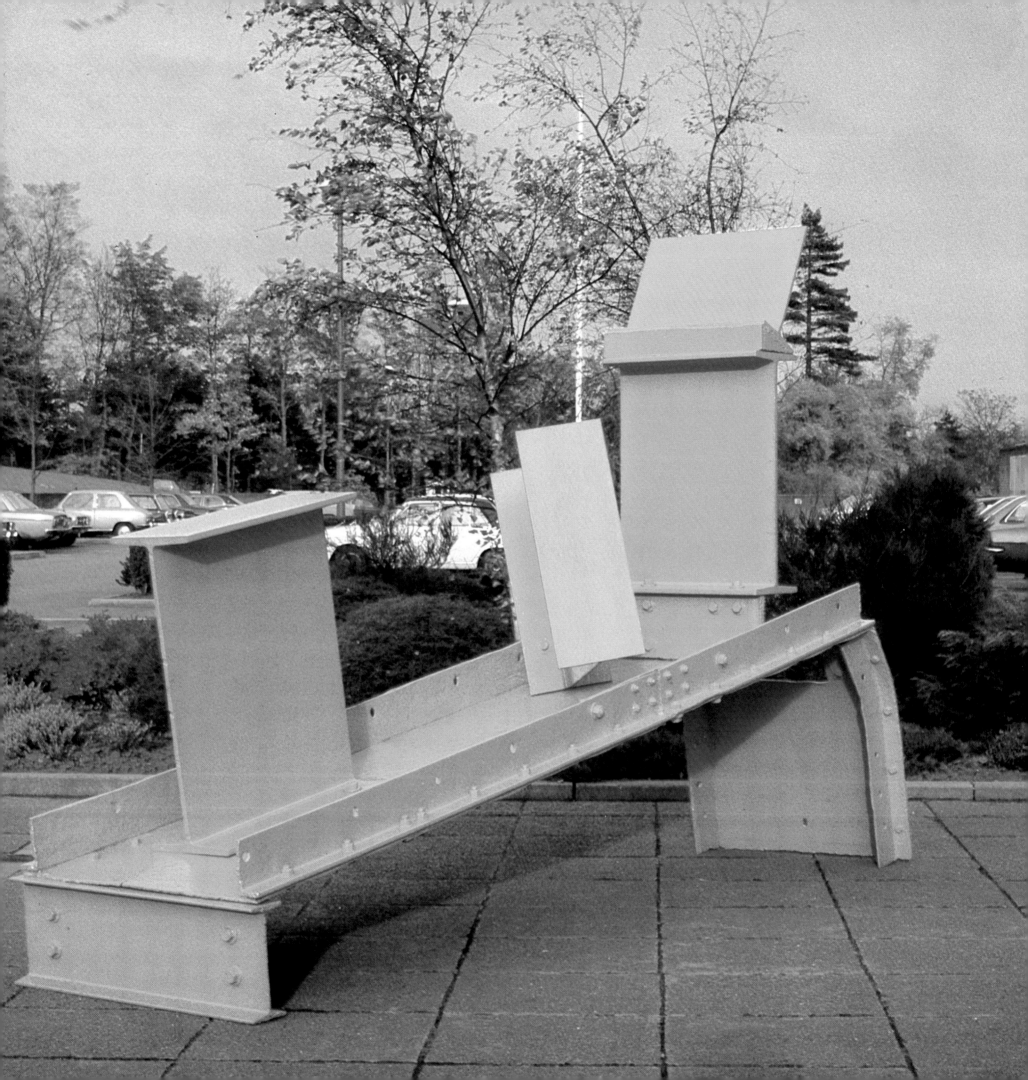

Despite Caro's reservations about the Royal Academy's pervasive conservatism, he relished the opportunity literally to work through the history of art:

It was a wonderful place to learn because I would work on the figure every day. But I didn't do a lot of imaginative stuff there. In the evenings I'd come home to my own place, and there I would model more and I would make imaginative sculptures for myself, starting at four or five o'clock and working through in the evenings every day. And in that way I found myself working through the history of art. I think this is what a lot of students do. . . . It started by being excited by the romantic Romanesque attenuated figures. I remember one holiday, summer 1948, I went for two weeks to Chartres and drew every day, took photographs. I got to know that cathedral like the back of my hand, I knew every figure on it. I sunk myself, immersed myself in Gothic and Romanesque stuff. And then later I began to enjoy Greek things and to start to try and make a figure which had a Greek feel to it . . . and then Etruscan sculpture. . . . I suppose this is some way of swallowing history and getting it inside yourself, making a pool or a pond inside yourself on which you are going to be able to sail.

For all of its numerous drawbacks, the Academy proferred a vision of the art of the past that was noble, ideal, and classical. And the essence of this vision, not its reactionary forms, imbues Caro's own rational, ideal, classical but radically different art. Thus by the time Caro had finished his five years at the Royal Academy, he had thoroughly digested the past: it was the present that continued to elude him. The one twentieth-century sculptor he knew something about,

the one he thought to be the best then active, was Henry Moore. He simply arrived at Moore's house one winter afternoon in 1951, knocked at his door, and said, "Can I come in, I want to work for you." As Caro relates it, he told Moore he was a sculpture student and Moore asked him in to tea, looked at his photographs, and showed him around. Though there was no job available, Moore explained that he was thinking of building a foundry and so might be able to offer him employment in six months. Six months later to the day Caro telephoned Moore, who hired him.

In December 1949 Caro had married Sheila Girling, a fellow art-student at the Royal Academy. Together with his wife and first son Timothy, he moved from London to Much Hadham, about thirty miles away. Caro was Moore's part-time assistant there from July 1951 to August 1953. He worked for Moore on the foundry and helped him, as he had Wheeler, enlarge some sculptures, this time for two commissions for the London Time-Life building. Moore was very gracious with his time, often spending hours with Caro, discussing sculpture and criticizing the younger man's drawings.

While he was Moore's assistant, Caro attended drawing classes two days a week at the Royal Academy. Instead of . . . *showing the drawings to the teachers who would criticize whether it was accurate or not, or who'd come and make a little drawing of the nose and eye on the side of your drawing which always irritated me—you didn't learn anything much from that—I'd take it back to Moore and he was incredibly helpful. I always found it very difficult to understand how drawings worked, how a drawing could make sense, because I was so much into volume that it seemed to me false to have to put it down on a flat sheet of paper.*

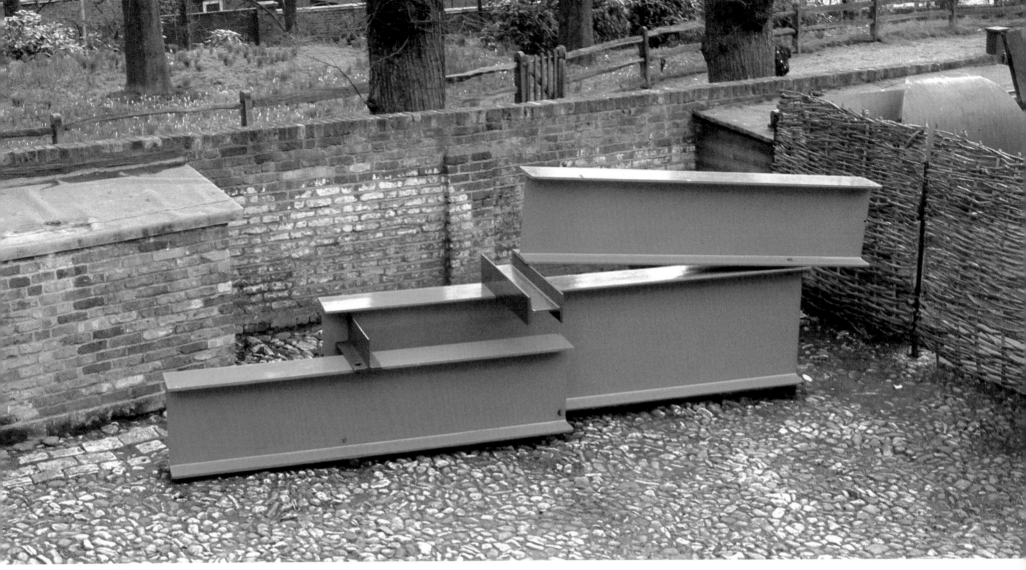

17. *Sculpture 7*. 1961. Steel painted green, blue, and brown. 5'10" × 17'7½" × 3'5½". Private Collection

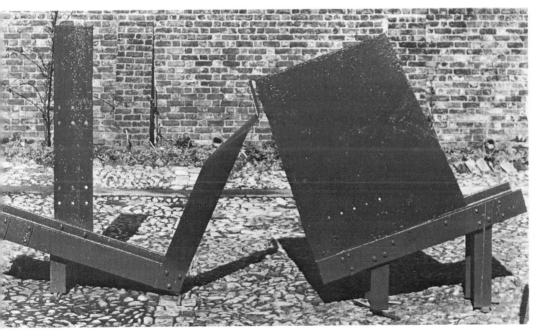

18. *The Horse*. 1961. Painted steel. 6'8" × 3'2" x 14'. Private Collection

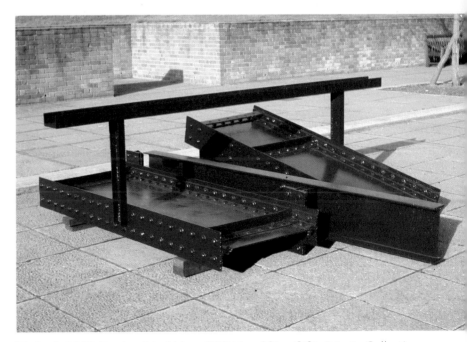

19. *Lock*. 1962. Steel painted blue. 2'10½" × 10' × 9'3". Private Collection

Moore's attitude to it was "Well, we'll try and break down the flatness of the paper, we'll try and make it work in a way like reality works." . . . For this reason he explained to me a logical system of the laws of light, inventing a light source; the more a surface was turned away from that light source the darker it became; also that perspective and intensity could work equally well on a figure drawing as on the drawing of a landscape . . . this is a system of drawing that made sense to me, though it doesn't make too much sense to a painter. I had always been taught to try to draw like Ingres, who floods light right across the surface. If you do that what sense does it make to a sculptor? Moore recommended the practice of drawing because if you draw a lot you can do a lot far quicker than making sculpture and this is a real help when you are changing fast.

Moore also generously lent art books to the young sculptor, whose exposure to contemporary movements had been extremely limited during his sheltered years at the Royal Academy. Through Moore, Caro received an intensive education in both twentieth-century and African art. "In my own work I think the books were really almost as much influence as Moore. Of course . . . I did some work that was very like Henry Moore but it misunderstood a lot about Moore."

In 1954, when he was nearly thirty, Caro and his family moved back to London, to a house in Hampstead where they live to this day. His years at Much Hadham had been nourishing, but not until he left Moore did Caro feel he had begun to be independent. Through his friend the sculptor Frank Martin, a fellow student at the Royal Academy, he was hired to teach at St. Martin's School of Art. Caro worked there two days a week, on Wednesdays and Fridays, until 1973, when he continued to teach one day a week and then less regularly, until 1979. He was instrumental in building the sculpture department into an internationally renowned avant-garde center. Both the teaching and the experience of being in London, at the core of activity in England, reinforced his sense of purpose. Although he had not yet found his personal direction, the atmosphere of challenge and change, the receptivity to new ideas he encountered there would help him make a radical break with his own past only five years later.

In the interim, however, he continued to work at a fairly conventional pace in a fairly conventional manner. Soon after he began teaching at St. Martin's, Caro started using his small garage as a work space, modeling figures in clay and later recasting them in plaster or, on the rare occasions when he could afford it, in bronze. In both his use of the figure and, especially, his handling of clay, Caro's work of this period recalls the late-nineteenth-century master August Rodin. The independence of form from subject in Rodin's work, as well as the master's single-minded focus upon the sculptural process and the nature of his materials, separated Rodin from his academic counterparts, placing him at the crucial junction between the end of an academic tradition and the beginning of the development of modern sculpture.

The process of modeling in clay, as Rodin explored it, differs substantially from working with other traditional materials like stone or marble or wood in which the sculptor carves or chisels into his materials, the form contained or defined by the size or shape of the block of stone or the body of the wood. Modeling in

clay is additive, it is a process of accretion, while carving or chiseling is a process of reduction. By implication, the additive process is one of extension, reaching out into the space of the viewer. It was this additive process and the expertise that Caro gained in handling clay that he brought to other, newer materials. In his subsequent use of steel and other equally intractable materials, Caro retained a sense of physicality and touch, and a feeling for improvisation and nuance that originated with his handling of more malleable materials like clay.

During this time Caro became friendly with the late Peter King, a Surrealist sculptor who also worked in Moore's studio. King introduced Caro to Abstract Expressionism, in particular to the painting of Jackson Pollock. London itself was in the midst of change, led by a group of younger Britons—Eduardo Paolozzi, Elizabeth Frink, Lynn Chadwick, William Turnbull, Kenneth Armitage, Bernard Meadows—whose spiky sculptures in an expressionist style (known as "The Geometry of Fear") were then considered highly controversial and daring. For the most part younger than they and far less advanced stylistically, Caro never became a convert to a truly expressionist style. But he admits to being excited by the direction in which their work was going.

Caro's interest in the expressive possibilities of the figure at first centered on the figure of the bull. Spurred on by his admiration of Picasso's sculptures and drawings of the same subject, an interest shared by other British sculptors at this time, Caro decided to investigate the animal at close range. He drove to an artificial insemination center some thirty or forty miles out of town. There he and Sheila, clad in white coats to keep the bulls from charging them, set about drawing the animals. The thoroughness with which Caro researched such subjects is indicative of both his training at the Royal Academy, and the seriousness of his approach to sculpture. Of overriding concern, however, was his need to break away from the constrictions the Royal Academy had imposed upon his way of working. In an attempt to free himself, Caro began to incorporate found objects into his work.

I was using found things and I remember seeing a large piece of a tree trunk. It had the beginnings of a sculpture in it. I went down there and spent half a day sawing that tree and somehow managed to get it down the hill and back to my place and then put plaster on it and made in into the thing I wanted, using it as a found object inside my sculpture.

Rather than exploiting the associative qualities of the found object, Caro used the materials as a means of stimulating new forms and ideas. The process enabled him to bring to his otherwise orthodox sculpture a measure of invention. Sometimes he devised extremely unconventional methods "for shaking myself up. . . . I got a lot of tables or boxes or stands in the room I worked in and I put a lump of clay on each one and then I'd go round the room and bang one lump with my fingers, knock one lump on the floor, hit one lump with a stick as I passed, and then look at them and see—is anything giving me a starting place? That sort of thing was a way of trying to open myself to working more freshly and more freely."

Caro's interest in the figure of the bull was relatively short-lived, and it was overshadowed by his continuing attraction to the human form.

Instead of making an angry beast like a little bull I

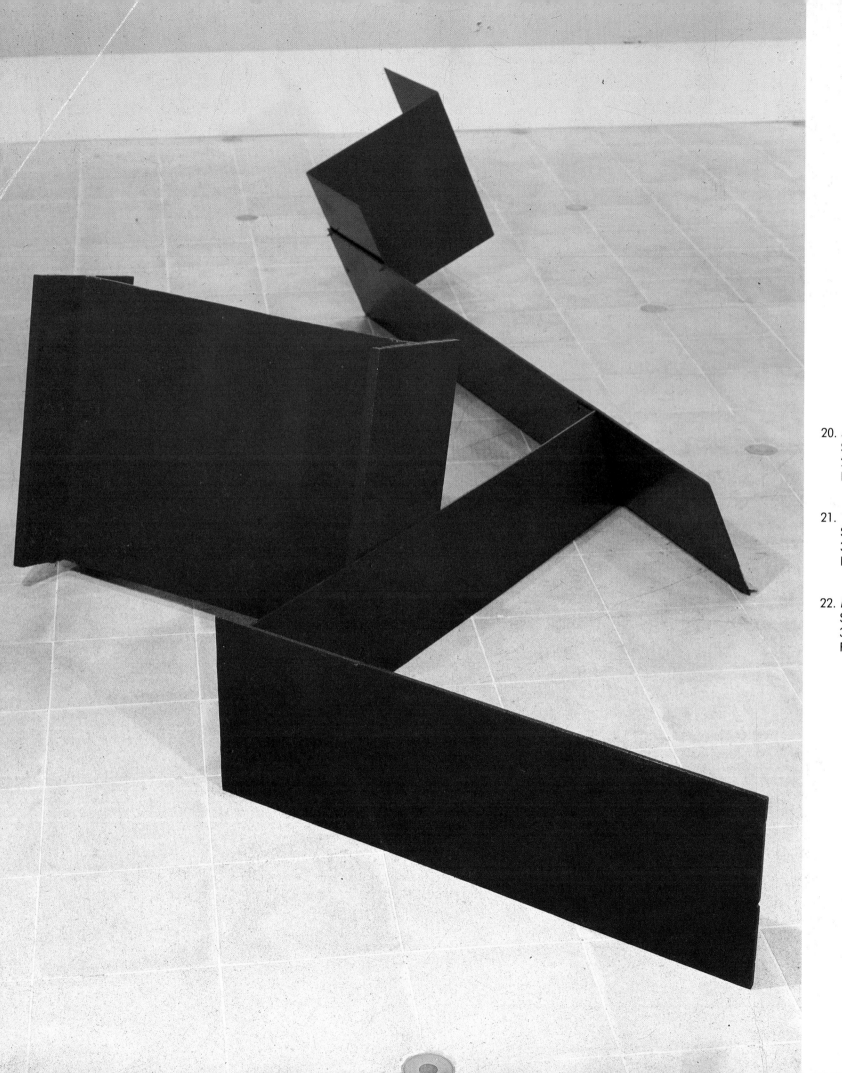

20. *Shaftsbury*. 1965
Steel
2'3" × 10'7" × 9'
Private Collection

21. *Titan*. 1966
Steel
3'5½" × 12' × 9'6"
Private Collection

22. *Bennington*. 1965
Steel
3'4" × 13'10" × 11'1½"
Private Collection

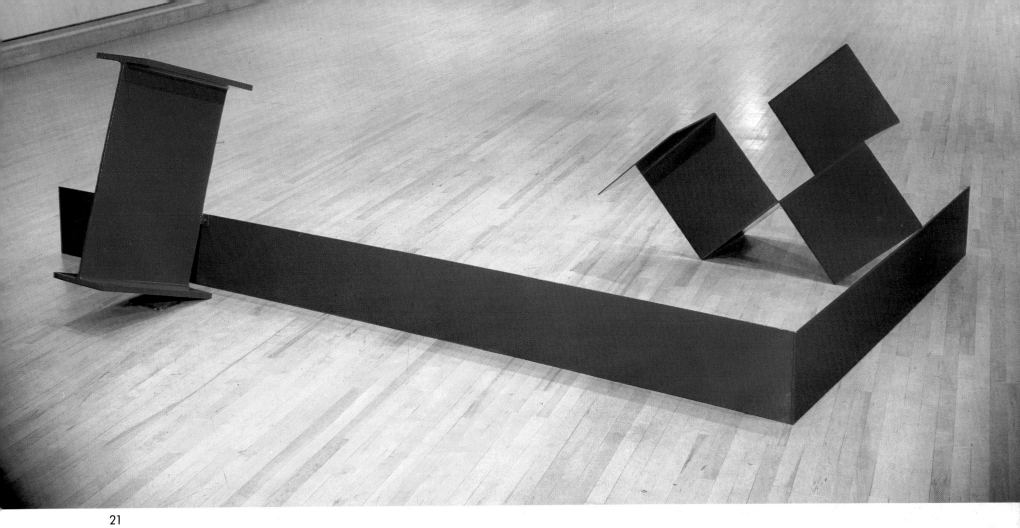

21

22

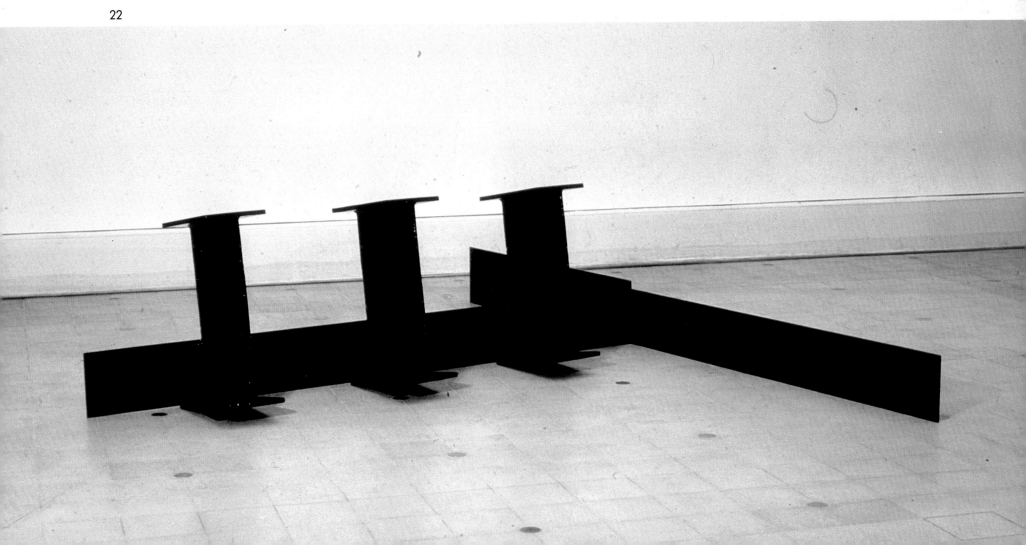

made a man—I made a figure with the same sort of qualities, and in some way that was quite a difficult thing to do at that time; it was quite a big leap. I don't know why a figure should have held that extra intensity, but I think the figure was rather sacred because distorting the figure was a different thing altogether from say, making a bull which had six horns; that was a much easier thing to do than building a figure.

As before, he handled the figures of men and women conventionally, modeling directly in the clay, but soon Caro added found objects like stones to roughen up their surfaces. In addition to real stones, he incorporated molds of cliff and rock outcroppings into his work.

We used to go to a place in Devon and fill up the back of our car with stones. Later I also used to go along the coast with a wheelbarrow, pushing it over those stones, and a sack of plaster and some bowls, and I would try and take piece-molds of the rocks that had been worn down, because they had the right sort of shapes in them. If you're making a piece-mold with something solid . . . if it has any return on it you can't pull it off. . . . So then the way to do it is to get water in between. If there's a tight fit you get a bit of water in and it swells and pushes off the plaster, so I used to wait until the tide came in and we'd just have our bathing trunks on and we'd be trying to pull this stuff off. . . . I'd get enough and then we'd drive back, a seven-hour drive, with the back of the car completely filled up with stones and with plaster molds. Sometimes I used vynamolds, rubber molds, bring it back home and then cast it into solid form so I could use it in the sculpture.

Although Caro exploited found objects and expressionist techniques to enliven his forms, he did not subscribe to the concepts underlying the movements which gave rise to these materials and methods. Neither Dada, nor Surrealism, nor Expressionism, so crucial to much art of the fifties, distracted him from his fundamentally classical point of view. Unlike David Smith and many of the painters of the first generation of the New York School, for whom Surrealism was an important catalyst, not only liberating them from their provincial past, but enabling them to enter the world of the imagination from which they fashioned a truly abstract art, Caro and his American colleagues of the next generation came to dismiss Surrealism and related tendencies as predisposed to literature and diametrically opposed to the central formal concerns of painting and sculpture.

During the mid- to late fifties, the period preceding his first mature, individual statement (*Twenty-Four Hours*, 1960, pls. 9, 10), Caro focused upon the figure in isolation. While there is a pronounced sense of the aloneness of the figure, these works project none of the feeling of *angst* common to much work of the period. (Kierkegaard's existential *Fear and Trembling* and the Theater of the Absurd were among the signposts of the era.) Nor do they project the heroic stance which characterizes sculpture prior to the late nineteenth century. Instead they reflect a concept of the figure as a genre subject similar to still-life, a concept that was most succinctly expressed in Degas's intimate *déclassé* dancers (fig. 1) and laundresses. Figures such as *Man Holding His Foot*, 1954 (fig. 3, pl. 8), are engaged in the most mundane activities. Caro consistently sought to portray the commonplace and the prosaic gesture caught in a moment in time. His

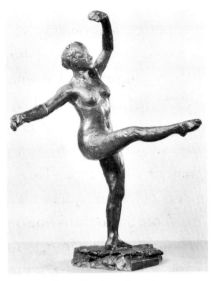

fig. 1. Edgar Degas, *Developpé en avant*. The Metropolitan Museum of Art, New York, Bequest of Mrs. H.O. Havemeyer, 1929.

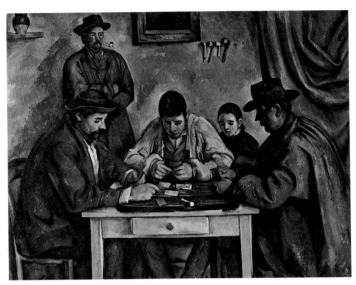

fig. 2. Paul Cézanne, *Card Players*, 1890–92. The Barnes Foundation, Merion, Pa.

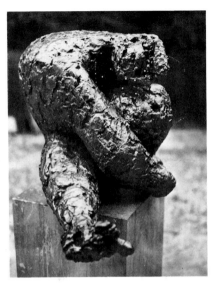

fig. 3. Anthony Caro, *Man Holding His Foot*. Private Collection.

subjects recall the stoic, essentially classical figures of Cézanne's *Card Players* (fig. 2) rather than the exaggeratedly elongated forms of Giacometti or the tortured expressionism of the work of Caro's British compatriots. Caro speaks of his objectives:

The sculptures themselves were of people . . . men or women engaged in sort of intent operations. I would make a sculpture . . . say, of a man taking his shirt off. Your head is in the way so it almost seems to shrink; so the head in my sculpture would be small, like a nut. Or a woman lying down and she would be pressed, she would have her whole weight relaxed, sunk to the ground and so she would appear to be pressured in that way. The first group of sculptures was about that sort of thing. Later, where again I used more broken and textured stones in them they were even more intent; intently turned in, rather in the way that a photograph is chosen for Tempo *or* Life *magazine . . . , giving that very moment which somehow sums up,*

say, the man lighting a cigarette. I used to look a lot at photographs in those magazines because somehow they really chose the photograph which gave that moment significance.

In the studio I have a picture on my wall which comes from Life *magazine . . . of prostitutes playing chess . . . it's very much what I have always considered my sculpture to be about. It's rich and fleshy and delicate; at the same time it's so crisp.*

The idea that these great fleshy beautiful naked or lightly clothed ladies with beads round their necks are playing chess—the two things together are such a great combination. It does say something about what I like: sensuousness and crispness together.

Ironically, Caro's figurative work was more closely related to contemporary painting than to sculpture. Giacometti, the most important exponent of the sur-

realist tendency in sculpture and, with David Smith, the major sculptor to emerge in the fifties, did not impress Caro, although Caro's early work, in its tactile surfaces and distorted forms, superficially resembles that of the Swiss artist. Moreover, Giacometti's explicit extra-pictorial references, his expression of existential ideas of individual freedom and responsibility and man's isolation, of anxiety, guilt, and dread, appear to be antithetical to Caro's burgeoning interest in abstract form, gravity, mass, and density.

In a curious reversal of the character of painting and sculpture, Giacometti's three-dimensional figures are strangely intangible; the artist uses them to question the nature of physical reality. Giacometti's work is cerebral, hermetic, disengaged, and introspective—it is more about the human condition than about "being"—and it is ultimately equivocal about the question it poses. It is sculpture deliberately without substance.

Yet whereas contemporary sculpture offered little to Caro, painting was a rich source of inspiration. The distortion of Caro's figures of the mid-fifties acknowledges the work of Francis Bacon, Willem de Kooning, and Jean Dubuffet, all of whom Caro especially admired at this time. Where Giacometti's sculpture is impalpable, the paintings of Bacon, de Kooning, and Dubuffet speak of matter, of mass, of the corporeal, no matter how abstract, decorative, or two-dimensional the forms and composition. While the work of these painters could be considered existentialist or expressionist in attitude, being violent, emotive, provocative, and potentially nihilistic, it is nonetheless intensely palpable, possessed of a powerful sense of tangible life.

Caro was particularly impressed by Dubuffet's

Corps de Dames series, which was exhibited at London's Institute of Contemporary Art in 1955. Although he had imbedded stones into his clay figures the preceding summer, Dubuffet's example inspired Caro further to roughen up his forms. His sitting, kneeling, bending, and reclining figures became bulkier, the texture of the clay more apparent, the forms more massive, powerful, and sensuous, the limbs, buttocks, and breasts more exaggerated. It was to this world of material existence, allied with abstract form, that Caro was attracted.

In the fall of 1955 Caro was invited to participate in a group show at the Institute of Contemporary Art, together with William Scott, Hubert Dalwood, Peter King, Jack Smith, and Ralph Brown. Caro exhibited *Man Holding His Foot* and *Seated Figure*, 1955 (pl. 5), and was singled out for special praise, as the following quotations reveal:

Only in the case of Anthony Caro is the forcefulness of method matched by a similar violence of form. . . .[2] and: *Of the new "sculptors" the most impressive on this showing seems to me to be Anthony Caro, whose . . .* Man Holding His Foot *. . . reveals, besides the influence of Picasso and Henry Moore, a sheer sculptural power indicative of rare promise.*[3]

Caro employed pictorial distortion as one of the basic components of his sculpture. For example, in *Man Holding His Foot*, he attempted to maximize the intensity of his figure through both extreme distortion and aggressive modeling. (This amalgam of the pictorial and the sculptural occurred also in Caro's teaching, when he combined sculpture and drawing in the same class.) But the forcefulness of Caro's fig-

ures is suppressed by the planar nature of their composition. Caro's emphasis upon shape, plane, line, and curve is often at odds with the bluntness of his forms and the roughened textures of his surfaces. Despite their full, often distended limbs, his figures tend to read as flattened, foreshortened forms, rather than as fully rounded volumes occupying real space. Furthermore, Caro's inherent reserve and classicism seem to inhibit any excessive emotiveness in his work. It is clear, however, that Caro is striving to portray that "rich and . . . delicate" as well as crisp nature of his subject that he found so attractive in *Life* magazine's photograph of prostitutes playing chess.

Caro owes an obvious debt to Moore in such works as *Man Taking Off His Shirt*, 1955-56 (pl. 7)—a debt apparent in the abstraction of the figure and limbs, the exaggeration of torso, and the emphasis upon surface. However, Moore's smooth concave and convex forms, his hollowed-out shapes, his contrast of open and closed volumes, and the importance he accords to voids are absent from Caro's work. Moreover Caro's work of this period lacks Moore's command of internal space and his ability to activate the space around the sculpture. But already evident in Caro's sculpture, especially in the extremely effective *Woman in Pregnancy*, 1955-56 (pl. 3), is much that is his alone: an emphatic flattening of volume, an emphasis on weight, mass, or gravity, a distinctive feeling for the curve in relation to the right angle, and a feeling for the plane—these are all singular features of his later, decidedly abstract work (cf. *Orangerie*, 1969, frontispiece).

In 1955 Caro attempted, without success, to find a gallery in London. Disappointed, he went to Italy to try to show, attracted to its fairly lively sculpture scene.

The Galleria del Naviglio in Milan gave him an exhibition in March of 1956. In London Gimpel Fils agreed to show his work after the Milan exhibition. The Milan show occasioned no reviews and nothing was sold. (In fact, Caro did not start selling his work with any real success until 1965.) A small audience did develop for the clay and bronze pieces of 1954 to 1959, but this following vanished when he began to experiment with steel in 1960.

By mid-1959 Caro was very dissatisfied with his work and began to search for a new direction. At this point he met the American critic Clement Greenberg at William Turnbull's house, and invited him to his studio. Caro was impressed by Greenberg's insight on these occasions.

He made me see that my sculpture was simply not good enough and needed radical rethinking. . . . I tried to make some abstract sculpture. I got some old wings of cars and added plaster to them. They came out wrong. . . . They came out like figures somehow.

Shortly thereafter, Caro received a Ford English-Speaking Union Scholarship to spend two months in the United States. He stayed in New York for about three weeks in the autumn of 1959 and then traveled to several cities across the country. He renewed his acquaintance with Clement Greenberg and met, among others, Kenneth Noland, Robert Motherwell, Helen Frankenthaler, Adolph Gottlieb, and David Smith. The trip was a revelation.

The whole thing went up a key. The whole thing went from steady, let's be good, let's make good art sort of thing, to let's blast it apart, let's make it great, now

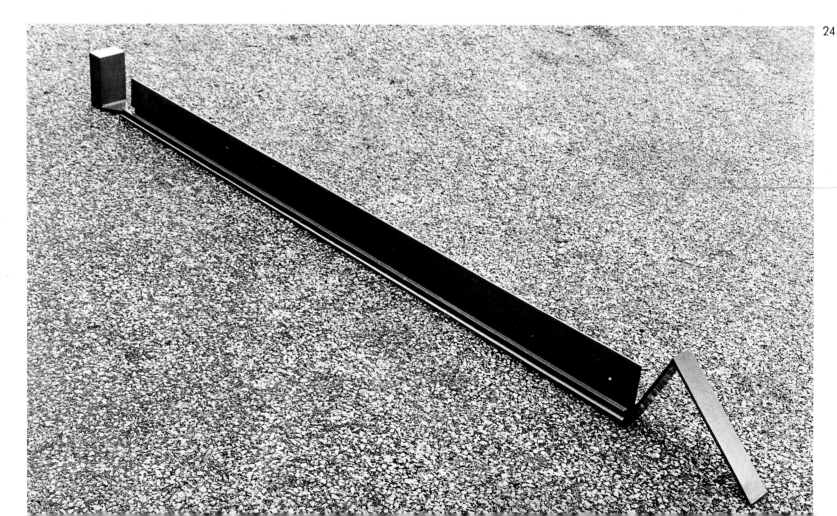

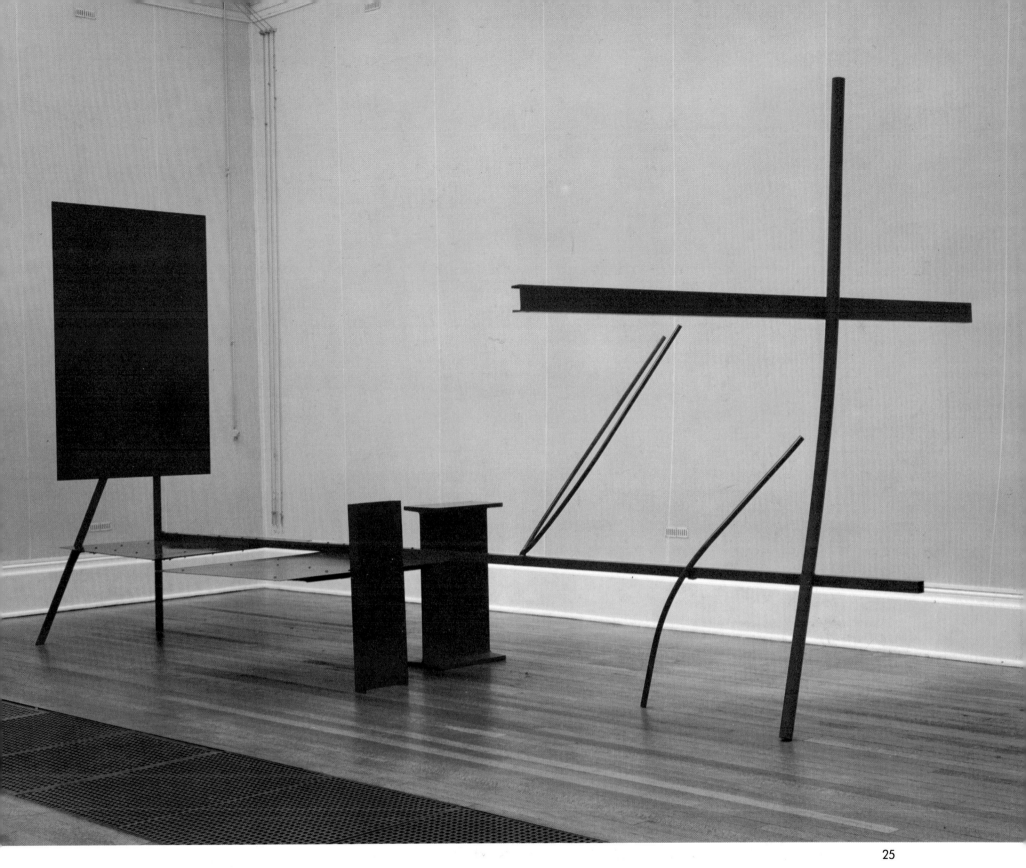

23. *Sill*. 1965. Steel painted green. 1'5¼" × 4'8" × 6'3"
Private Collection

24. *Strip*. 1965. Aluminum and steel painted red. 7" × 3" × 6'6¾"

25. *Early One Morning*. 1962. Steel and aluminum painted red.
9'6" × 20'4" × 10'11". The Tate Gallery, London

we've really got to do something. You know? I can't describe that raising of a key, that extra turn of a screw, that extra twist of excitement about America then and about the endeavor that's required of those that are going to work in that scene.

Caro recalls that in New York Greenberg told him, "If you want to change your art, change your habits." He decided to experiment with a different material, one suggested to him by David Smith's work, and upon his return to London he began to use steel.

I went down to the docks when I got back and found pieces of beams, big H-beams, also rough pieces that had been cut off bridges, got a lorry and got them back here.

I had been trapped by the ease of clay, by the luscious sensuality of clay that would do just what I wanted it to do. It had got me foxed, it was doing it for me—it was doing it, in a way. Steel's hard, intractable. It was difficult to work with steel I found, and it gave me just the resistance at the time that I needed.

Funnily enough, my engineering training didn't seem to teach me a damned thing about how to use steel the way it was meant to be used; so I was using beams and channels in my own way, not as they were used in architecture or bridge building, or anything like that.

While the visit to New York and the subsequent decision to use steel proved to be the catalyst for a dramatic breakthrough, Caro's rapid change in style was not entirely at odds with the painstaking progress his work had been undergoing since 1953. None-

theless, this transformation was remarkable in its thoroughness. Caro rejected the very means of expression he had developed in his past work, substituting flat planes for mass and volume, impassive or neutral surfaces and industrial materials for heavily worked, expressive modeling, total abstraction for figuration. Caro not only liberated himself from his past but from a laborious traditional working method. In shedding his past with such conviction Caro was able to make that extraordinary leap into his own time and to free himself to experiment with form as though he were seeing its potential for the first time.

Despite the radical nature of his departure, Caro never did relinquish his early experience at the Royal Academy and with Wheeler and Moore. The knowledge he gained of various materials, and of working with both monumental sculpture and small-scale works, stayed with him. Unlike most sculptors, even those with less traditional backgrounds, who mechanically enlarge sculpture from smaller models, Caro decided to work directly in the scale required for each piece. He did, however, utilize his training in making maquettes to full advantage when he first began his exquisite series of small table pieces in 1967. While Caro eschewed grandiose public monuments, he did not abandon large-scale sculpture. And even in the largest of his works there is an attention to details of placement, a sense of intimacy which engages the viewer rather than creating a feeling of awe or majesty or a sense of isolation from the object at hand. In both his large-and small-scale work Caro employs with consummate skill his absolute knowledge of materials and his extraordinary feeling for appropriate size. Caro was able to free himself from the conventions of the figure without relinquishing its

expressive plastic possibilities: his abstractions could be passive or aggressive, dynamic or quiescent, emotionally active or neutral. Thus he revivified a dying tradition, abandoning its outworn elements and stripping it of its pomposity, yet retaining its grandeur and authority, translating its outmoded forms into a modern idiom, a new means of expression.

Caro began to address himself to these issues in *Twenty-Four Hours*, 1960 (pls. 9, 10), the first piece he produced after his visit to the United States. Frontal and emphatically pictorial, it comprises large sheets of metal cut into a circle, a trapezoid, and a square. The circle and the trapezoid are vertical. The square tilts away from the two forms in front of it. The disc, the only element which conveys a sense of movement, is placed off center to the right in what is otherwise a fairly symmetrical composition. Its surface is enlivened with a painted circle reminiscent of Smith's painted sculpture and, more specifically, of Noland's circle paintings. New to Caro's work is its abstractness, the use of steel, and the relatively large size of the piece—it measures 4'6½" x 7'4" x 2'9"—as well as the general angularity, resolute planarity, and frontality, the restriction of surface inflection to the subtle understated painting in the disc, a discreet asymmetry, the rough edges of the cut steel, the slight tilting away from the perpendicular plane, and the irregular seaming where the shapes are welded together.

Caro discusses the genesis of the piece and his goals:

It came partly by chance. I got most of it made in two halves and then stuck it up on chairs and it looked right there and I went on. Sculpture does sometimes come like that. You very often don't recognize a new path when you're there. You do the art up to the very edge of your nerve and experience and feelings, and then it's left to others to tell you how new it is. The feeling nearly always comes first, and then rational thought comes in to make it a reality, and inspiration is simply when the work goes well and you get what you're striving for. But inspiration for me is a very suspect word. It makes all the days of hard work, and the bad days, count for nothing; and sometimes it's because, just because of the bad days that you know what to discard, and what can and can't be done. Making art work is not a flash in the pan.

I did know certain things I didn't want, and I think that's often a thing that happens. I was very clear about what I didn't want—I didn't want encrusted art-like objects. I wanted sculpture that was in my world.

I wanted something that moved me and meant something in terms of being there in a very immediate way. Also, I wanted it kind of stated, kind of there—no arm twisting.

I painted it brown and stuck it out in the courtyard, and for me that was clear. . . . Okay, it wasn't a figure anymore, but who says that art has got to be illustrative? I think that the lessons of American painting had proved to me that it didn't need to be, that really the least important thing about good art is what it's of, what the subject is. The feelings and mood are somehow implied and the sensibilities of the artist are reflected in the work.

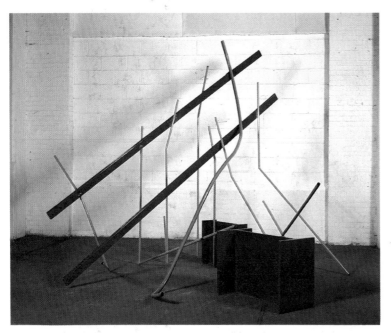

26. *Month of May.* 1963. Aluminum and steel, painted magenta, orange, and green. 9'2" × 10' × 11'9". Private Collection

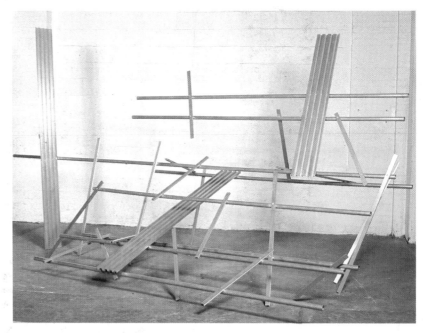

27. *Hopscotch.* 1962. Aluminum. 8'2½" × 15'7" × 7' Private Collection

Frontality and planarity are even more insistent in yet another work of 1960, *Sculpture 2* (pl. 12). In an attempt to subvert his consciousness of traditional composition, Caro began the piece on the floor of his studio. This method of working was inspired by the way in which Kenneth Noland painted, and the way in which David Smith worked (as Caro learned from a magazine article about Smith). Like *Twenty-Four Hours, Sculpture 2* is painted, and, indeed like much of Caro's sculpture executed between 1960 and 1974, it is quite large (7'6" x 8' 5½" x 1'4"). And again like *Twenty-Four Hours* it displays a restrained asymmetry, in this instance accomplished by the slight elevation of the right side of the sculpture and by the diagonal ridge that bisects the the top portion of the sheared-off rectangle. The entire right section of the piece is, in fact, placed slightly above and behind the flat sheet of steel to its left, suggesting the barest semblance of depth. Although there are several significant horizontal elements—chief among them the ridge that bisects the plane on the left and the two I-beams supporting the right-hand section—the thrust is predominantly vertical. A short time later, however, Caro abandoned his experiments with vertical compositions in favor of working horizontally.

In the early 1960s Caro was working and teaching, visiting his colleagues, looking at work, producing slowly but always trying to discover something new in his sculpture. In his classes at St. Martin's Caro encouraged his students to "let loose" by giving them unorthodox projects or suggesting that they use unconventional materials like chicken wire and straw. Even in conventional studio settings he presented unconventional situations: for example, his students worked from a model in motion (a practice of Rodin's lost to later generations). He asked his students to

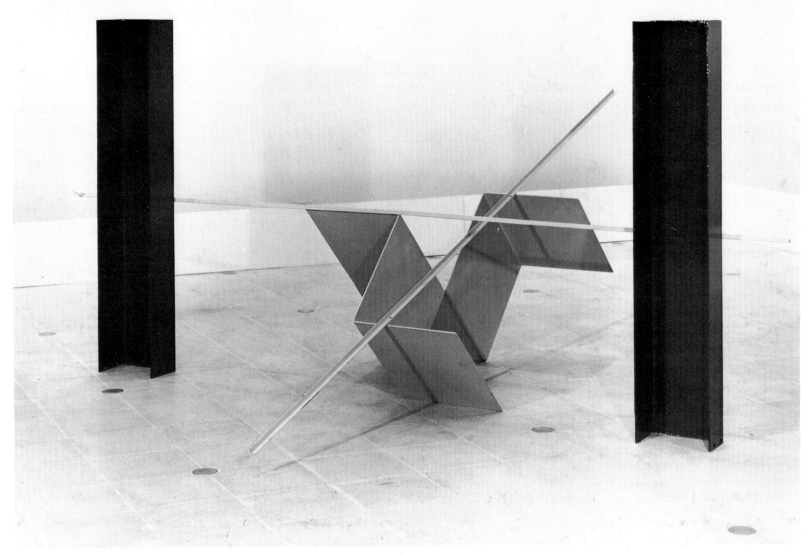

28. *First National*. 1964. Steel painted green and yellow. 9'2" × 10' × 11'9"

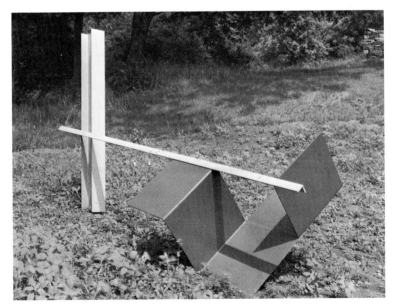

29. *Sunshine*. 1964. Steel painted red and orange
5'2½" × 4'9" × 10'½"

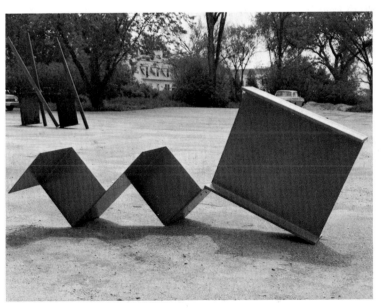

30. *Rainfall*. 1964. Steel painted green. 4' × 8'3" × 4'4"
Hirshhorn Museum and Sculpture Garden, Smithsonian Institution,
Washington, D.C.

draw in a room apart from the one in which the model was posing; he proposed that they make masks, some of them as large as eight feet high; and he had them invent radical ideas for sculpture—one devised a sculpture game which utilized other students as well as L- and T-shaped rods. Caro speaks of this period as follows:

It was a very exciting time. We would be going to one another's studios, or into the sculpture school; there'd be work to look at, work that would call your own work into question. When we went to each other's studios and saw what the other person had done, it would make you say, "My God, he opened up a whole area" or "He's pressing a new area, say, for example the use of color, which I hadn't thought about, and that, maybe, raises some doubts about the direction or quality of what I'm doing." All of us were questioning the assumptions by which sculpture had said "I'm Sculpture."

Anything was possible in those years. It wasn't really the material that was important. What was important was the examination of what sculpture could be to you in your life. It was no longer an object to put on the mantlepiece and forget about, or to put on a pedestal in a public place. It was a question of how it could be more immediate, more real.

From 1960 to 1963 Caro worked on his large sculptures in the same garage attached to his house in Hampstead that had served him since 1954: it was difficult if not impossible for him to see his work at a significant distance. Certainly it was difficult for him to visualize the finished work in the round. But Caro

used this to his advantage, to help bring a new order into his art.

Often, one would get larger than the space available and poke out of the door into the courtyard. But I deliberately worked where I could not see them properly because I was after a new rightness for them, and one I could not take for granted but had to discover; and to have seen them from a distance when I worked on them would have tempted me to correct them, to balance and order them in a way I knew. Then, when each one was finished, I'd ask a friend to come along and we'd make them, weld and bolt and paint them.

The advantage of making them where I couldn't stand back from them was . . . to prevent my falling back on my previous knowledge of balance and composition. Working in a one-car garage, as I used to do, was a way of trying to force my mind to accept a new sort of rightness that I wanted. I had to refrain from backing away and editing the work prematurely. When I took the work outside, it was a shock, sometimes, insofar as it looked different from sculptures that I was accustomed to. [4]

The sculpture of this period is generally rectilinear, with curved elements used sparsely and then primarily to counter or to soften the planarity of the whole, as, for example, in *Early One Morning* or in *Pompadour*, both of 1963 (pls. 25, 14). Made of I- or T-beams, painted, and non-environmental, they do not function as effectively out-of-doors as the later work, nor were they intended to. In fact, Caro wanted them to be seen up-close, though not, of course, as close as he was when working on them. He said, "I prefer to

think of my sculptures indoors. Indoors they should expand into space. Outside, when you get back to look at them from a distance, the grip of the sculpture is diffused."[5]

Caro may have chosen to work indoors as a matter of principle, partly as a reaction against the stereotyped large-scale public sculpture with which he was so familiar. But it is also likely that his particular form of abstract sculpture—so absolute in its geometry and rectilinearity—required an environment of a similar order as a frame. Unlike David Smith, whose fluid, active, gestural forms seem perfectly at ease in the rambling landscape, Caro's contained, rectilinear, ultimately rational forms of this time seem more at home, certainly more imposing, within the boundaries of the garage or gallery. It was not until Caro no longer restricted himself to a certain formal economy that his sculpture began to breathe and to be marked by an expansive, flowing character. It became equally at home in interior and exterior spaces, seen close up or from a distance.

Although Caro had seen only one or two of Smith's sculptures (he remembers only one—a sentinel figure) on his visit to New York in 1959, this work was sufficient to influence him significantly. Already inspired by Greenberg's advice and by the climate of excitement and innovation in the United States, he was equally stimulated by Smith's use of welded steel. Steel was a material that had come to be identified with David Smith, as iron had come to be identified with Gonzales before him. Steel and iron had come to signify newness, change, experimentation, and reduction in twentieth-century sculpture. Caro began to forage in scrap yards and to forge his own personal style, employing scrap steel, sheet metal, and girders.

He crudely bolted and welded these elements together and applied household or industrial paints to their surfaces.

Smith represented much more to Caro than a change in style or a change in materials; he more than any other sculptor represented the new approach to sculpture that Caro was seeking. He was at once the embodiment of the heroic generation of the New York School of the fifties and a member of Caro's new circle of friends of his own generation. And although Caro emulated Smith at first, he was too much an individual to follow closely in his path for more than a year or two. While his indebtedness to Smith is apparent in the works of the early sixties, the differences between the two sculptors are even more intriguing than the similarities.

Their fundamental differences begin with their points of origin: Smith's first important sculpture was Surrealist-inspired; Caro's was not. Smith's sculpture remained illusionistic, anthropomorphic, and totemic; Caro's does not allude to the figure. Smith's is based in nature, integrated into landscape; Caro's work is ground-related but not derived from nature. Smith's sculpture is muscular, gestural, episodic. Caro's work is lyrical rather than heroic, the parts are uninflected; it is concerned with classical balance, harmony, and rational proportions. Smith's flatness of conception—above all the emblematic quality of the image—enables the viewer to apprehend a sculpture in its entirety almost immediately. However, because Caro emphasizes the individual parts, the collaging of elements, the relationship of unit to unit, he compells the viewer to experience the individual parts in order to grasp their totality. We can usually comprehend a Smith rapidly from one fixed, most often frontal,

position. But Caro's sculpture, even when frontally oriented, takes on different appearances from different angles: it is discursive; its effect is cumulative. Thus our experience of the work is slowed down, multi-leveled, and complex. Smith's sculpture is anchored to a single fixed point, its play in space is limited because activity is generated only from the base upward. Caro, almost from the inception of his mature style, chose not to use the base. This made it possible for him to anchor his forms in several places, thus enabling him to articulate and encompass greater areas of space with minimum means.

Both *Twenty-Four Hours* and *Sculpture 2* (of 1960) are transitional works. Resolutely frontal and planar, yet still tentative in expression, they reflect Caro's seeming unwillingness entirely to abandon elements of his earlier style. This is especially true of *Twenty-Four Hours*, where he continues to use irregular edges and rough seams, and to emphasize the surface by exploiting the corroded, pitted, and pebbly texture of his material, much as Noland retained vestiges of Abstract Expressionist drips, marks, and brushed edges in his first concentric circles.

Midday (pls. 15, 16), finished only a few months after *Twenty-Four Hours* and *Sculpture 2* in 1960, represents Caro's breakthrough into his fully resolved personal idiom. Like its two immediate predecessors, *Midday* is large (7'¾" x 3'1⅜" x 12'1¾"), steel, and painted (this time yellow), and composed of I-beams and other industrial units: it is forthright in its composition and direct in its effect. But it is no longer vertical, flat, or planar: this new sculpture is horizontal and conceived in three dimensions. Although reminiscent in its posture of his 1956 *Woman in Pregnancy, Midday* is entirely without anthropomorphic reference.

Indeed, in contrast to David Smith's vertical compositions, which often approximated the human form, Caro's low-lying horizontal constructions rarely even remotely suggest the human figure. Caro's sculpture is completely self-sufficient; its reality is that of its own inherent logic as abstract construction. In *Midday*, the emphasis is on the form and process—the literal nuts and bolts—of sculpture making. Just as his friend Kenneth Noland wanted to make paintings that were strictly about the formal qualities of painting, so it was Caro's intention to make sculpture solely about sculpture. Thus Caro focused upon the internal construction of the piece, the ordering of its separate parts, the way they were joined, and the use of color to achieve an overall synthesis. The problems he addressed in *Midday*, the problems of testing the boundaries of sculpture, were to engage him in all of his subsequent work.

Works like *Sculpture 7* or *The Horse*, both of 1961 (pls. 17, 18), continued the ideas set forth in *Midday*. *Sculpture 7* explores the horizontal emphasis established in the earlier sculpture; *The Horse* contrasts the horizontal or ground-defining context of the construction with the vertical or diagonal thrust of several of its members, an interplay examined as well in *Midday*. Both *Midday* and *Sculpture 7* exhibit density and compactness, a ground-hugging directness, while *The Horse* is marked by a sense of the pictorial spread or field. In *The Horse*, linear elements which function in a three-dimensional way define space in a manner that is indicative of much of Caro's later work.

Although the simplicity, directness, and resolute abstraction of *Twenty-Four Hours* and *Sculpture 2* are predictive of Caro's future direction, these pieces are rather anomalous in his oeuvre. Both are atypical in

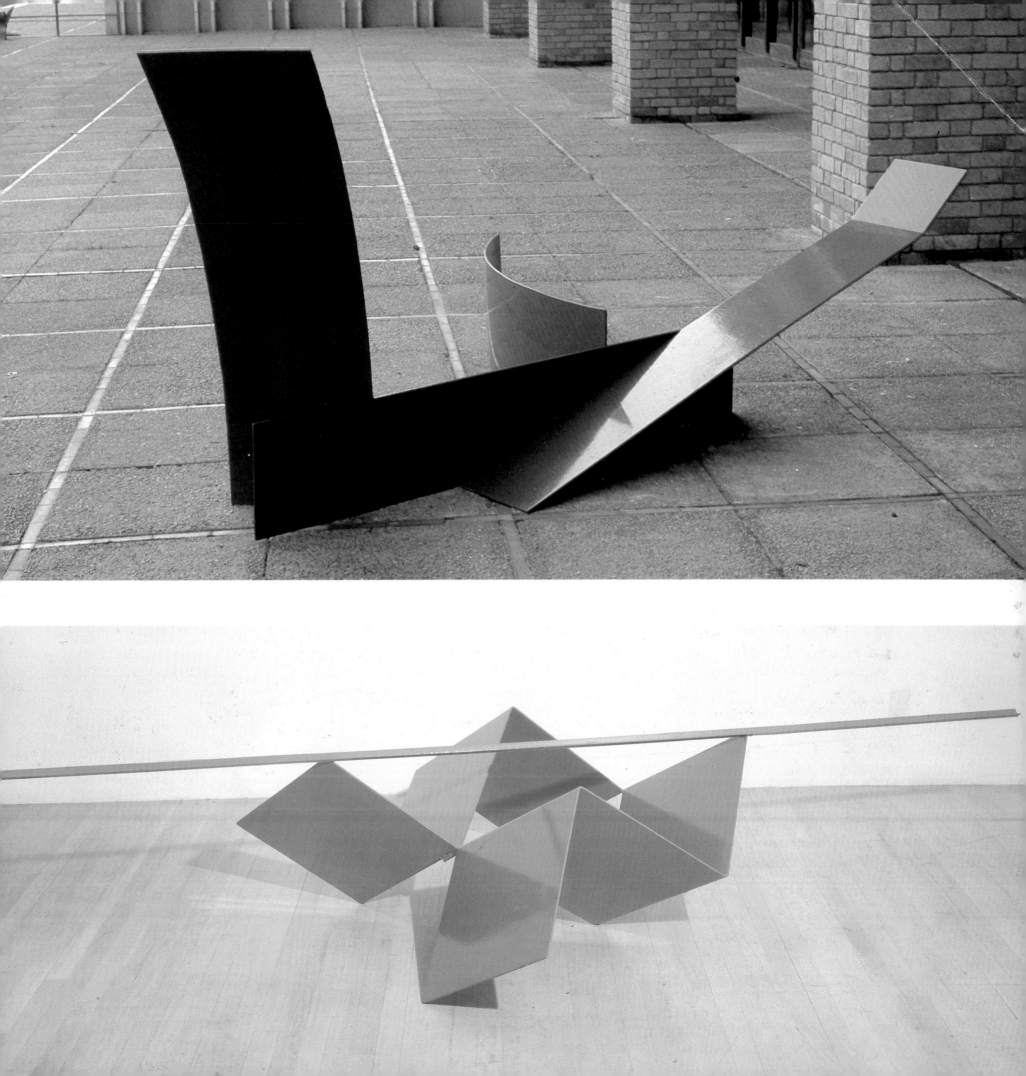

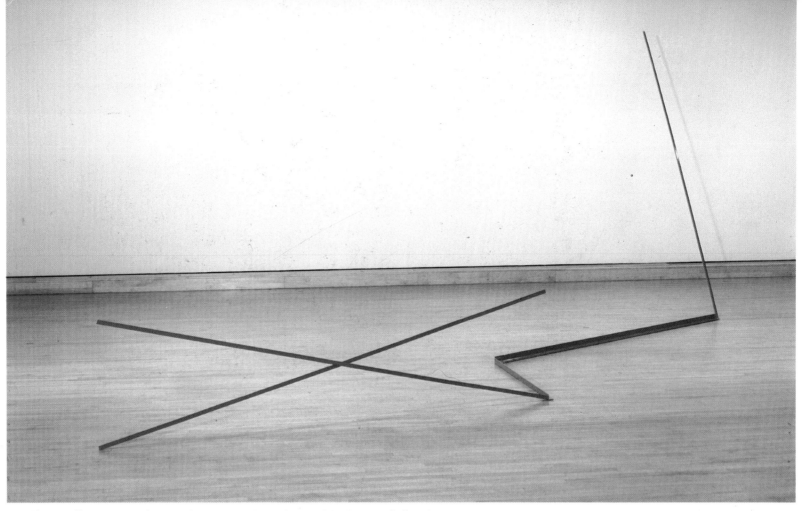

33. *Sleepwalk*. 1965. Steel painted orange. 9'2" × 8'4" × 24'. Private Collection

34. *Wide*. 1964. Steel and aluminum painted burgundy. 4'10¾" × 5' × 13'4". Private Collection

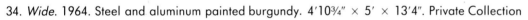

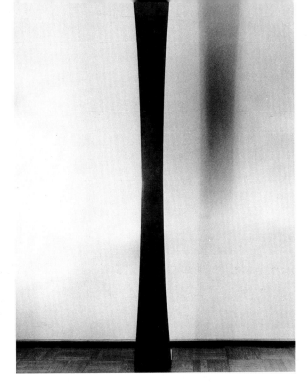

fig. 4. Ellsworth Kelly, untitled, 1974. Milwaukee Art Museum.

fig. 5. Carl Andre, *Copper-Zinc Plain*, 1969. Private Collection.

that they exist on a single plane, while as a rule shifting angles and planes characterize even the most frontal of Caro's subsequent sculpture. These earlier works do, however, share an essential feature common to all his work: they confront the issue of the base, an issue central to the development of advanced sculpture in this century. William Tucker points out that in sculpture the base mediates between the object and the ground and that it "represents the world in terms of its gravitational pull in immediate contiguity to the object: the role of the base is at once physical, in terms of support; visual, in terms of presenting the object at proper level; and symbolic, in terms of the object's relation with the world."[6] But the role of the base in traditional sculpture also served another function; like the altar, it served to put distance between the viewer and the work. In contemporary thinking, the base or pedestal no longer serves any useful function. As the nature of sculpture changed from the representation of things to the representation of sculpture as sculpture, so the base was progressively winnowed away; it was absorbed into the body of the sculpture

or rendered obsolete. In keeping with this evolution Caro has devised a solution here: both *Twenty-Four Hours* and *Sculpture 2* (1960) are imposed directly on the ground.

In placing his forms directly on the ground Caro shares an approach with two otherwise vastly dissimilar artists, Ellsworth Kelly and Carl Andre. Later, in 1965, independently of either Caro or Kelly, Andre carried the diminishment of the base to its ultimate conclusion, dismissing it altogether and using the floor itself (fig. 5). Because Kelly is primarily a painter, testing as sculpture configurations which originate in his canvases, conceiving of them as a three-dimensional equivalent of his pictorial imagery, he can tolerate the intrusion of a flange or plinth to stabilize a piece (fig. 4). Andre does not need such supporting elements because he stacks, butts, or places units of similar size directly on the floor. Stacking, butting, and alignment are also essential to Caro, but they constitute only a part of his fundamental sculptural vocabulary. Over the years Caro evolved a body of work that not only eliminates the need for the base

39

but that incorporates into the sculpture itself features that previously constituted the *raison d'être* of the base.

Caro began to cantilever portions of his sculptures off the ground as an alternative to the traditional base as a means of support. The spaces between sculpture and ground varied in size from the seam-like aperture in *Sculpture 7* to the substantial triangular or wedge-shaped openings in *Midday* or *The Horse*, and they became active and integral parts of his constructions. The larger interstices enliven otherwise static groupings or rectangular units; they also accentuate the passage from sculpture to ground. Caro occasionally incorporated similar spaces into the body of his sculpture. As *Sculpture 7* reveals, these openings, like his color, articulated the transition from one form to another, from one axis to another, from elements of one size to elements of another size, from one level to another.

By elevating these low-lying sculptures off the ground, Caro draws more attention to the floor plane than he can in the vertically oriented *Twenty-Four Hours*, which sits directly on the ground. Caro emphasizes the ground plane even more powerfully in *Lock* of 1962 (pl. 19) by keeping the actual level, the horizon line, of the piece very low: the insistently horizontal *Lock* is only 2'10" high in contrast to *Midday* with its strongly vertical members and its over-human-scale height of 7'10". The slight elevation of *Lock* (off the floor) and the vertical thrust of some of its elements are checked by an extended horizontal double T-bar which pins or ties down the three other major components of the piece. Despite the decorative touches provided by the bolts, *Lock* lacks the evocative qualities and casual grace of Caro's best work of this period. A bold statement about low-lying sculpture, *Lock* anticipates works of the mid-1960s in which Caro concerns himself with the ground plane, or horizon line; with the horizontal, ground-hugging configuration deliberately constructed below eye-level as seen in *Titan* and *Bennington* of 1964, or *Shaftsbury*, *Sill*, and *Strip* of 1965 (pls. 21, 22, 20, 23, 24), and in the particularly accomplished and masterful *Prairie* (pl. 52) of 1967.

Caro seems to have turned to linearity, to a kind of drawing in space, as a relief from more monolithic structures. Thus, in the interim between *Lock* and *Titan*, he made *Hopscotch* in 1962 and *Month of May* in 1963 (pls. 27, 26). The emphasis in both of these works is upon fanciful lines comprising slim rods or narrow channels which incise the space around them, rather than upon closed structure. *Hopscotch* is a slender, lattice-like construction; its ephemeral form is dissolved even further by its aluminum surface (aluminum is a material Caro seldom used, preferring more rugged materials; in this respect only it calls to mind David Smith's contemporaneous *Cubis*). The fairly regular, spare but relatively complicated concentration of geometric units in *Hopscotch* makes it seem more ordered and rational than *Month of May* with its apparently randomly disposed, curvilinear rods of aluminum and painted steel. Neither *Hopscotch* nor *Month of May* is indicative of Caro's central direction; both are perhaps best described as digressions which Caro was to expand upon as a more consequential part of this thinking in later groups of sculpture like the *Emma Lake* pieces of 1977.

The direction his work was to take is clearly apparent, however, in *Sculpture 2*, 1962 and in *Early One Morning* of the same year (pl. 25). In each, Caro

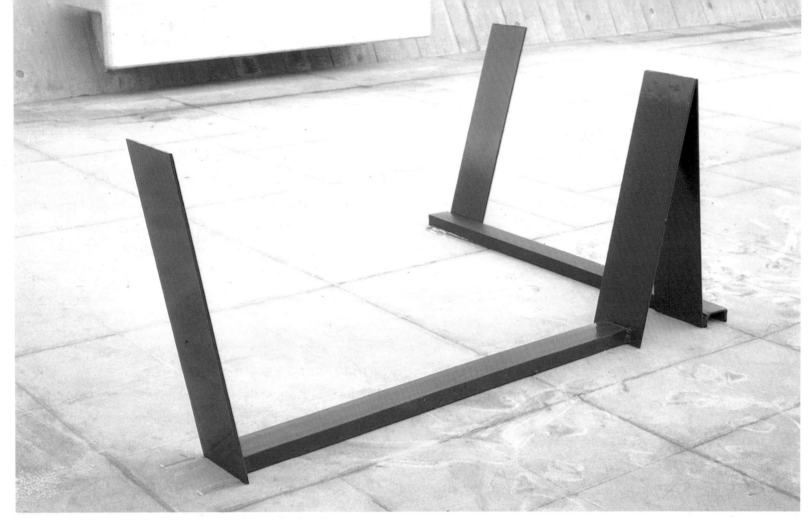

35. *Green Sleeper.* 1965. Steel painted green. 2′ × 4′10″ × 3′7″

36. *Burnt.* 1965. Steel painted purple. 1′11″ × 7′3″ × 9″

tenuously balances the concrete and the ephemeral, the logical and the fanciful, the function of volume and of line in describing space. In each, monochrome color unifies mass and line—green in *Sculpture 2*, red in *Early One Morning*. Both *Sculpture 2* and *Early One Morning* are ambitious in their occupation of space. Both are completely resolved in that many diverse elements are successfully integrated in them: vertical as well as ground-hugging units, severe geometry and a few softening diagonals and the occasional curve. These two works represent an amalgam of the linear and the three-dimensional that does not occur again until sculptures like *Prairie*, some five years later. Caro was striving in these years for clarity of form and in order clearly to articulate his forms he most often monochromed his sculpture. Sometimes he polychromed a piece to "open it up more" (*Month of May*, for example) or articulated a predominant color with smaller passages of deeper colors (*Sculpture 7*). Occasionally he returned to sculpture he had originally polychromed and re-painted it with a single color. At this time Caro generally chose heady colors—brilliant and clear reds, oranges, yellows, greens, magentas; later in the sixties he preferred softer, deeper, duskier hues. His monochrome color not only helps organize and synthesize a potentially disparate arrangement of seemingly random units. It also diminishes the physical and visual impact of the steel and endows the material with a certain anonymity. At the same time, the color makes the sculpture itself more personal. The colors, like the titles, are chosen after the works are completed and are not intended to be descriptive, but Caro's selection of particular colors is as deliberate as his choice of materials; color is one of the factors

which defines the particular nature and meaning of each work. Caro is one of the few sculptors in recent memory able to use color as an integral part of his work, as an element which enhances its ultimate effect rather than as a distracting addition. The clarity, strength, and spirit of Caro's color contribute another dimension to his work. His color fits his sculpture like a skin. Caro's colors were invariably chosen in collaboration with his wife. They emphasize and elaborate the feeling that the sculpture expresses. Twenty years later, Sheila Girling again added her sympathetic contribution in coloring his writing pieces.

In 1963 Bryan Robertson invited Caro to show at the Whitechapel Art Gallery in London. In this, his first one-man museum exhibition, Caro showed fifteen sculptures executed between 1960 and 1963. He said, "The Whitechapel show was exciting for me. Exciting to fill the big space of the gallery with my new pieces which I had never seen *en masse* before, all painted and rich and clear." The show included the seminal *Twenty-Four Hours* and such important pieces as *Midday* and *Early One Morning*. It opened to mixed reviews, as evidenced by the following:

What these sculptures seem to lack is just that feeling for materials which Caro is at pains to disguise, principally by painting them. For one thing, to disguise a girder is really not possible. It merely adds an air of the phoney. . . . The result is much of Caro's work has a synthetic feeling about it, its impact depending too much on merely being bigger than we are. All the same, this is an important exhibition. Caro has shown most impressively that sculpture need not be dependent upon the human figure. And that not all roads lead to Moore. [7]

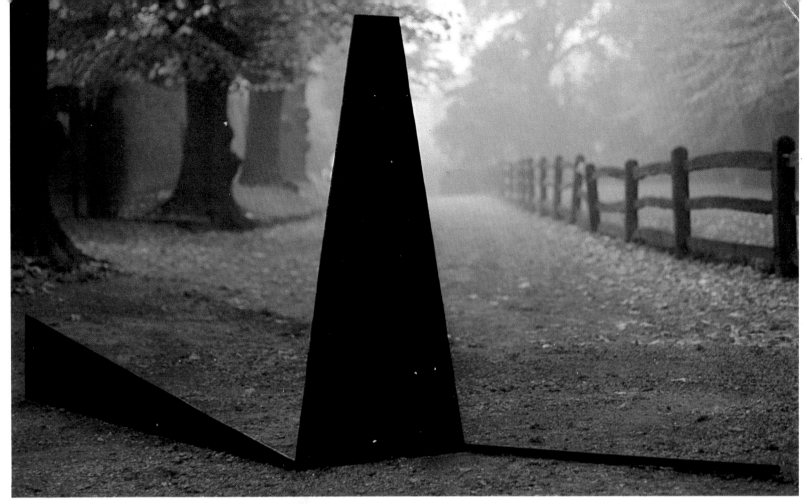

37. *Slow Movement*. 1965. Steel painted dark blue. 4'3" × 8'9" × 5'. The Arts Council of Great Britain

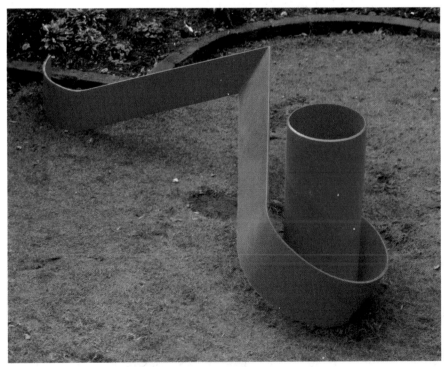

38. *Reel*. 1964. Steel painted burgundy. 2'10" × 3'4" × 8'9"
Storm King Art Center, Mountainville, New York

39. *Eyelit*. 1965. Steel painted blue. 9'4½" × 5'6" × 3"
Collection André Emmerich Gallery, New York

Caro aims . . . to open up areas of awareness which have not previously been dignified by art. This is a painful process: we do not always care to have those areas brought into the open and we prefer the experience of art to relate to and clearly illuminate other forms of experience. For these reasons many people will simply shut down when faced with Caro's sculptures.[8]

Shortly after the Whitechapel show opened, Caro left England to teach at Bennington College in Vermont; except for a few breaks he remained there as a visiting faculty member until 1965. Caro did not work after his arrival in Bennington: being there was a total change in environment for both his work and his family life, and he was laid up for a while after he broke his leg in a skiing accident. Gradually, however, he began to make sculpture again.

Paul Feeley got the old fire station at the college for me to use as a studio. It was four times as big as my garage at home and there was a big parking lot outside for me to put work, to paint and look at.

In those years, Bennington was humming with activity. Kenneth Noland lived there, although he did not teach at the school. Jules Olitski came to teach at the same time as Caro. Peter Stroud, from England, taught Art History. Paul Feeley was there; Greenberg visited from time to time, as did Michael Fried, Ray Parker, Larry Poons, and Frank Stella. And of course David Smith was living and working at Bolton's Landing, some 90 or 100 miles away. Caro says, "The conversations with those guys were incredible, it was refreshing . . . it was about basic things talked about in the questioning way I hadn't done since university." At Noland's urging, Caro started to work in series. However, Caro's art was not serial in the conventional sense of the term; for him working in series was a convenience, not a calculated program designed to produce a group of related sculptures based on a single concept. He made several pieces at once instead of one at a time as he had previously. This procedure enabled him simultaneously to develop individual sculptures within a given idiom; the result was diversity rather than similarity. Caro found that the process enabled him to work more quickly than he had previously. The method spurred his creative capacities—it was a release in terms of both time and invention. In the Bennington series Caro used H-beams and Z-shaped steel elements that he had not found in England:

My first shot at a sculpture in Bennington was actually to set up those similar H-beams that I'd had trouble with in England, tackle head on the problem of relating quite separate units. And again it didn't work. Then I loosened up, used the Zs and made some sculptures; and at the end of the time at Bennington I was putting the beams down and using the Zs in the same sculpture. I'd managed to join them in a very much more loose way, by means of using a vertical wall—low vertical walls.

The last one I made in that series at Bennington didn't have any Zs in it at all, it just had the beams and the wall.

And he made discoveries about using the floor plane. He discovered that the elements of his sculpture could

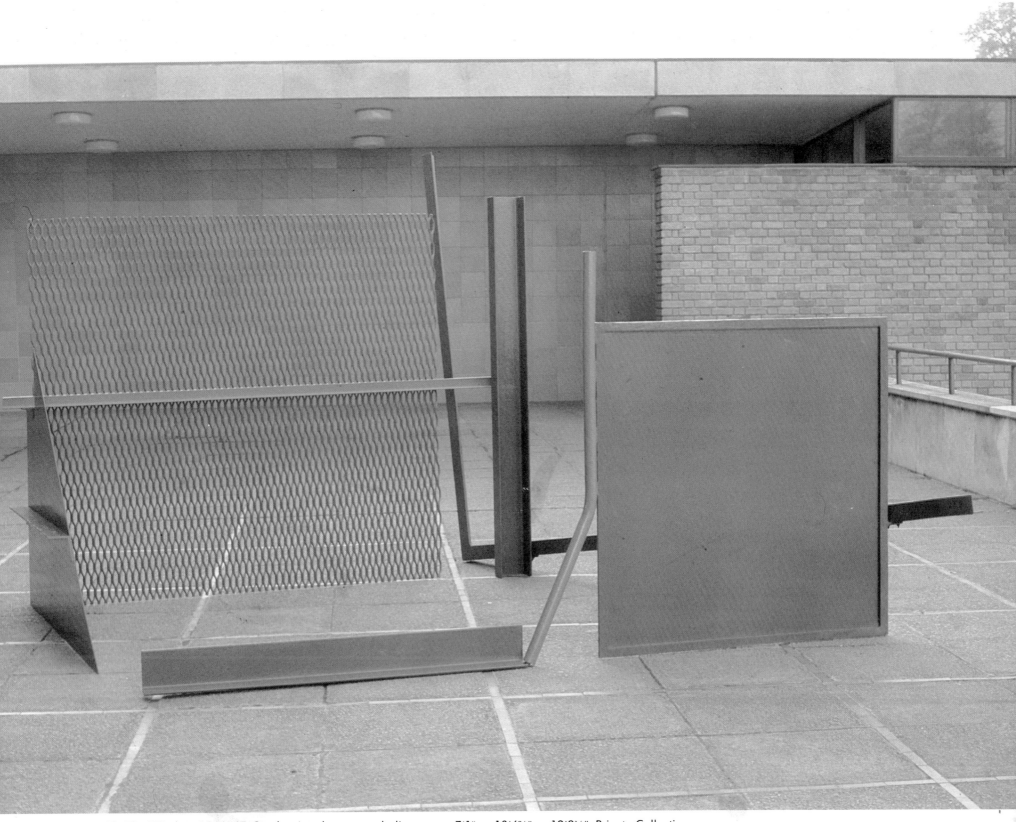

40. *The Window*. 1966--67. Steel painted green and olive green. 7'1" × 10'6⅜" × 12'9½". Private Collection

function more effectively on the floor than they had when they were thrust up in the air, as, for example, in *Month of May.* And of course it is quite in accord with Caro's instinct for the rational, the logical, to make sculpture on the floor, a natural support, than to make sculpture that exists in mid-air. Furthermore, his sculpture as it existed on the floor could more logically and smoothly connect with the walls.

In retrospect, Caro's discovery of the floor plane, like many significant breakthroughs, seems both profound and simple. To be sure, he had dealt with the floor in works as early as *Sculpture 7* of 1961, and *Lock* of 1962; but the approach at that time was cautious and involved also with other alternatives. In works of the new series such as *Titan, Bennington,* and *Shaftsbury,* however, he addresses the issue of the floor plane and horizontality boldly and directly.

All these Bennington sculptures are composed of relatively few units, mostly beams which Caro only slightly tilts off the vertical or horizontal. Each work is organized in relation to a low wall; in each the order seems random, casual, relaxed, almost as if Caro had put it together by chance—and in this they are predictive of the approach of many other artists working in the late sixties and the early seventies. Indeed Caro relies on improvisation to a greater extent in these and in related works than he had done previously: he explains that working with the floor gave him greater freedom to improvise than was possible when constructing vertically.

Working with the floor also allowed Caro to eliminate the problem of gravity which confronted him in his vertically aligned pieces. Thus he was able to concentrate upon creating an effect of weightlessness. He had already worked with the concept when he began to cantilever his pieces up off the ground, but he had soon recognized the futility of "throwing my pieces up in the air and having them hang around up in the air." By placing his channels directly on the ground and having them merely touch rather than balance or prop one another up (as *Sculpture 7*), Caro eliminated an element of gravitational pressure. He could then focus on lateral extension, on achieving the maximum width in relation to minimum height, using the "wall" and angled beams as barriers to contain what might otherwise have been the accelerating movement of the piece. (Although the eye tends to slide swiftly along the contours of the smooth, relatively uninflected sculptural elements, it comes to rest at every turn, at every intersection. Moreover, the viewing experience is slowed because we look down at these sculptures.) By placing his beams directly on the floor, Caro allowed the floor to ". . . act as part of the sculpture and not just [as a] base." Because his forms rest on the floor but are not aligned flat against it (as they are in Andre's sculpture), they retain an independence from the floor and appear to skim or float upon its surface. Thus they have an air of autonomy that gives them an added dimension of lightness and buoyancy.

In their appearance, Caro's "primary structures" of this time were often linked with the work of the Minimalists. Although Caro feels that the first sculptures of his to have any sort of connection with a minimalist aesthetic came from his contacts in 1964 with artists at Bennington (Noland, Olitski, and Feeley), with whom he found he had much in common, it was perhaps inevitable that his sculpture would be grouped with the most radical sculptors to emerge in the mid-sixties. Indeed, both Caro and the Minimalists rejected the de-

42. *Frognal.* 1965. Steel painted green. 3'4½" × 9'1" × 12'4"
The Museum of Modern Art, New York
Gift of Mr. and Mrs. Richard Rubin

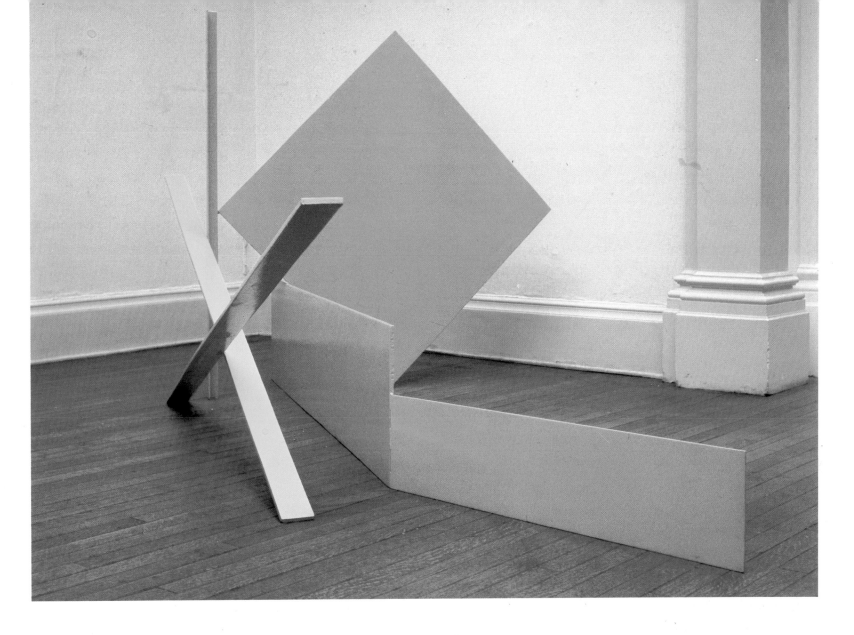

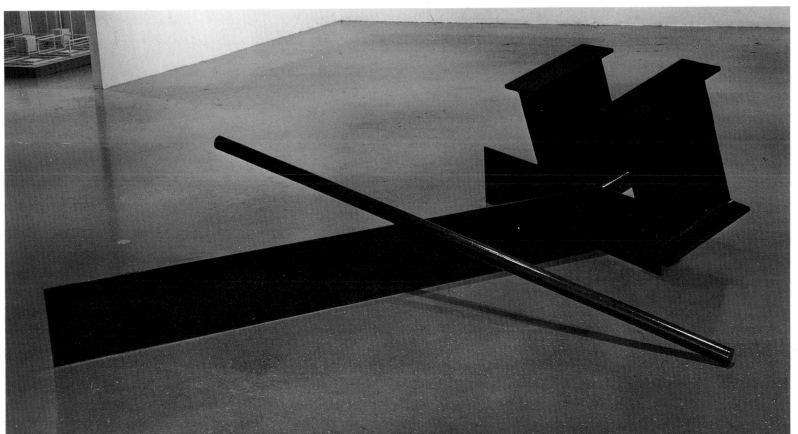

clamatory or rhetorical style and generally avoided the grandiosity of much sculpture of the past. But the contrasts between Caro and his American "counterparts" could not be more striking. Caro's art is constructed, it is part of the dynamic of Picasso, Gonzales, and Smith; Minimalist art is reductive, related to the work of Brancusi, Tatlin, and Rodchenko. The Minimalists focused on the primacy of concept over execution and on sculpture conceived for specific sites; Caro focuses on the primacy of the work as a self-sufficient entity. The Minimalists preferred the factory to the studio, they limited themselves to ordinary industrial materials, and they vehemently rejected craft or direct personal involvement in the making of the sculpture. They were fundamentally opposed to "composition," believing it to be outmoded, and instead adopted a standard unit or module to which they added other similar or identical units, thus substituting arrangement and repetition for composition. To be sure, Caro also came to use industrial materials, partly as a means of purging sculpture of conventional or expressionistic overtones. But his choice of materials has not been as stringently restricted as that of the Minimalists. And despite the rational appearance of Caro's sculpture, his process is an intuitive one which involves a great deal of alteration and adjustment, clearly setting him apart from the Minimalists.

Furthermore, Caro has varied his materials, adjusted his compositions, and applied color much in the manner of Cubist collage and construction. If Caro appears spare and restrained in relation to Smith, he seems positively baroque and expansive in contrast to the Minimalists. His open-ended working method and his intimate familiarity with his materials endow his art with humanistic overtones. He has not adopted a fixed ideological position; his concerns have evolved and expanded over the past decade. Caro has reveled in his materials and his labor, and, much like Miró and Matisse, he has allowed an element of the fanciful to engage him, the more so as his work has continued to develop and change in recent years. This is in marked contrast to the Minimalists, whose disengagement from direct involvement with their work, whose emphasis on intellectual process rather than on physical realization of objects, has, despite the use of mundane materials, often endowed their work with an elegance and refinement seemingly at odds with their radical objectives.

Although David Smith had invited him to Bolton's Landing when they first met in the fall of 1959, Caro was not able to visit until he came to teach at Bennington. He was impressed by "Smith's direct, spontaneous approach to work and materials." The influence was reciprocal: it appears that Smith learned from Caro as Caro had earlier learned from Smith. By 1964 Caro had evolved his very personal, understated style; and *Flats* (fig. 7), made at Bennington in 1964 is the probable source for Smith's *Cubi XXIII* (fig. 6) of the same year. Significantly, Smith adapted what he needed from Caro into his own formal idiom. In *Cubi XXIII*, Smith favored a lateral extension that is uncharacteristic of the majority of his work. But, in keeping with his preference for verticality, Smith emphasized the point at which his V-shaped forms met, and he included a column as a significant feature of the structure of *Cubi XXIII*. Similarly, he remained consistent in his use of materials, preferring polished stainless steel to Caro's painted steel. In *Flats*, Caro had developed the length, width, and

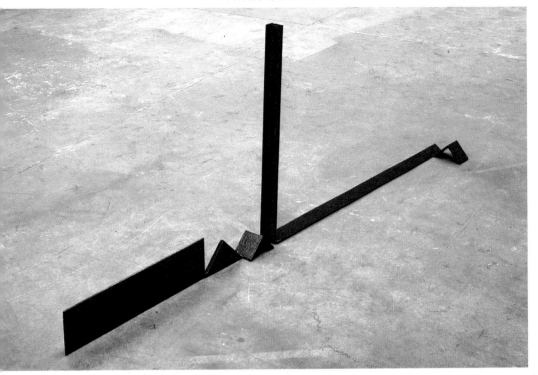

43. *Cleeve*. 1965. Steel painted red. 4'5½" × 7'11" × 9½"
Private Collection

45. *Smoulder*. 1965. Steel painted purple
3'6" × 15'3" × 2'9"

44. *Homage to David Smith*. 1966. Steel painted orange. 4'6" × 10' × 5'4"
Private Collection

fig. 6. David Smith, *Cubi XXIII*, 1964. Los Angeles County Museum of Art. Museum Purchase, Contemporary Art Council Funds.

fig. 7. Anthony Caro, *Flats*, 1964. André Emmerich Gallery, New York.

depth of his Z-shaped structures, while Smith confined his V-shaped forms and the column to a relatively shallow, planar, and frontally oriented space.

In yet another example of 1964, untitled, Smith does make use of painted steel, and of I- and L-beams in a manner that paraphrases Caro's own work of the early sixties (see *Midday* and *Sculpture 7*) but, once again, Smith's predilection for the vertical takes precedent over Caro's horizontal low-lying forms. As we have previously noted and re-emphasize here, the fundamental differences between the two artists is Smith's preference for anthropomorphic structures while Caro's sculptures are entirely without reference to the human form. Smith's emphasis upon action, upon gesture and motion is as much a feature of his work as is Caro's emphasis on evenly dispersed compositional sequences and on form in repose.

When Caro returned to London in July 1964 he continued to work with walls in sculptures such as *Lal's Turn, Wide,* and *Reel* (pls. 31, 34, 38), and he decided to get professional assistance with his welding. He considers himself a poor welder and does not particularly enjoy the job. (Eventually, though, he learned to do it well enough to be able to tack his sculpture together.) Previously he had depended upon sculptor friends who helped him weld once a piece was in position and propped up on blocks. David Annesley worked with him on *Hopscotch,* Michael

Bolus on *Early One Morning,* and Isaac Witkin helped with *Lock* and *Midday.* At Bennington, Shorty Griffin, a local welder, had assisted him, largely because Caro was incapacitated by his broken leg. Now Caro found a small firm called Aeromet, run by Tom Hunter and Charlie Hendy. The skills of these professional technicians were far different from those of Caro and his colleagues.

Several years later Hendy left Aeromet to work for Caro on a full-time basis. In 1970 Pat Cunningham took over as Caro's assistant. Several years later, Caro spoke of these assistants:

They're very good craftsmen, they have their own style of making things, and these influence one quite a lot. . . . [Pat Cunningham] is a terrific welder and a real artist with steel. When Charlie worked for me, and we were working side by side, it was a very close working relationship. . . . Both Charlie and Pat have been able to grasp my structure . . . Prairie [for example] is not merely an artwork—but my goodness, it's a work of engineering. Underneath Prairie (1967), inside Prairie, is first of all a cradle which holds the wings together. The wings are two separate parts; they're held together underneath; and on top of that sits the corrugated steel and they're held together on top, to stop them flopping down, by a single tie. The whole thing comes to pieces, it's all spiggoted. It was

46. *Stream.* 1966. Steel and aluminum painted blue. 9″ × 8′8½″ × 3″

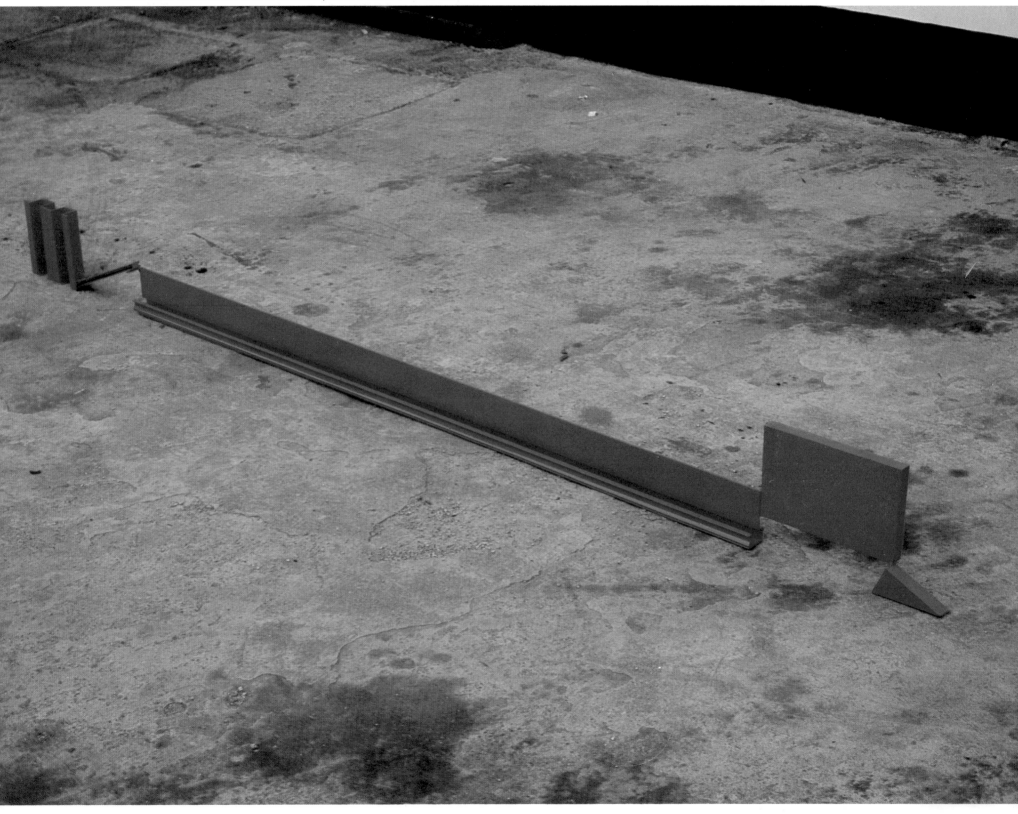

clever of Charlie to make that, terribly clever of him to think out how that would work. . . . Charlie's engineering was very good and as it so happened, fitted very well at a time when I wanted a very neat sort of engineering too. . . . Just at this moment I'm leaving my welds showing a lot more, leaving rough edges: Pat is well aware of the way I want my welds to look.

The fact is . . . I have to make the choices . . . both of the sort of joins I want, the sort of finish, as well as what I leave in and take out. I have to do some cutting and I have to do some welding, but what I do mostly is choosing, choosing and placing. . . . Pieces don't sit "bam" onto something, onto another piece, like that. They do sometimes do that, but they tend more to run and to join and to touch.

Caro came back to Bennington in the spring of 1965. At first he simply took up where he had left off in London, working with the wall as he had done there. America continued to be extraordinarily stimulating for Caro. He felt he could see the best art here, that he could talk, argue, and work with the best people (he and Noland have even collaborated), and come home toughened up. The competitive atmosphere had a positive effect on him. "Everytime I go there, there is a new work by them [Noland and Olitski], there's new things happening, there's new excitement; [you] pull your socks up . . . It's incredibly battery charging and the screws are on there. You've got to; they're competitive and they're all in there trying to make better art. You've got to make better art if you're going to keep up with that, you've just got to."

When Caro settled down to work, he worked even faster than he had previously done at Bennington.

". . . this time, instead of making five or six or whatever it was, I made more like twenty in an even shorter time, really trying to let the run keep going, keep itself going." At this point, Olitski proposed that Caro eliminate the wall from his work. Caro took the suggestion and pushed it further; as Olitski wanted to see how far he could strip a painting down and still make it painting, so Caro tried to see how far he could strip a piece down and still make it sculpture. To this end, he was simultaneously developing three different series of extremely simple works. Two series were linear, one was planar. And in contrast to *Titan, Bennington,* and *Shaftsbury,* which stress the floor plane and horizontality, Caro once again began to investigate vertical thrust. To emphasize slender linearity, he ran across the floor thin rods which change direction bend and shoot up into the air. *Sleepwalk* (pl. 33) shows Caro's concern with the wall and floor plane (articulated by an X-shaped unit) as well as with vertical thrust. These pieces were lean and simple in the extreme. The free-standing, line-like *Eyelit,* 1965, typifies the reduction Caro was seeking but this extreme simplification proved to be something of a cul-de-sac. Dissatisfied with the direction in which some of the work was going, Caro kept the linear works and destroyed the majority of the planar ones.

Despite his introduction of curved elements into his work (*Sculpture 2,* 1962, *Pompadour, Month of May,* both 1963), Caro's sculpture remained predominantly rectilinear throughout most of the sixties. His planar emphasis made the works embrace space gradually, in successive stages, recalling the shifting faceted planes of analytical Cubism (*Early One Morning,* 1962) or the shallow modules of Constructivism (*Yellow Swing,* 1965, *Homage to David Smith,* 1966). The

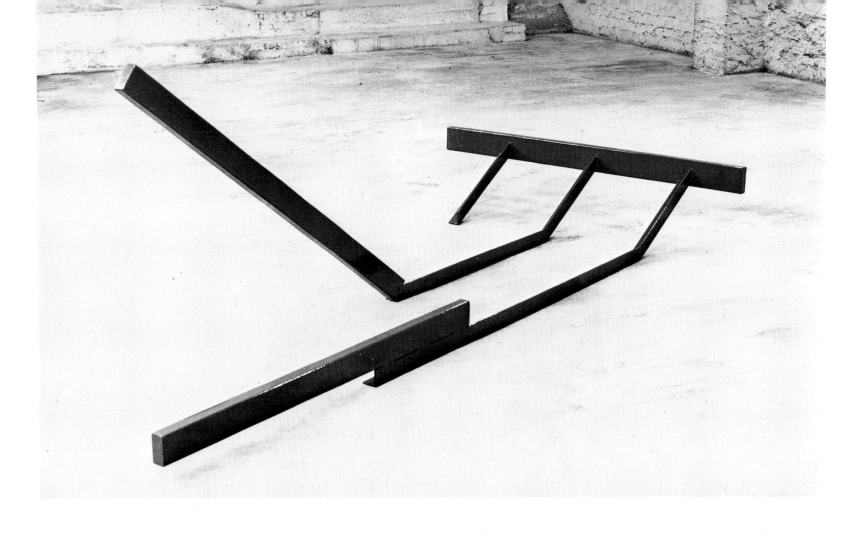

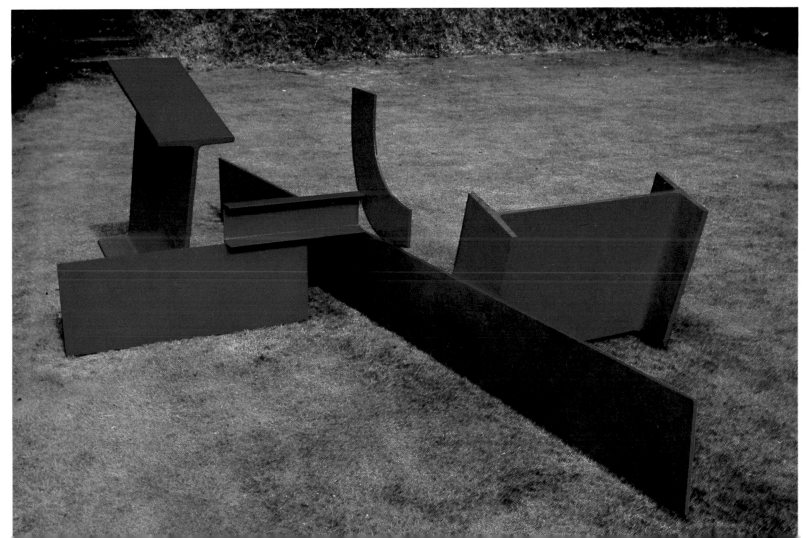

49. *Span*. 1966. Steel painted burgundy. 6'5½" × 15'4" × 11'. Private Collection

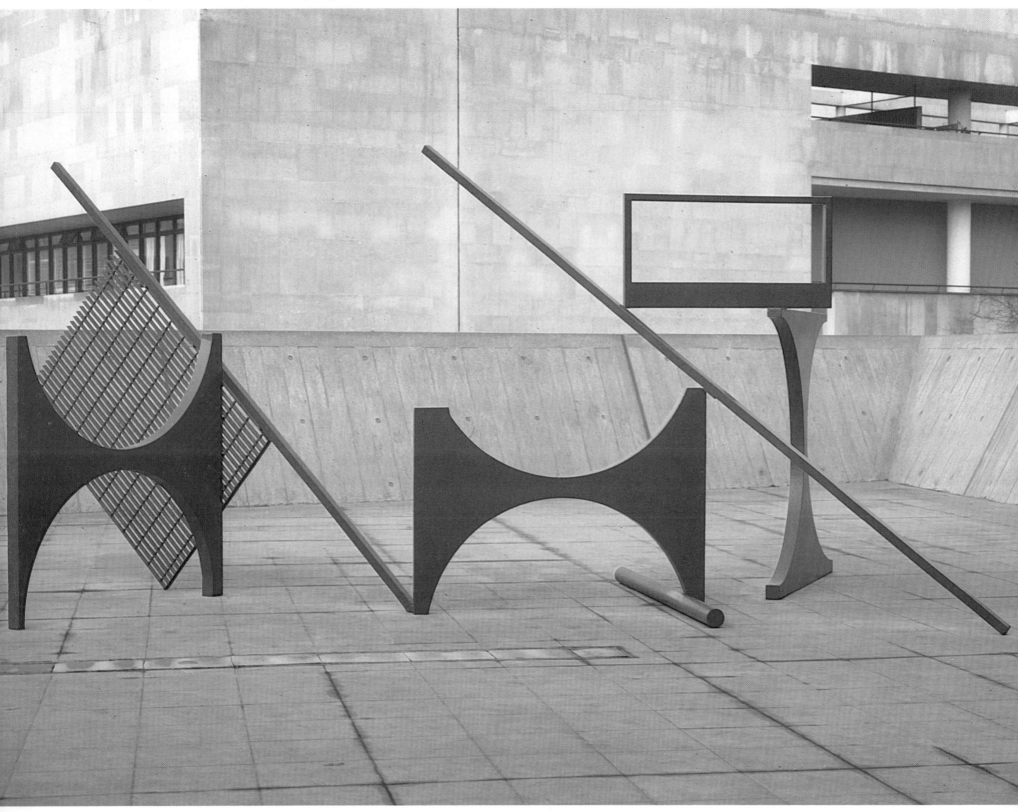

sculpture suggests transparency (*The Carriage*, 1966, *The Window*, 1966-67) rather than volume or density. Although he had already begun to explore the curve's potential for opening up space in *Reel*, 1964 (pl. 38), not until 1969 in *Orangerie* did Caro exploit this possibility to its fullest effect. In the interim between these two pieces he continued to produce exquisite, if less spacious, geometric works.

Slow Movement of 1965 (pl. 37), for example, is characterized by an extremely spare composition comprising the simplest of steel units: two tapered and blunt-ended triangular elements and one long, thin channel. The tall, majestic central figure is offset by the smaller, more ground-related triangle; both are anchored, their activity reduced by the least substantial member of the triad—the narrow strip. Caro uses a similar device in *Frognal*, also of 1965 (pl. 42), employing a round steel bar to complement a regular structure of more substantial H- and T-shaped steel channels. In *Slow Movement* the steel angle-iron balances the irregular shapes of the triangles; in *Frognal* it offsets the tilt of the piece. Without these elements, *Slow Movement* and *Frognal* would have seemed incomplete; with their addition Caro introduced an element of the fanciful to an otherwise straightforward construction. Throughout much of his work Caro has demonstrated a singular ability to unite the order and calm of rectangular form with the more evocative, shifting, and precarious irregular or eccentric shapes and exaggerated acute angles and sweeping curves. His most successful work displays a subtle understanding of the need to balance these two extremes.

The breathtaking grace and ease of such fluid statements as *Slow Movement* is not always evident in his more complex pieces. *Yellow Swing*, 1965 (pl. 41), for example, lacks the vitality which informs and humanizes his best work. It does, nevertheless, display Caro's characteristic genius for composition. The focal point of the sculpture is an off-center, diamond-shaped plate of painted steel. To the left and in front of the plate are a series of rectangular metal strips. The single upright and rectilinear element both unifies the parts and establishes the center of the piece. Here Caro typically uses the relative frontality of the sculpture to give the viewer a fixed point of view, but shifts the axis of the sculpture in relation to this point. The sculpture thereby becomes multi-directional and opened-out rather than strictly frontal and contained. The passages that effect these changes propel the viewer from sequence to sequence until the work can be apprehended in all its views.

In suggesting both movement and stasis in his work, solely by means of an abstract composition of horizontal and vertical units activated by diagonal elements or interstices, Caro has introduced a new sculptural equivalent to the abstract painting of the early twentieth century, in particular to the Suprematist painting of Malevich. Like Malevich, he employs the diagonal, either as an opening or as a solid sculptural element, to bridge space—in this instance actual or literal rather than imagined or metaphysical space. The assymetrical equilibrium, with diagonal elements connecting plane to plane, is decidedly reminiscent of Malevich's compositions. Here, however, it is above all Caro's ability to assimilate disparate parts within a total unified, autonomous whole that makes the comparison with early twentieth-century abstraction so striking.

In *Homage to David Smith*, 1966 (pl. 44), Caro uses

50

51

LIFT

50. *Carriage*. 1966. Steel painted blue
 6'5" × 6'8" × 13'. Private Collection

51. *Red Splash*. 1967. Steel painted red
 3'9½" × 5'9" × 3'5". Private Collection

similar devices with dramatically different results. Where *Yellow Swing* is quiet and introspective, the *Homage* is extroverted, incorporating many of the forms of earlier cantilevered sculpture such as *Midday*, but their organization reflects Caro's move towards openness and extension, towards spanning ever greater areas of space. In *Homage to David Smith* as well as in *Span* of the same year (pl. 49), Caro attempts to alter our perception of the position of real forms in actual space. To do so in the *Homage* he uses an arch or gateway which appears to guide our reading of the I- and T-beams from one axis to another. In *Span* he employs a series of arcs, screens, open rectangles, and poles to effect the transition from one measured space to another. In all this, he distorts our conventional notions of perspective by the torsion or twist of his forms, by the several faces of his sculpture which he turns to the viewer. But the physical literalness of his sculpture, the regularity and rationality of its components, and the space it claims, offset the potential confusion and complexity of his multi-axial structures. These extremely heavy works are lightened, as for the first time Caro allows the surrounding space to enter into his work. The openness of these pieces, then, derives not from their still regular forms but from their growing axiality and their framing and articulation of space.

Caro employs a new device, a transparent scrim, or wire mesh screen to open up the interior of *Span* and other works of 1966 and 1967 such as *Aroma, Red Splash, Carriage*, and *Source* of 1967 (pls. 56, 51, 50, 53). Again, there is a visual comparison with Minimalist sculpture. The American sculptor Robert Morris used a similar screen (fig. 8) at around the same time as a bridge between the space of the viewer and the

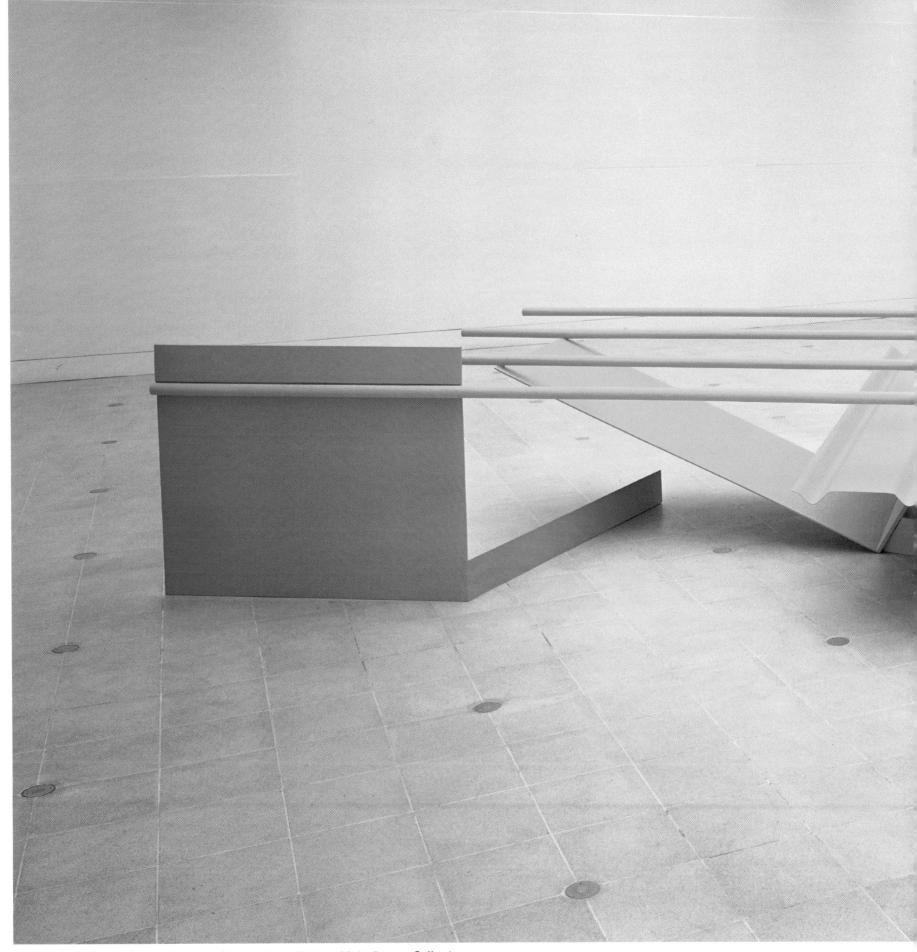

52. *Prairie*. 1967. Steel painted matt yellow. 3'2" × 19'1" × 10'6". Private Collection

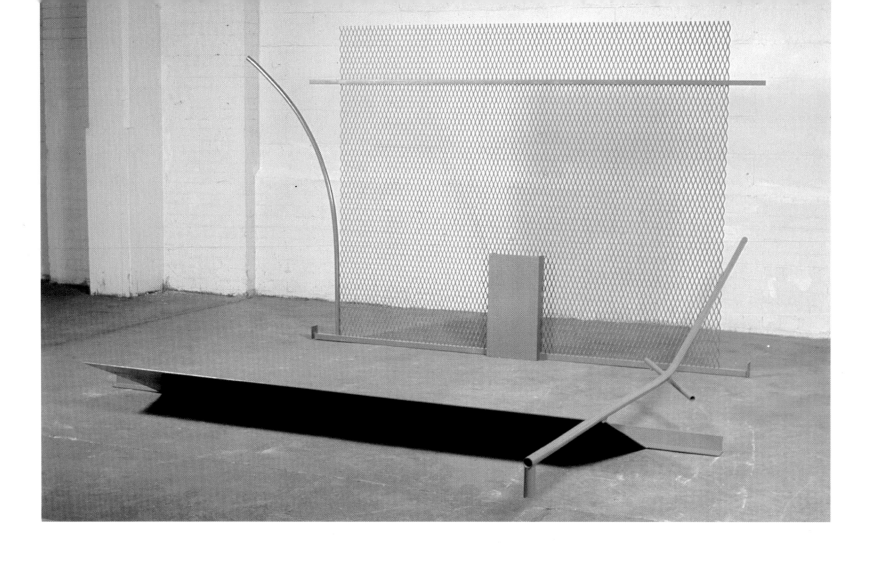

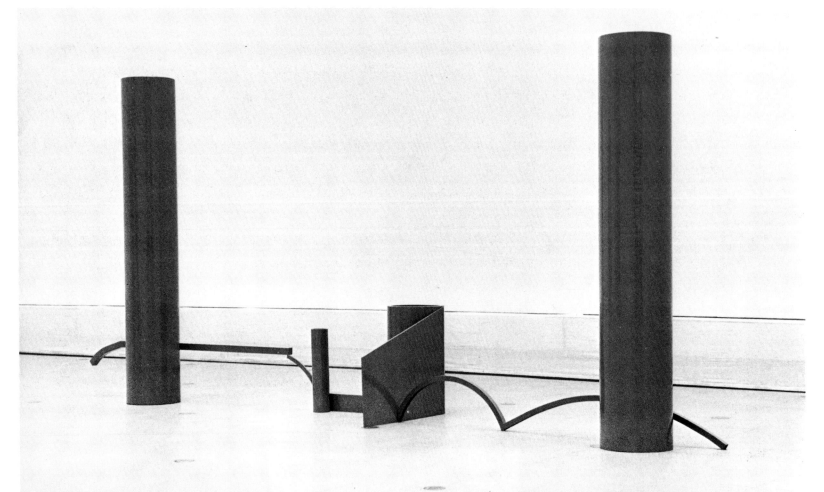

space of the sculpture. Because of Morris' involvement with performance, his objects are often imbued with a sense of drama, mystery, and irrationality. But once again, Caro's approach is more classical: his screen is primarily a pictorial, not a psychological device, a contemporary version of the Renaissance "window onto reality." The element of theater, of the irrational, of chance or change affecting the viewer's perception, so central to Morris' art, did not affect Caro's work, but the physical demands of the screen or scrim in relation to real space *did* preoccupy him to a large extent. The idea of penetration, of being able to see into but not enter a work was an extension of—or an alternative to—the more closed modules of Caro's earlier steel pieces. The spectator can penetrate sculptures such as *Carriage* and *The Source* and *The Window* (pl. 40), to a degree Caro did not previously allow. As in Morris' work, we are blocked physically from entering the sculpture but are able to see into it and to participate in it. The extreme openness and slightly ephemeral overtones of these sculptures remain exceptional in the context of Caro's total oeuvre to this point. The openness and buoyancy, lightness and delicacy of these few sculptures is predictive of the extraordinarily adroit sculpture Caro was to produce in the 1970s.

In any major oeuvre there are certain works that both herald a new direction and are in themselves singular statements; in Caro's work, *Midday, Prairie,* and *Orangerie* figure among this select group. *Prairie* (pl. 52) is a sculpture about levels. Caro describes the evolution and meaning of this major piece:

I got the corrugated sheet and I had it for a long time—for about six months, sitting on a block at the studio. And that piece of steel sitting there at that height, about two foot six inches high, for a long time worked on my mind. I like to have time to allow for the possibilities to develop. If it comes in the back way then it finally has an effect. It matures inside . . . six months later I started adding poles to it and making it.

People got very confused when they saw that sculpture in the exhibition at Kasmin, Ltd. First of all they thought it was called Prairie *because it was painted yellow, or maybe it looked like waving corn; well, it's not to do with that. None of my sculpture is to do with that sort of experience. Originally, I got the name* Prairie *from the paint trade name "Prairie Gold," which I was going to use on it. In fact, the sculpture was blue at one stage, which was all wrong for it. But* Prairie *has the feel of extension; the word "prairie" had the feel of extension and that was what that sculpture was about, extension at different levels.*

I was using the ground a lot. . . . I suppose partly to do with having used the table to make table pieces, my thought was that these data that we're using—floor, table, they're just levels; we can question the way these data act as levels. You don't question them by asking questions, you question them by making sculpture. Now, Prairie *was a question about levels, but it was also a question in a way that's got to do with spread, extension, those wide expanses, a floating thing—yes, floating.*

We gain access to *Prairie* by means of the rectangular plate of painted steel positioned in the left foreground which directs the eye into the work. We are, however, denied entrance by a series of four poles

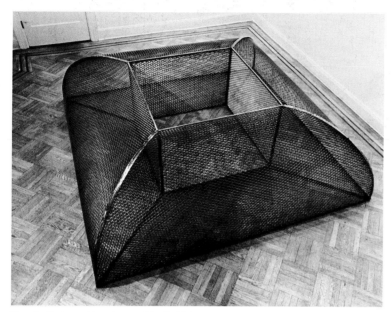

fig. 8. Robert Morris, untitled, 1967. Private Collection.

which indicate the horizontal span but not the full depth of the work. These poles are the offspring of the steel rods which had balanced and anchored earlier sculptures such as *Slow Movement* and *Frognal*, but these have taken on new and demanding functions. Here they act as leveling devices and as a measure of space, and they make the space physically impenetrable by closing off access to the interior of the work. From the central configuration, a piece of corrugated metal, extend three flat pieces of steel, one of which thrusts diagonally from left to right, toward the spectator, reaching further forward than the rectangular plate at the left. The rear of the sculpture is demarcated by a pole that rests delicately on the tip of another flange. At first glance, *Prairie* seems a marvel of geometry; it is regular, stable, and self-contained. Upon closer examination, however, we see it is full of contradictions, of things that are not what they initially seem to be; we see it is the embodiment of a magi-

cian's sleight of hand: poles balance tenuously in space, units appear to connect but do not join where we expect them logically to meet. The rippling corrugated metal, seductive, slim poles, and graceful, asymmetrical flanges evoke a weightlessness at odds with the reality of the sculpture's powerful presence. It is a remarkable presence indeed, a sculpture conceived at the highest level of imagination, the true indication of Caro's genius.

Caro's work took a decidedly fanciful turn at this time, as evidenced by *Horizon*, 1966, and *Deep Body Blue*, 1967 (pls. 54, 55). These sculptures are refreshingly different from their more rectilinear predecessors. In each a series of fluid curves lightens the weighty upright members and infuses them with a new lyricism. Even more unusual, and predictive of Caro's future direction, are *Argentine* and *Trefoil* of 1968, *Sun Runner* and the masterful *Orangerie* of 1969 (pls. 59, 60, 62, and frontispiece). Here, graceful flowing curves which were the subsidiary themes of *Horizon* and *Deep Body Blue* become the sculptures' central forms. The convex and concave discs of *Argentine* are lightened immeasurably by the carefully planned, though seemingly random, curved metal strips. These strips link the two shells (actually tank ends purchased from the David Smith estate in 1967) and also propel them into sweeping, expansive space. Caro's ability to control such large space in sculpture is an accomplishment few can match. While the Minimalists achieved comparable control through the repetition of industrial unit hardware over great areas, Caro attains this end through masterful composition, careful adjustment, exquisite balance, and extension.

Trefoil is more contained than *Argentine*, primarily because its central element is a table or platform. The

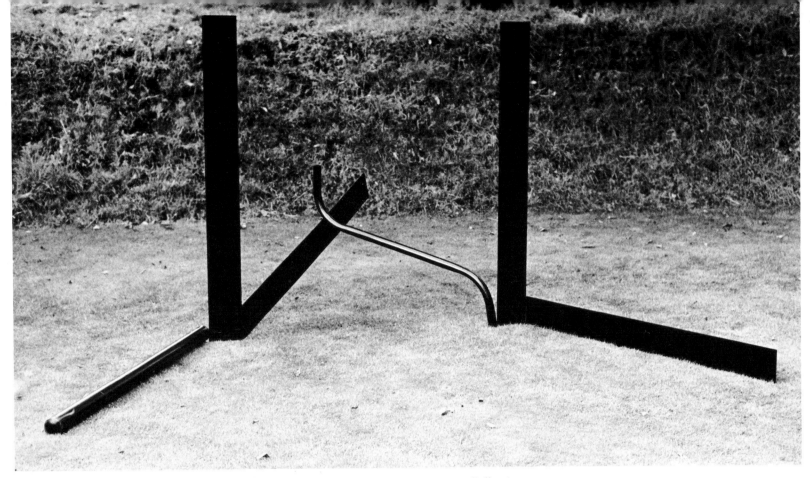

55. *Deep Body Blue.* 1967. Steel painted stark blue. 4'10½" × 8'5" × 10'4". Private Collection

56. *Aroma.* 1967. Steel painted blue. 4'10½" × 11' × 6'8". Private Collection

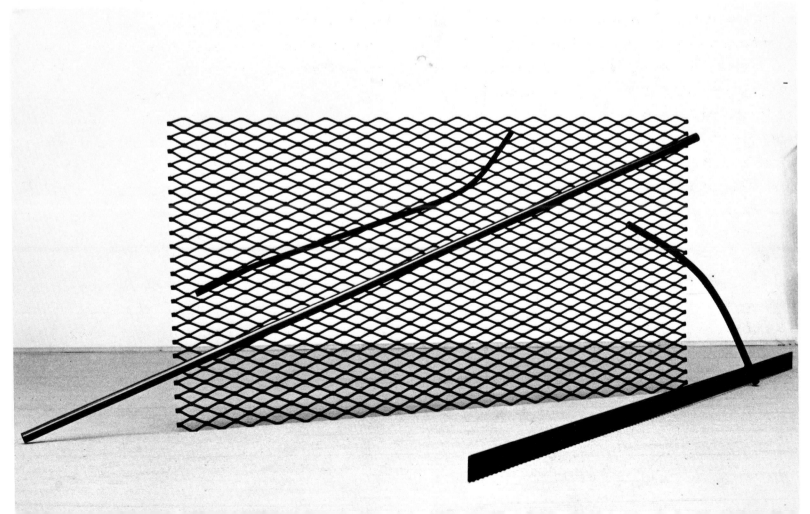

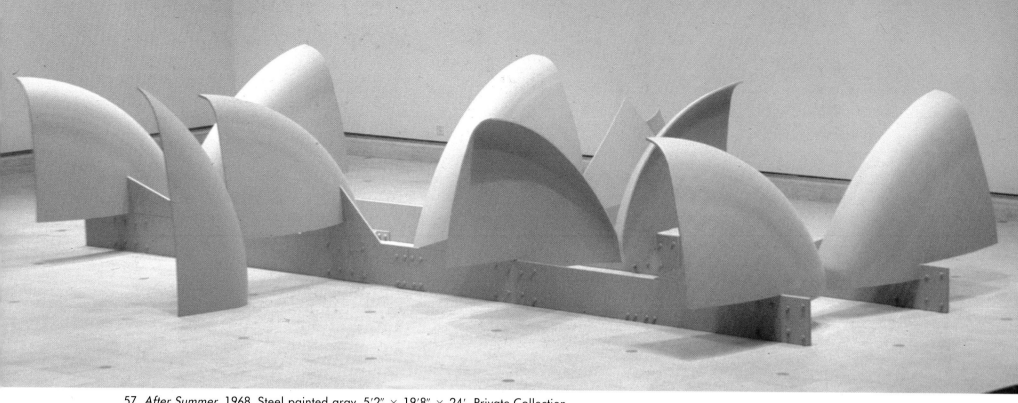

57. *After Summer.* 1968. Steel painted gray. 5'2" × 19'8" × 24'. Private Collection

sculpture's activity springs entirely from this rectangular plane; although the curves and verticals extend above, below, and from the sides of the table, our attention is always directed back to the center of the work. The pointed arches and strong right angles which make up the piece form a Gothic tracery in space which creates a curiously eccentric configuration. This Gothic flourish is encountered once again in *Sun Runner*, whose pointed shapes resemble medieval armor or heraldic emblems. But Caro does not use a table in *Sun Runner*, which is splayed out, much like *Argentine*. Here, however, the thrust is preeminently vertical—the fully upright mass concentrated at the left gradually unfolds towards the right until it gently touches but does not come to rest upon the floor at the right. The low-lying configuration very much holds its own against the cluster of larger forms. Despite its strongly vertical thrust, the sculpture is not even remotely figurative: *Sun Runner's* subject is pure balance and equilibrium.

Although Caro uses a table and similar shapes in *Orangerie*, this sculpture is most unlike *Sun Runner* and *Trefoil*. Its slim, elegant shapes and curves, reminiscent of Matisse's cutouts, are disposed with greater virtuosity and with a hedonistic sense of abandonment. *Orangerie's* ambitious structure and completely successful integration of elements endow the piece, which is far more complex than either predecessor, with a monumentality that belies its size. This is a rare work indeed, in which perfectly conceived and executed parts are crystallized to form a breathtaking and culminating visual statement.

Caro built upon the formulations of *Orangerie* to achieve new ends. Thus, in *Sun Feast* and *Georgiana*, of 1969-70 (pls. 63-66), he makes ample use of the graceful sweeping arcs of *Orangerie* yet he creates fundamentally different effects. In *Orangerie* curves arch high above the table and swoop beneath it; in *Sun Feast* a few elements hover just slightly above the table plane while most are placed emphatically be-

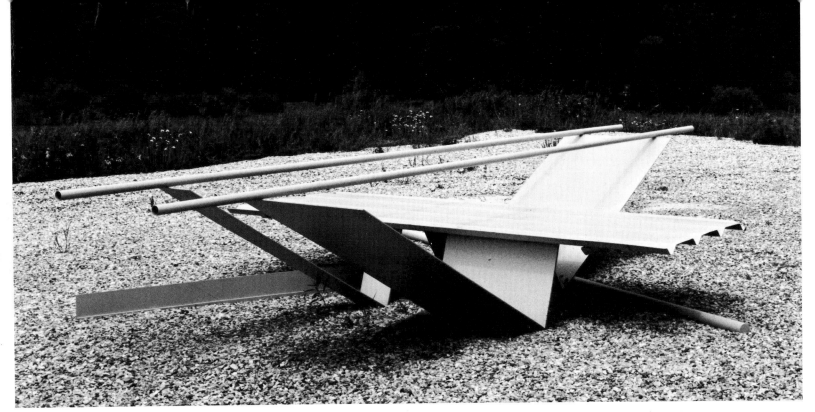

58. *Cadence*. 1968. Steel painted light brown. 4'1½" × 18'8½" × 16'6". Private Collection

low it. The much fuller forms in *Sun Feast*, like those in *Argentine*, are an even more pronounced point of contrast between the two pieces, as is the greater spread, both horizontally and in depth, of *Sun Feast*, in comparison with the shallower, more vertical alignment of *Orangerie*. And in *Sun Feast* there is a greater sense of movement around the piece than there is in *Orangerie*, where the forms are more tightly clustered, generally centralized, and concentrated in front of the table. Caro continues the open forms of *Orangerie* in *Georgiana*. Here he refers to the table plane but does not actually use the form, employing instead a narrow steel angle-iron. Moreover, he insists on a far greater axiality, as he had earlier in *Span*. He also introduces the cutout shape, substituting an open loop for the closed disc of *Sun Feast* and using "windows"—rectangular frames with empty centers, to extend the spatial scope of the work. The open areas in the ring and two rectangles are beautifully bridged by the plough-like shapes familiar from

earlier works, including *Orangerie*. Caro's graceful linking of part to part and his telling use of a few curved shapes to offset his severely geometric structure create an extremely rich and effective sculpture.

Caro's experiments with tables on a large scale, in works such as *Trefoil*, *Orangerie*, and *Sun Feast*, proved short-lived, but the results were striking. In each of these pieces the table is positioned at a different level. In *Sun Feast* Caro actually used a work bench, which is slightly higher than a table (and which is subsumed by the massive surrounding shapes of the piece). The table of sorts in *Orangerie* is placed higher than eye level. In *Deep North*, 1969-70 (pl.67), the platform is higher still, being cantilevered eight feet above the ground. In fact, *Deep North* is one of Caro's few sculptures to date which begins to assume architectural proportions. The technical problems involved in getting this massive structure off the ground seem to have precluded the invention of the kind of fanciful shapes that characterize *Orangerie*,

Sun Feast, and *Georgiana*. Although curved elements branch off one side of the platform, the sheer size of the piece (it is nineteen feet wide) and its architectonic nature are overwhelming and impressive. In any event, Caro did not pursue this direction, but turned his attention instead to the small tabletop pieces.

Discussions with the critic Michael Fried in the summer of 1966 had encouraged him to begin this brilliant series. David Smith had already experimented in this area and he in turn had been inspired by Giacometti. Giacometti had invented the concept of using the table as an integral part of his sculpture, combining it with such evocative elements as a severed hand, a draped bust of a woman, an abstract sculpture and a bottle in *The Table*, 1933 (fig. 9). The juxtaposition of these disparate objects, the elegantly turned legs of the table, the drapery drifting over the table's edge, all combine to form a haunting poetic image and a compelling visual statement, which is clearly the precursor of Smith's *Voltri XIX* and *XVI*.

In the surreal *Voltri XIX*, exhibited at the Tate Gallery shortly before Caro began his own table pieces, Smith uses such Daliesque imagery as steel forging tongs that bend limply over the edge of the table. On the other hand, the forms of *Voltri XVI*, those of the sculptor's work bench, are not Surrealist objects signifying the human unconscious, but are formalist in origin and are rooted in the artist's autobiography. Caro, however, ignores personal autobiography and explores only the purely abstract possibilities inherent in table-top sculpture: his work is neither metaphorical nor descriptive and thus diverges from that of both Giacometti and Smith.

Caro's mature table pieces are usually small in scale; they are intimate and object-like. They rest directly on their bases, which are not incorporated as active components of the work. The tables serve as neutral supports and as foils for the sculptures. Earlier, Caro had hesitated to make small sculptures, fearing they would look like maquettes of his larger work. However, his use of the table allowed him to isolate these smaller pieces from the monumental free-standing sculptures, to identify them as self-sufficient entities rather than as models for more massive forms. Indeed, the small scale and self-sufficiency of these pieces recall Degas's small bronzes as well as some exquisite bronzes of the early Renaissance, two possible sources of inspiration for Caro.

Caro himself describes the genesis of the table sculptures and the function they served for him:

I messed about for a long time with clay and all sorts of things, to try and make sculpture that would actually sit on a table, without success, and finally, in conversation with Michael Fried, came to realize that there was something special about the table, that is the table's edge. The other special thing is the fact that the things on the table relate to the hands of the people who sit at the table. They don't relate in a presence way, as one person relates to another, but they relate [as] a cup or a jug relates—you know, it's got a handle so there's never any feeling that the cup there is a model for a great big cup. Its size is right for the way it works and it identifies the way it's to be used by means of its handle. It's much the same principle with a table sculpture.

The first things I got were some scissor handles and cut them up and used them in my sculptures, just as straightforwardly as that—stuck them into sculptures

59. *Argentine.* 1968. Steel painted purple. 4'1" × 11'4" × 8'10". Private Collection

which went over the sides of the tables.

I used to make table sculptures in the evenings. I prefer to make table sculptures in this garage up at home. There's something nice about their different size, their smaller size, and by this time I had a studio away from home and I used to work on larger things there, then in the evenings come back and it would be rather like drawing. I made a lot, just as one would make a lot of drawings, and drawing has never been easy for me, never been such a pleasure for me. Making table sculptures is fun, very open and loose.

Caro estimates that to date he has produced close to five hundred table pieces—to be more exact, four hundred and seventy by the time of his exhibition at the Kunstverein Braunschweig in May 1979. The photographs in the catalogue of this show clearly document the progression of the series. At first Caro explored the downward pull of gravity and made the sculptures bend over the table edge, thus incorporating the table into the work (for example, *Table Piece V, Table Piece XVII* [pls. 72, 74], all of 1966). As the series evolved, however, his interest in the tabletop as base diminished and he concentrated increasingly on the creation of small-scale, free-standing sculptures which simply rest on top of the table (*Table Piece I, Table Piece XIV, Table Piece XXI* [pls. 69,68, 75]). He was able to combine the two ideas in the most effective works, such as *Table Piece XLII* (pl.76), when the perfectly proportioned tube, arc, and scissors handle rest in perfectly conceived relationships with the top and sides of the table. Some of these small pieces look like sketches, although they do not relate directly to specific monumental works, others have

heroic qualities despite their relative lack of size; all are possessed of a particular sense of balance and repose very different from that of the larger work. Thus, Caro has brilliantly succeeded in claiming a new size for sculpture, independent and contemporary in character.

Caro incorporated various materials—not only the scissors handles he has mentioned, but brass or steel tubing and other random scraps—into the first table pieces of 1966-67. These elements were subsequently chromed, glazed, polished, or sprayed with automobile paint. He began to play with the possibilities of fastening together or collaging the disparate fragments happened upon in the scrapyard or left over from larger works. For example, in *Table Piece VIII* (pl. 71) of 1966, Caro combines a steel tube, an L-shape, and an arc with the handles of three scissors to create a very effective multi-planar polished steel piece. The dynamic diagonal tube contrasts with the stable L-shaped element, which, despite its small size, anchors the sculpture in place. Caro offsets the upward thrust of the diagonal bar with the downward curving unit as if to acknowledge the power of the central L-shaped component. Playfully, he adds the fillip of the three scissors with their seductive loops undercutting the otherwise severe geometry of the piece.

Caro's concern with both the studied and the playful is unique among the sculptors of his generation or even of the fifties. His uncommon ability to fashion these small pieces from the merest scraps of materials allows him to endow these little works with the same industrial look of the larger sculpture, while at the same time expressing a more casual and spontaneous approach. Thus, small works such as *Table Piece*

60. *Trefoil.* 1968. Steel painted matt yellow. 6'11" × 8'4" × 5'5"
David Mirvish Gallery, Toronto

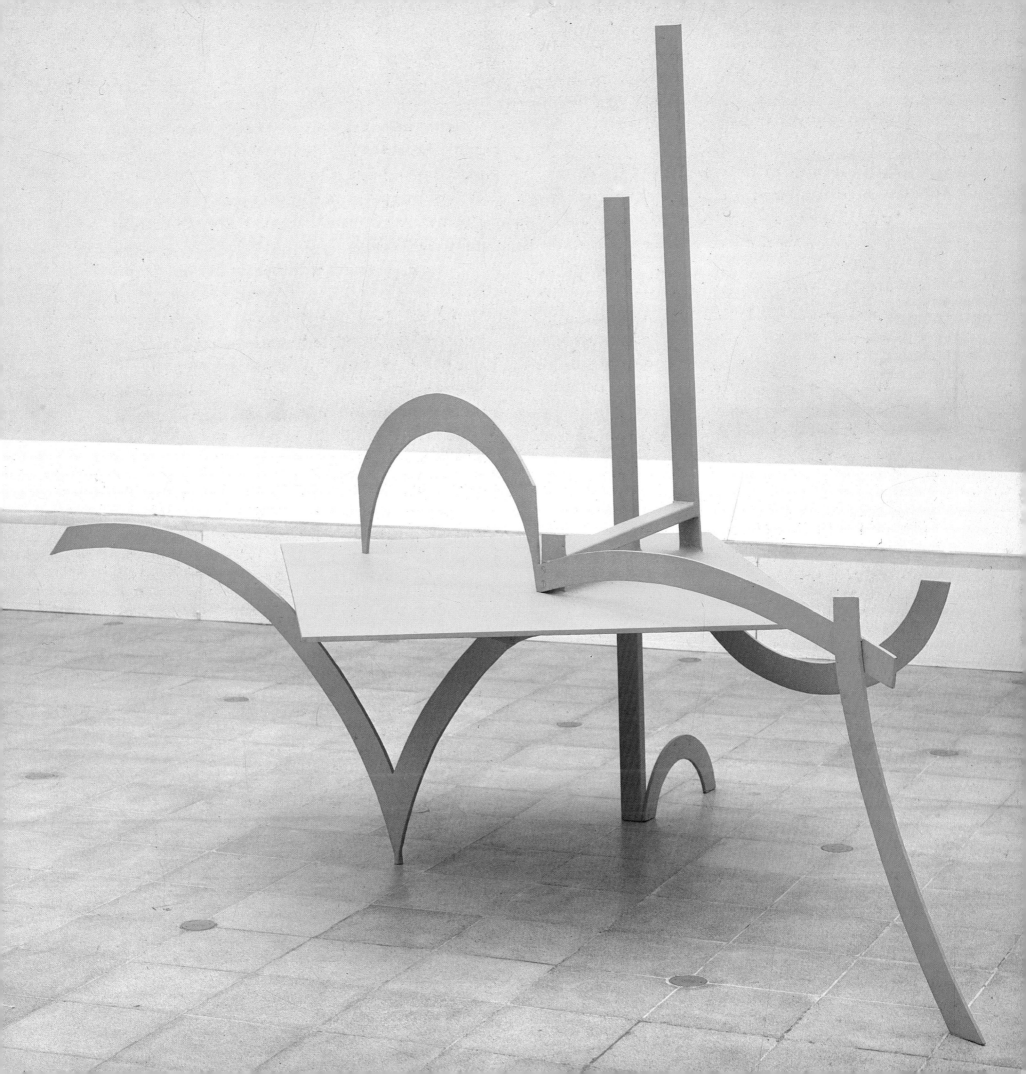

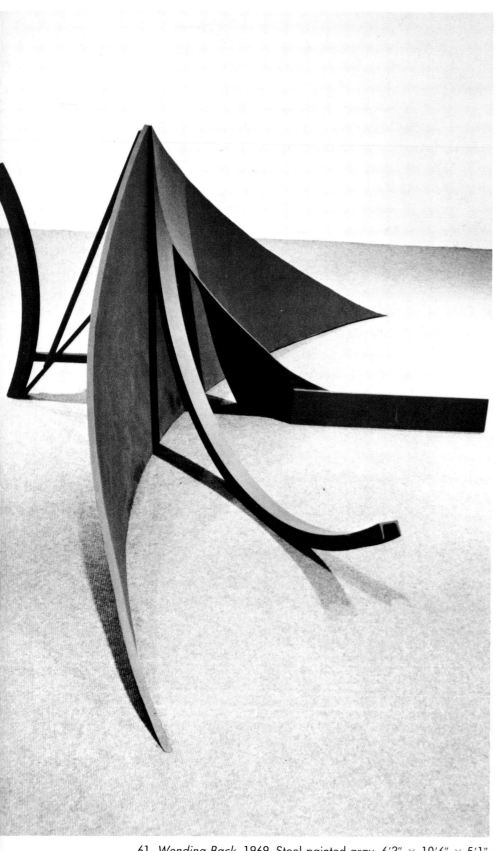

61. *Wending Back*. 1969. Steel painted gray. 6'3" × 10'6" × 5'1"
The Cleveland Museum of Art

V and *VII* (pls. 72, 73) reveal a refreshing attitude of experimentation, a testing, an air of chance and discovery not as evident in the larger more ambitious pieces.

For the next few years Caro continued to experiment with rather modest materials on a relatively small scale. In some of these little sculptures, notably the aforementioned *XVII* of 1966 and *XLIII* of 1967, there were intimations of the dynamic gesture which was to characterize his later development. Here the proportions of the internal elements have grown, although the overall dimensions of the sculptures have not increased significantly. The dynamic gesture is apparent also in *Table Piece XLVIII* of 1968 (pl. 80), where Caro typically uses a scissors handle for its value as a ready-made object. He does not exploit the metaphorical associations of the handle, but makes use of it largely for its value as shape.

By 1968 the table series was well under way, its development consistent with the growing maturity of Caro's approach to sculpture in general. He was not retracing the painful and revolutionary transition from figuration to abstraction that he had effected in his large-scale sculpture in 1960; rather, in these small works, as in the larger examples, he was now expanding upon an innovative but established vocabulary of forms. His handling of small-scale sculpture grew increasingly confident between 1966 and 1968. His clear appreciation of the potential of the small-scale object, his employment of these real, everyday objects with their absolute, given size fixing the scale of his work, and his increasingly successful integration of hand-made and prefabricated elements may be seen in such superb works as *Table Piece LXIV (The Clock)*, 1968, or *Table Piece LXXXVIII*

(Deluge), 1969-70 (pls. 87, 89), table pieces which are comparable in their forms and mastery to the large-scale *Orangerie*.

Deluge is among the finest table pieces. Like *Orangerie*, it is replete with a multitude of sweeping curves that gracefully arch up in the air or drift below the level of the table. Although subtitled (by William Rubin) after a drawing by Leonardo, *Table Piece LXXXVIII* is resolutely abstract; the reference to the Renaissance drawing was no doubt prompted by the sculpture's classical harmony. There is neither narrative nor metaphor, only delight expressed in this, one of Caro's most sensual works. This sensuality may derive from the very intimate scale of the piece: the spectator can relate to it in a way that is impossible when confronting larger more formidable works (*Orangerie* is a notable exception). Both *Deluge* and the less complex but equally effective *The Clock* offer an interesting point of contrast to Smith's *Timeless Clock* of 1957 (fig. 9); Smith's piece is the sculptural equivalent of drawing—of drawing in space; Caro's constructions are intricately articulated compositions of graceful arcs, curves, and straight edges that always infer completed geometric forms.

Unquestionably, Caro's explorations of small-scale sculpture—because of its ease of handling and the greater opportunity for experimentation it thereby affords—had a positive effect upon his large-scale pieces. The large works of the period, like the table sculptures, opened up and out and became more volumetric. Further connections between Caro's large and small works are evident; for example by 1969 he was using shapes in his table sculptures that were similar to those of *Sun Runner* (see, for instance, *Table Piece LXXXII*, pl. 91). However, he never at-

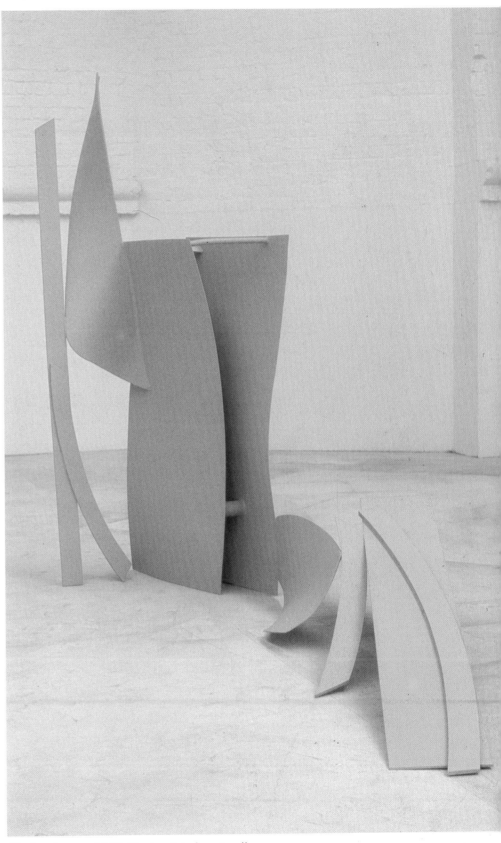

62. *Sun Runner*. 1969. Steel painted matt yellow
6'½" × 3'8" × 8'4". Private Collection

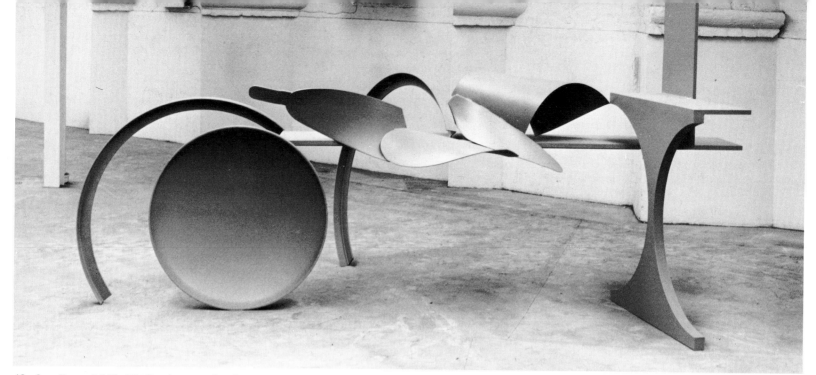

63. *Sun Feast.* 1969--70. Steel painted yellow. 5′11½″ × 13′8″ × 7′2″. Private Collection

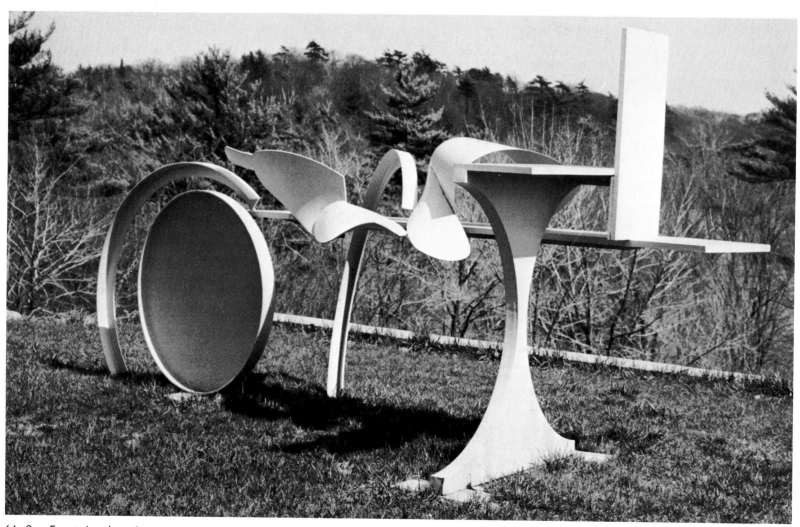

64. *Sun Feast.* Another view

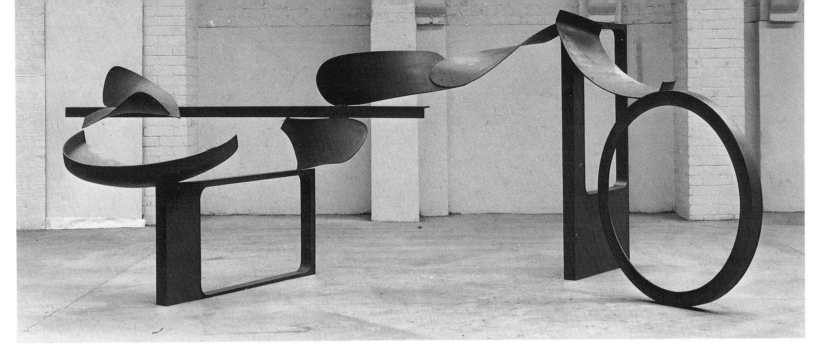

65. *Georgiana.* 1969–70. Steel painted deep red. 5' × 8' × 15'3". Albright-Knox Art Gallery, Buffalo, New York. Gift of Seymour H. Knox

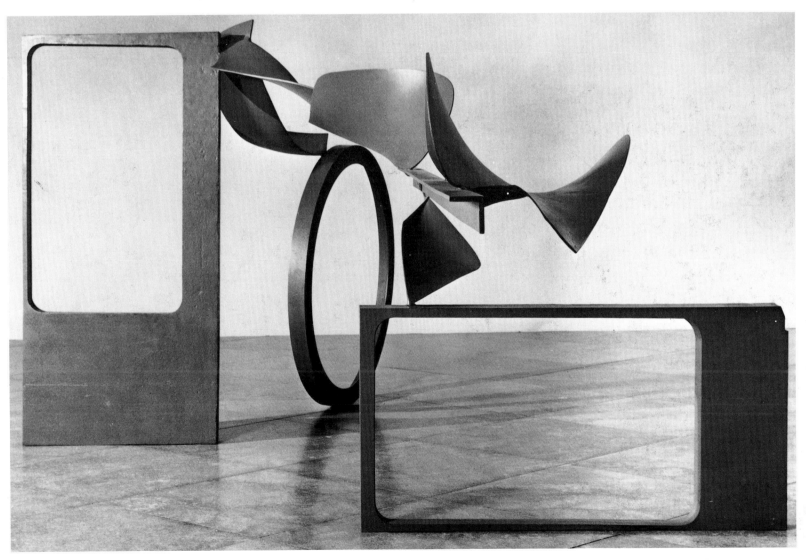

66. *Georgiana.* Another view

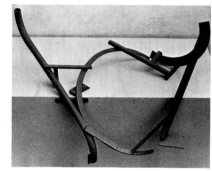

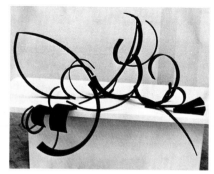

fig. 9. David Smith, *Timeless Clock*, 1957. Private Collection

fig. 10. Anthony Caro, *Table Piece LXIV (The Clock)*, 1968 Private Collection

fig. 11. Anthony Caro, *Table Piece LXXXVIII (Deluge)*, 1969 Private Collection

tempted to replicate works by enlarging or reducing them, but continued to develop large and small sculpture as two independent means of expression. The first table pieces were generally small, usually attaining less than two feet in their largest dimension. However, they gradually grew until some approached the size of certain floor pieces: for example, *Table Piece LXXXII* and *Deluge*, as well as *Table Piece LXXV*, of 1969, which reveals affinities with *Trefoil* of the preceding year, all measure approximately five feet in any one given dimension. Increased size notwithstanding, Caro specifically refers in the works of this genre to the table plane rather than to the floor— hence their unique character and effectiveness. This distinction is apparent when we compare *Orangerie*, where the thrust clearly moves up from the ground, to contemporaneous table pieces, which relate to the tabletop, the seam where tabletop and side meet, and the sides of their stands. Thus, the base, while it does not function as an active structural member, is a fundamental component of the table pieces.

Caro has experimented with a few small wall pieces, called *Alpha* or *Beta* (pls. 92, 93), box pieces (see, for example, *D*, pl. 95), and floor pieces (which are the size of table pieces, but are better looked down on), all designated by letters or words to distinguish them from table pieces, which are always identified by numerals. These wall, box, and floor sculptures occur intermittently between 1970 and 1972, and are not among Caro's most convincing work. Most of his small sculptures are, of course, table pieces: *Table Piece XVII*, 1966 (pl. 74), *Table Piece XVIII*, 1966, *Table Piece XXII* and *XLII*, 1967, *Table Piece XLVIII* and *XLIX, LIX*, and *LXVIII* of 1968 are but a few of the fine examples of this idiom dating from this period.

In *Table Piece XCVII*, of 1970 (pl. 90), Caro partially encloses the now familiar plough-like forms, which have a willful organic life of their own, with a geometric "picture plane": so masterfully does he combine the two elements that the integrity and force of both remain undiminished. This sculpture initiates a new approach: previously Caro had individually distinguished the top and side of the table sculpture as well as the base on which it rested. He emphasized each

67. *Deep North*. 1969--70. Steel, cadmium steel, and aluminum painted green. 8' × 19' × 9'6". Private Collection

68. *Table Piece XIV.* 1966. Polished steel 10″ × 2′ × 1′7½″. Private Collection

69. *Table Piece I.* 1966. Polished steel lacquered green. 9¼″ × 1′8⅛″ × 1′10⅛″

70. *Table Piece XVIII.* 1967. Steel polished and lacquered. 10″ × 1′9″ × 1′8″. Private Collection

71. *Table Piece VIII.* 1966 Polished steel. 2′3″ × 1′1″ × 1′8″

72. *Table Piece V.* 1966 Polished steel lacquered blue. 9¼″ × 6″ × 10½″

73. *Table Piece VII.* 1966. Polished steel. 1′11″ × 3¾″ × 1′2″

74. *Table Piece XVII.* 1966. Steel polished and lacquered 2′11″ × 1′9″ × 5½″. Private Collection

75. *Table Piece XXI.* 1967. Steel polished and lacquered. 1′2″ × 6¼″ × 2′8½″ Acquavella Gallery, New York

76. *Table Piece XLII.* 1967. Polished steel sprayed green. 1′11½″ × 1′3½″ × 2′5″

77. *Table Piece XXII.* 1967. Steel sprayed jewelescent green. 10″ × 2′7½″ × 2′3″

80

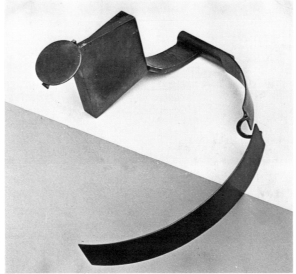

79

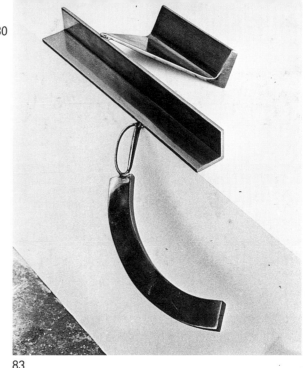

78

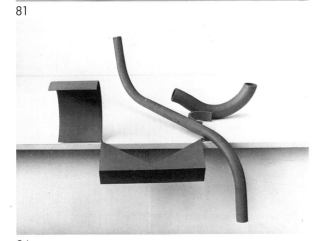

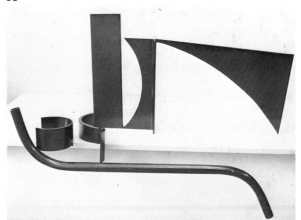

78. *Table Piece CCCXLV*. 1977. Steel rusted and varnished. 1′7″ × 3′11″ × 2′

81. *Table Piece LVIII*. 1968. Steel sprayed cherry 1′8¼″ × 2′8″ × 2′8″. Kunsthalle, Hamburg

84. *Table Piece C (Century)*. 1970. Steel painted tan. 2′ × 5′7″ × 4′4″

79. *Table Piece LXV*. 1968. Steel blued and varnished. 11″ × 1′1½″ × 1′7″ Private Collection

82. *Table Piece LIX*. 1968. Steel sprayed silver gray. 11½″ × 1′5″ × 1′7″

85. *Table Piece XCV*. 1970. Steel painted green 1′2″ × 2′2″ × 2′1″

80. *Table Piece XLVIII*. 1968. Polished steel 6″ × 2′1″ × 1′1½″

83. *Table Piece LXXX*. 1969. Steel painted deep blue. 1′1½″ × 4′5″ × 1′8″

86. *Table Piece XCVI*. 1970. Steel sprayed charcoal. 2′11½″ × 4′5½″ × 1′4″

87

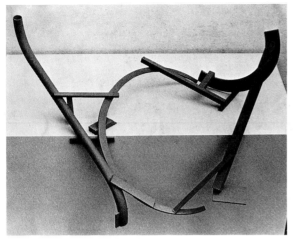

88

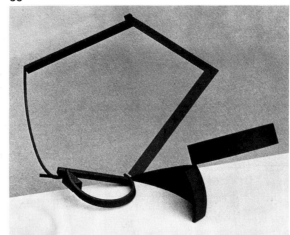

89

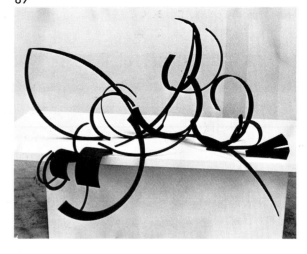

90

91

87. *Table Piece LXIV (The Clock)*. 1968. Steel painted with zinc chromate primer. 2'6" × 4'3" × 2'8". Private Collection

88. *Table Piece LXVIII*. 1968. Steel painted buff, eggshell finish. 1'10" × 4' × 2'10" Kunstsammlung der Ruhr-Universität, Bochum

89. *Table Piece LXXXCIII (Deluge)*. 1969. Steel painted with zinc chromate primer. 3'4" × 5'3" × 3'2". Private Collection

90. *Table Piece XCVII*. 1970. Steel painted tan 2'1" × 4'5" × 3'8"

91. *Table Piece LXXXII*. 1969. Steel painted eggshell brown. 1'7" × 4' × 4'10" The Tate Gallery, London

92. *Wall Piece Alpha*. 1970. Steel painted aluminum--silver. 2'10" × 3'8" × 7"

93. *Wall Piece Beta*. 1970. Steel painted gray 2'8" × 4'5" × 1'10"

92

93

interstice, each passage, each carefully calculated transition from plane to plane. Here, however, instead of acknowledging top, seam, and side as separate planes he synthesizes them into a single plane. This formulation led him to develop a number of successful table pieces in the 1970s, such as *Table Piece CXVI*, of 1973 (pl. 173), whose elements cascade over the edges of their bases.

In May of 1970 Caro went to the United States and worked in Noland's Vermont studio. With the sculptors James Wolfe and Willard Boepple, he began to experiment with very heavy structural steel, using curved forms or arcs and sections of beams. *The Bull* (pl. 104), is one of a number of massive sculptures made at this time signaling a significant redirection in Caro's work. Although its powerful components are vastly different from the lighter open-ended forms of *Orangerie, Sun Feast,* and *Georgiana, The Bull* is related in its massiveness to *Deep North* of 1969-70. Familiar too, is the confident assemblage of curvilinear and rectilinear elements, for Caro had already proven himself a master of such synthesis. But now, for the first time, Caro has left certain steel segments unpainted, applying oil or varnish to protect

94. *Lap.* 1969. Steel painted matt yellow. 3'7" × 5' × 8'

them against weathering, identifying the ruggedness of the forms with the ruggedness of the steel of which they are made.

Caro returned to London in June and started to construct works in which he stacked I-beams and employed steel shapes. He began some sculptures as table pieces but subsequently extended them so they reached the floor (for example, *Moment*, pl. 105). In November he went back to the States and once again restricted himself to using structural steel—I-beams, angles, and plates. Gradually, Caro decided to leave all the elements of his sculpture unpainted and merely to oil or varnish them (examples are *Ring, Canal, The Dog, The Box, Gorge, Behold*). When he ceased to paint his sculpture, Caro drew attention to the nature of the material itself. The raw, unfinished, rusted steel was to change the character of Caro's sculpture, contributing its innate qualities of density, mass, and weight as major components of the new work.

The use of unpainted steel engendered constructions that were strikingly different in many respects from the work of the sixties: the monumental, densely

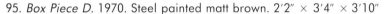

95. *Box Piece D.* 1970. Steel painted matt brown. 2′2″ × 3′4″ × 3′10″

96. *Box Piece E.* 1971. 1'8" × 3'7" × 3'10". Steel. Private Collection

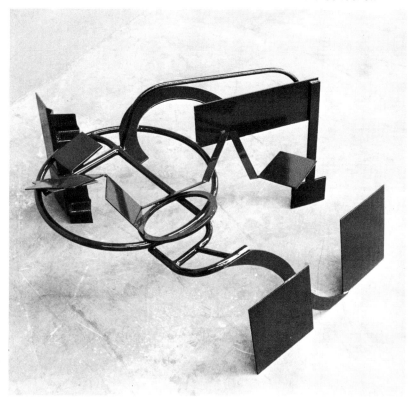

97. *Again.* 1970. Steel painted blue. 2'11" × 6'5½" × 6'3".
Private Collection

98. *Crest.* 1970. Steel rusted and varnished. 4'1" × 3'10" × 2'8"

impacted, vertically oriented *Straight* series of 1972. *Straight Up* and *Straight Left* (pls. 113, 114) are the most impressive of this group of seven sculptures. The forms of these compositions are adjusted in relation to a dominant vertical or diagonal steel plate that functions like a picture plane. For example, most of the smaller elements of *Straight Left* project backward and forward from this plane; the plane is cut open to allow forms to traverse it, in a manner foreshadowed in certain of David Smith's *Zigs.* Like

Silk Road, Dark Motive, Ordnance, and *Up Front,* all of 1971 (pls. 120, 119, 121, 124), the *Straight* series sculptures are emphatically regular in configuration. Following so soon after the extremely curvilinear *Georgiana, Orangerie,* and *Sun Feast,* and the curved, albeit regular forms of *Deep North* or *The Bull,* they confirm Caro's characteristic working pattern of varied explorations and rapid changes of vocabulary. While the rectilinear or geometric predominates in 1970-71, he continues to use the curve in works such

99. *Root.* 1970–71. Steel painted brown
2'11" × 2'7" × 2'7". Private Collection

100. *Garland.* 1970. Steel painted green and red
4'7" × 14'1" × 12'4". Private Collection

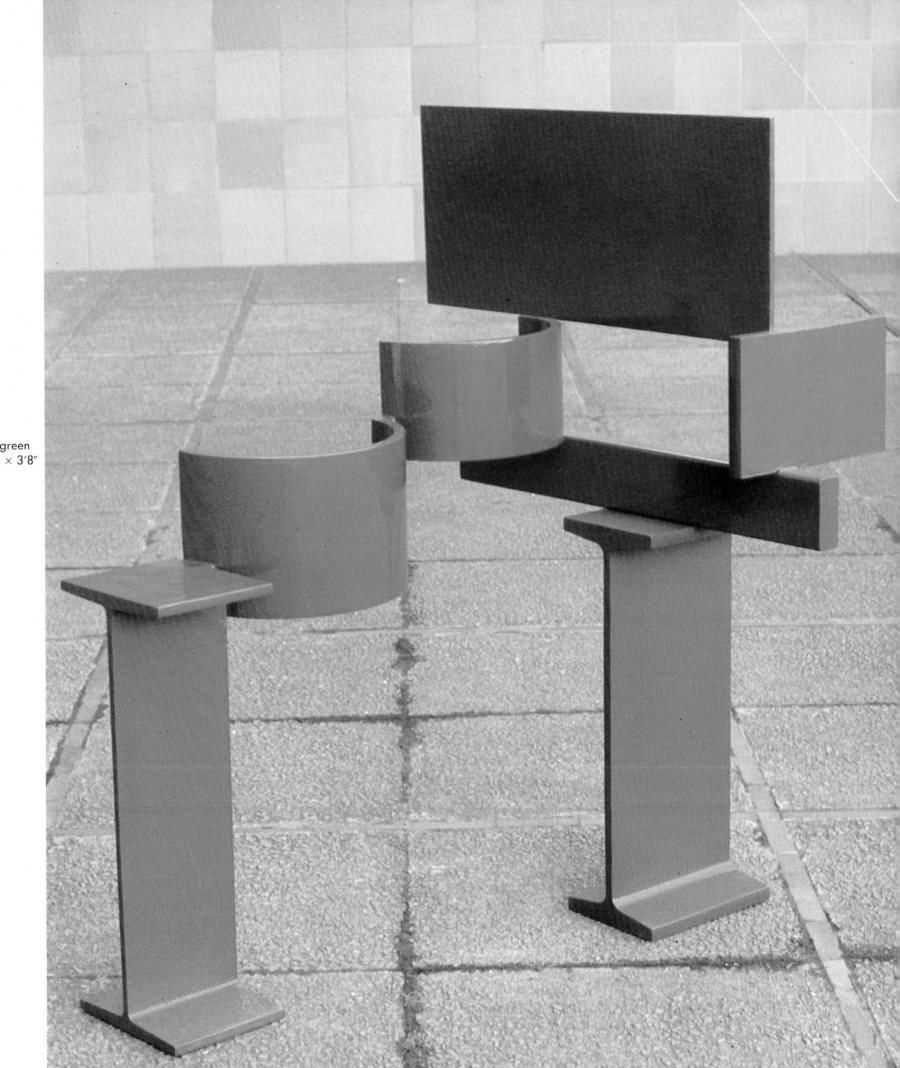

101. *Tantum.* 1970
Steel painted green
3'11" × 2'10" × 3'8"

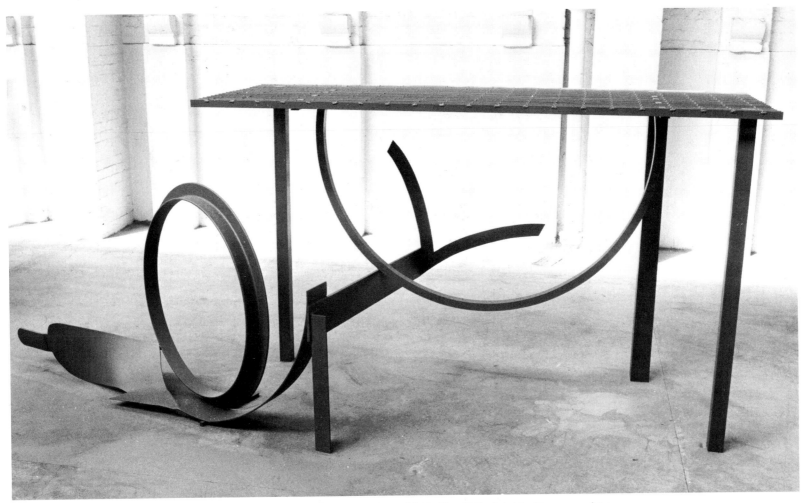

102. *Clearing*. 1970. Steel and aluminum painted burgundy. 4'9" × 5' × 12'4". The Philadelphia Museum of Art

as *Serenade* and *Cadenza* (pls. 125,126). The afore-mentioned *Sidestep*, the seemingly random *Air* (Caro's lowest-lying piece to date), and *Cherry Fair* (pl. 128), where two large plates are set off by a cluster of smaller fragments, are understated works which contrast with the more declarative sculptures of the time.

The rugged bulkiness and bustling activity of *Straight Up* and *Straight Left* were somewhat diminished in *Trianon* of 1971-72 (pl. 129) by the reintroduction of flatness, compression, lateral extension,

and an occasional space-spanning arc or projectile-like linear element. The crisp profile of *Trianon* hints at further changes in Caro's work, changes that were forthcoming in the even more streamlined Veduggio series of 1972-73.

The Veduggio sculptures (made in Italy with James Wolfe) are curvilinear, and they are flatter and simpler in construction than the *Straight* series with its jagged crush of intersecting planes, straight edges, and trapezoidal shapes. In *Veduggio Flat, Veduggio Sun, Veduggio Sound*, and *Veduggio Glimpse* (pls.

103. *Haze.* 1970. Steel painted red. 1'7" × 7'5" × 7'3". André Emmerich Gallery, New York

104. *The Bull.* 1970. Rusted steel. 2'8" × 9'11" × 4'9". Private Collection

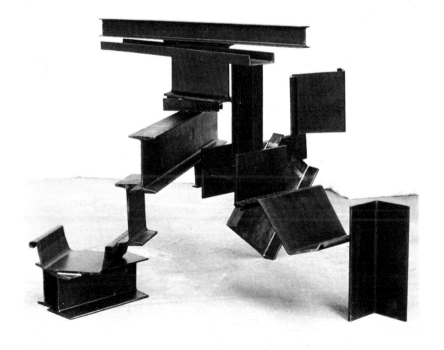

105. *Moment.* 1971. Varnished steel. 4'5½" × 8'8" × 6'6". Private Collection

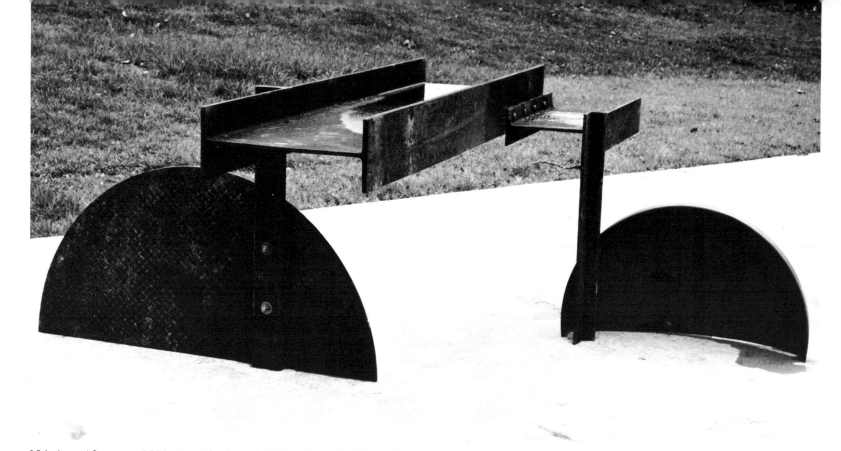

106. *Late Afternoon*. 1970. Varnished steel. 3'2" × 7' × 9'. Private Collection

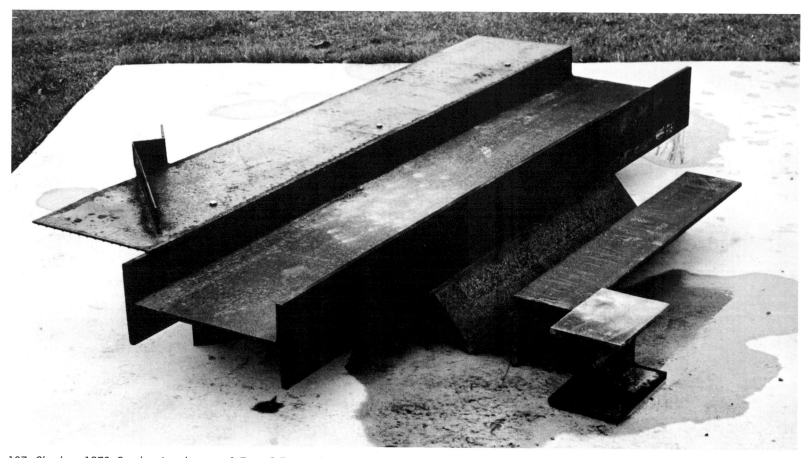

107. *Shadow*. 1970. Steel painted green. 1'7" × 8'7" × 5'9"

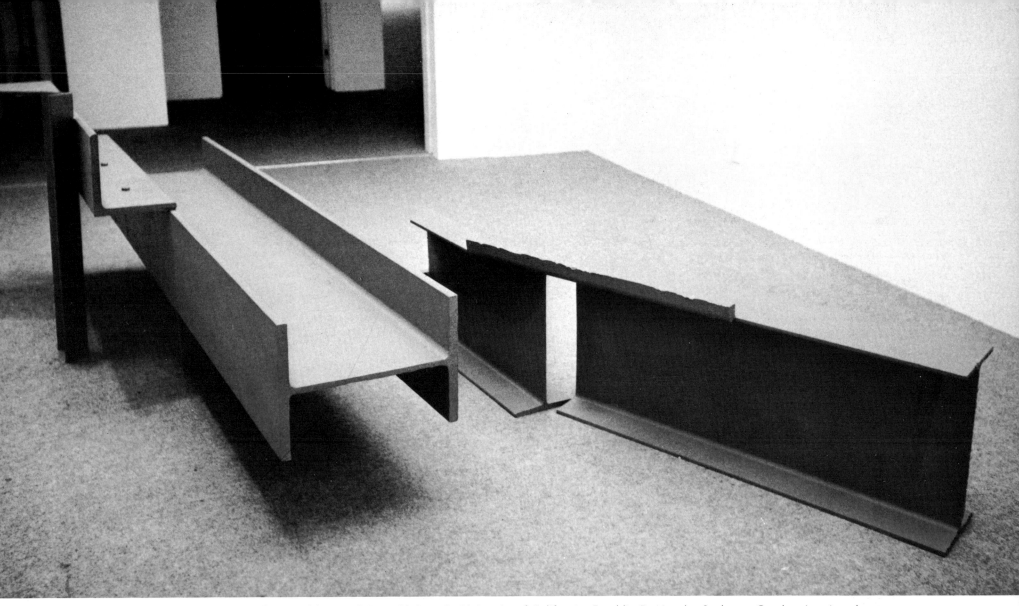

108. *Halfway*. 1970–71. Steel painted brown. 2'5" × 10'4" × 5'. University of California, Franklin D. Murphy Sculpture Garden, Los Angeles

135, 136, 138, 137), Caro uses the narrow steel channels or I-beams of the *Straight* series and of much of his earlier work. But now they are minor notes or accents in an opened, less dimensional, even pictorial presentation of rippling, liquid shape. Even where two forms cut into each other at right angles, as in *Veduggio Sound*, the overriding effect is of frontality. This frontality is produced by a post-and-lintel structure which Caro explores throughout the series. The post-and-lintel structure naturally creates the impression of a doorway, an archway, a passageway, or a gateway; the unusual melting shapes border on the organic, the biomorphic—a fleeting glimpse of form or the shadow of form—although Caro steadfastly maintains that his forms are neither allusive nor drawn from the real world. Once again Caro's forms share something with Kelly's admittedly organic shapes. In fact, the slender silhouettes of some of the shapes in the Veduggio series anticipate Kelly's sculptures of 1974. And there is a decided affinity in both *Veduggio Flat* and *Veduggio Sun* to Helen Frankenthaler's fluid paintings of the early 1950s, especially *Mountain and Sea* of 1952. Despite the sculpture's contemporaneity, however, it seems likely that the

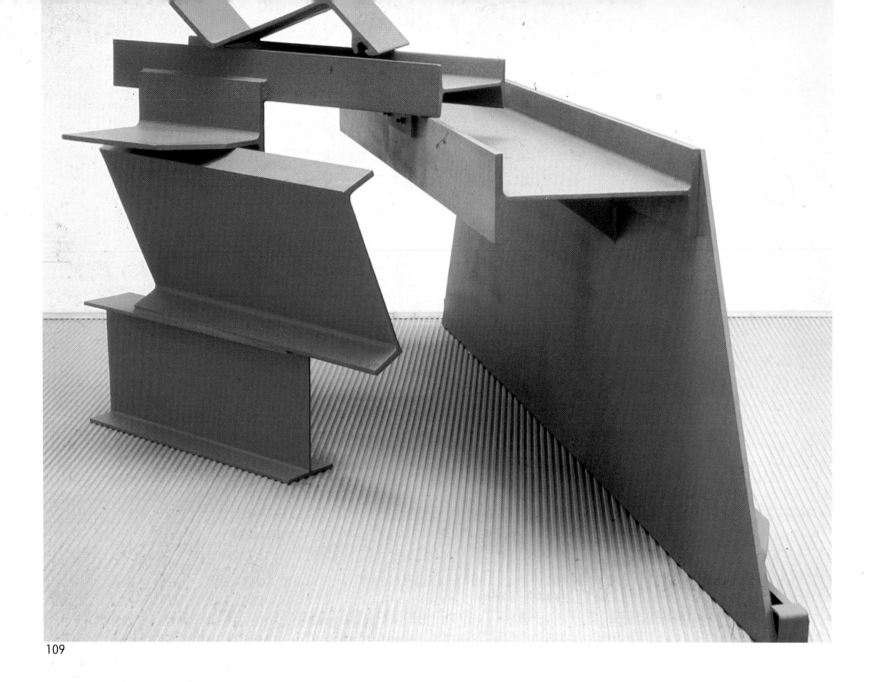

109

Veduggio pieces echo another age, and are ultimately inspired by an ancient source, classical Italy. The series is imbued with a monumentality and serenity not present in the immediately preceding angular works or even in the more active antecedents like *Orangerie*, whose curvilinear emphasis they share.

The simplicity and monumentality of this series derives in part from Caro's new attitude towards his material. As we have noted, steel had provided the structure for his earlier work, but he had disguised and embellished it with paint. In the transitional sculp-

tures of 1970 he dispensed with paint, thus revealing the irregular surface of the steel for the first time. In the Veduggio sculptures, he begins to allow a warm patination of rust to develop and enrich the surfaces. A sense of the irregular edge had been a notable feature of even the earliest work of the sixties: here it is reintroduced with a splendor and ease characteristic of the artist's maturity. Now he acknowledges as well the power of the material to suggest new forms: in *Veduggio Sun*, for example, Caro allows the curved edges of rolled steel (found in Italy for the first time) to

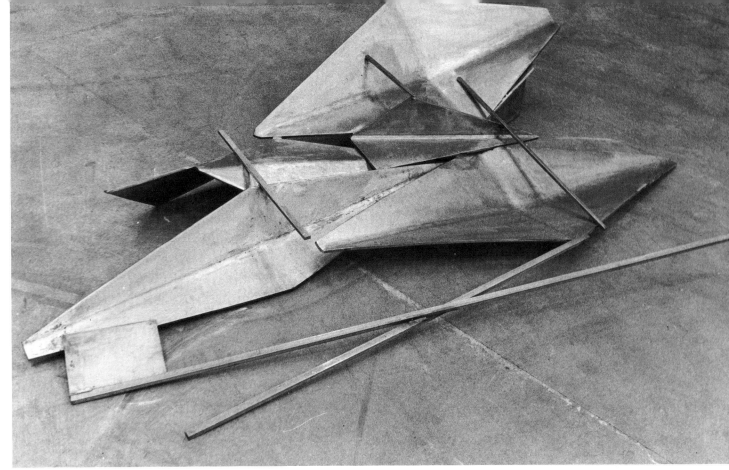

109. *Side Step.* 1971
Steel painted brown
4'3" × 9'7" × 4'10"
Private Collection

110. *Cool Deck.* 1970--71
Stainless steel
1'10" × 5'4" × 10'4"
Private Collection

111. *Crown.* 1970--71
Steel painted red
3'6½" × 6'10" × 2'8"
Private Collection

110

111

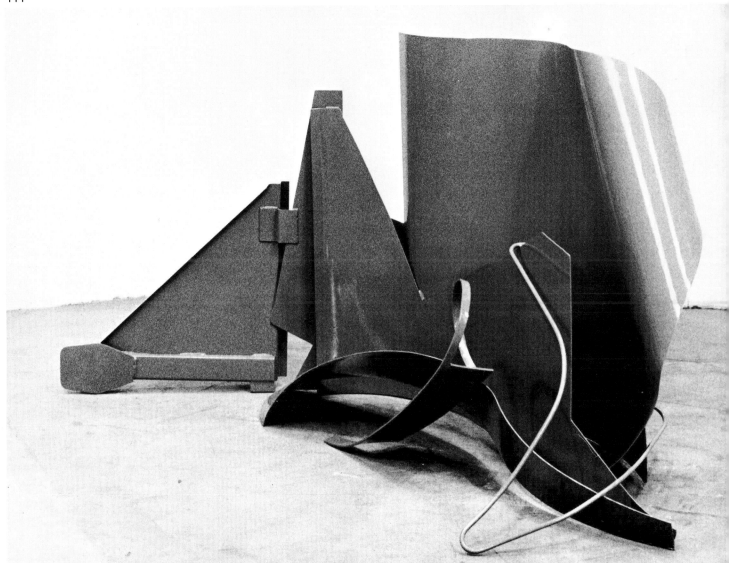

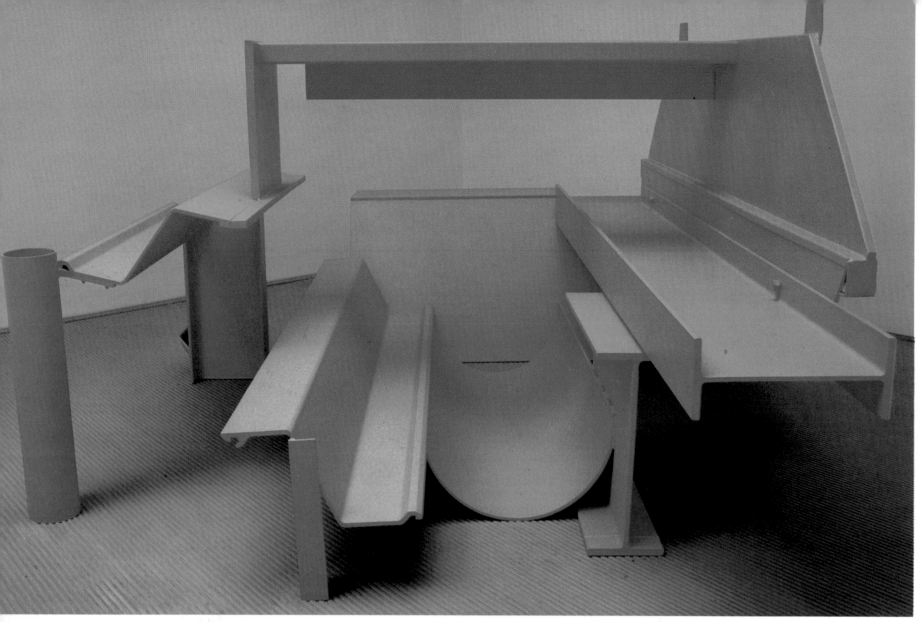

112. *Quartet.* 1970–71. Steel painted orange. 5' × 9'4" × 11'7". The Tate Gallery, London

become a dominant feature of the composition. The closest analogy for Caro's new approach to his materials may be found in the work of the Abstract Expressionists. Like the painters of the fifties who regarded the blank canvas as the field in which to express themselves freely and without inhibition, Caro exploits the potentialities of his new materials, drawing from them a greater variety of forms and effects than he could hope to obtain from the more limited resource of relatively inflexible precast steel units.

Although Caro continues to prop his pieces up with small channels of steel, he does not infer a return to the base in the Veduggio series as he had done in the *Straight* sculptures. Moreover, in the new work such supporting devices are no longer hidden: rather Caro accentuates these subdivisions, which contribute nuance and variety to the broad, uninflected expanses of flat steel sheets. Caro's use of large flat shapes, of the irregular edges of rolled steel, and of discreet but nonetheless important joints or structural supports, make the Veduggio series a true sculptural equivalent

113. *Straight Up.* 1972. Rusted steel. 4'5" × 3'7" × 5'8". Private Collection

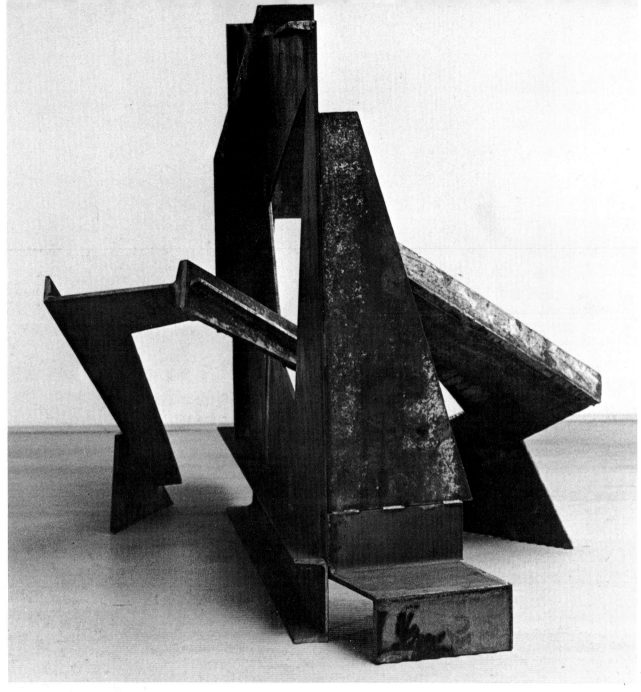

114. *Straight Left.* 1972
Rusted steel
5'1" × 4'6" × 8'2"
Private Collection

115. *Straight Cut.* 1972
Steel rusted and painted silver
4'4" × 5'2" × 4'3"
Private Collection

116. *Straight Measure.* 1972
Steel, ground and wire-brushed,
rusted and painted
3'10½" × 6'3" × 4'11"
Private Collection

117. *Straight On.* 1972
Steel rusted with
red paint rubbed in
6'7" × 5'8" × 4'4"

114

115

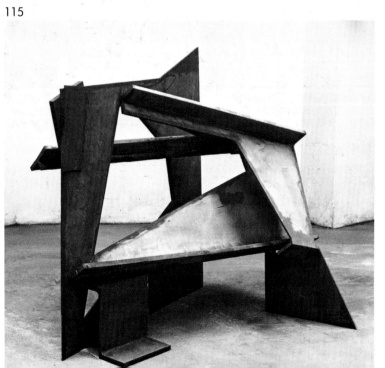

116

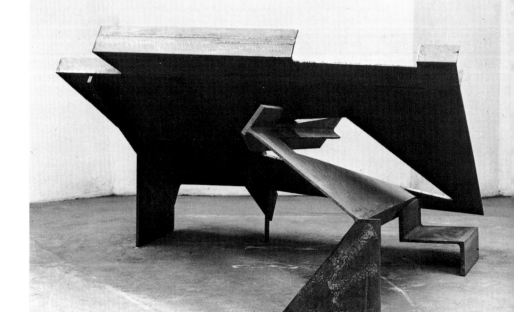

of Matisse's *découpages*.

Upon his return to England from Veduggio Caro continued to work with rust-patinaed rolled steel. He used the plates, as he had in the Veduggio group, primarily as vertical planes anchored and supported by straight-edged beams and panels. The most arresting in this second rolled-steel series is the superb *Durham Steel Flat* of 1973-74 (pl. 143), which is dominated by an immense plate of rolled steel that slants slightly off the vertical and is supported by rectilinear girders. *Durham Steel Flat* recaptures in a new form the abrupt and stark monumentality of works of 1960-61 such as *Midday, Sculpture 2,* and *Sculpture 7.* Here once again is the raw energy and vitality, the bigness that Caro often refined out of his art after 1962.

A comparison of *Durham Steel Flat* to *Durham Purse* (pl. 142) of the same year reveals Caro's continuing need to experiment and change. In *Durham Purse* the steel is folded to resemble a purse. The purse, a rather static element, is topped by a "clasp" that forms an extended horizontal accent and contributes movement to the composition. In *Durham Steel Flat*, on the other hand, the formulation is reversed. The major compositional element, the sail-like, slanted steel sheet with slightly rolled, irregular edges at top and bottom is so active that it must be stabilized by the anchoring rods and the rigid metal plate at its side. Two reviewers, sensitive to the changes in Caro's style, discussed the Veduggio and Durham works when they first appeared in exhibitions in New York and Zurich:

Monumental constructions of welded and bolted steel are enriched by a patina of warm rusted browns and

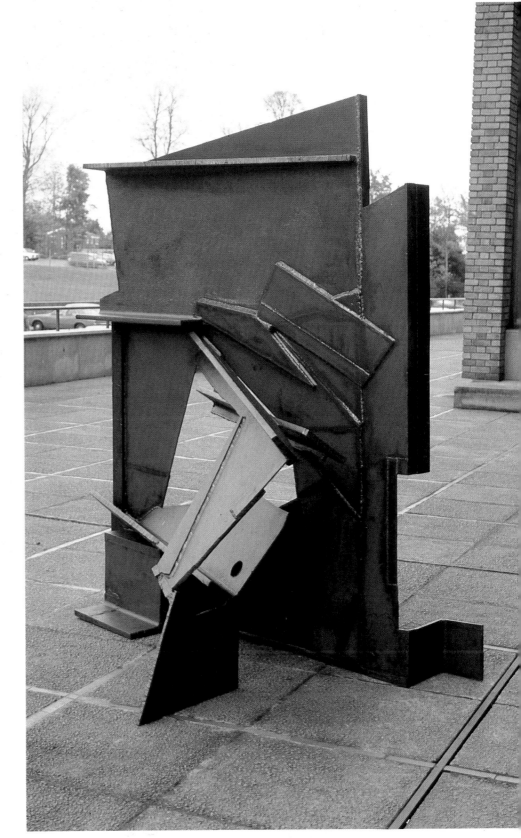

118. *Straight Run.* 1972. Steel rusted and varnished. 6'7" × 11'5" × 2'7". Baltimore Museum of Art

mottled textures which lend an organic quality to the hard metal. Caro's recent works bring new lyricism to the Constructivist tradition. While steel retains its intractable grandeur, the modes of behavior to which it is put—it can stand, lie, hover, bend, attach, buttress—make these sculptures alive and imposing presences.⁹

Now that he no longer excites avant-garde small talk, Caro is becoming a movement in himself, fertile, prolific, but essentially going it alone. This is the stage at

which an artist's lasting worth, rather than his trend-setting achievements, first becomes recognizable . . . his most recent pieces, made in Italy and London, have significantly different qualities from the two basic varieties of work, abrupt as in Midday (1960) and airily deployed as in Early One Morning (1962), with which he first established his reputation. A decade ago he took his steel from standard industrial stock and gave his products straightforward, eye-catching coats of paint, and his work looks comparatively impromptu, rough and ready. The finished

119. *Dark Motive.* 1971-74. Steel rusted and varnished. 5'1" × 11'3" × 26"

products would no longer seem conceivably at home in the farm machinery section of an agricultural show or among the girders on a clean construction site. Rather, they belong to the foundry and the rolling mill where the steel first emerges in its raw state.[10]

Upon the invitation of David Mirvish in Toronto, Caro went to Canada for June and July of 1974 and worked at York Steel Construction Ltd., Toronto. Once again he was assisted by James Wolfe and later also by Willard Boepple. Working for the first time in such

a vast steel yard, with cranes and other handling equipment and factory workmen, he was able to manipulate massive sheets of steel weighing thousands of pounds as freely as the lighter steel he uses in his own studio. Caro spoke of "the extraordinary weight of those things, those pieces which were unlike anything that I'd ever handled up to then. . . . They were enormous and those guys at the steel yard were handling them like butter because they were accustomed."

The pieces were moved in the summer to York Uni-

120. *Silk Road*. 1971–74. Steel rusted and varnished. 5′ × 12′9″ × 2′10″

121. *Ordnance.* 1971 (in progress). Steel rusted and varnished. 4'3" × 6'4" × 11'11"

versity where they were assembled by Wolfe, Boepple, and André Fauteux, the Canadian sculptor. Caro returned frequently to Toronto from London over the course of more than a year, working and reworking the pieces until he was satisfied, finally completing thirty-seven sculptures. He consciously attempted to produce a sense of improvisation, despite the use of heavy gauge steel. To retain a feeling of spontaneity he composed these sculptures quickly, as he had the Veduggio series, refining and editing them during his numerous visits. Working with massive sheets of steel, he achieved a feeling of impossible lightness. And

the constructions are astonishingly varied: he appears to have addressed, with remarkably fresh and arresting results, virtually every problem that had engaged him during the course of his earlier development. Thus, *Overtime Flat* (pl. 147) is propped up in much the same manner as *Durham Steel Flat*, but the greater weight of the steel and the rigidity of forms in the new work give it a feeling entirely different from that of the softer looking, more fluid Durham piece. The emphatic horizontality and ground-hugging configuration of *Scorched Flats* (pl. 148) are reminiscent of *Veduggio Glimpse* but, once again, the newer

122. *Focus.* 1971. Steel rusted and varnished. 3'10" × 8'8" × 10'

sculpture seems less flexible, less yielding than the earlier one. In the York series the curves and ruffled edges of the Veduggio and Durham constructions have been simplified and minimalized; and the pieces are endowed with a new and stronger sense of geometry and rigor. Even where curves are opposed to angles, as in *Surprised Flat* (pl. 149), they seem compressed and constrained rather than exuberant and free as they were in *Veduggio Plain* (pl. 139), a difference that is strikingly apparent despite the

similarly monolithic presences of both works. Indeed, Caro has moved from openness to compression in his evolution from the Veduggio to the York sculptures. A comparison of *Criss Cross Flats* (pl. 150) to a Veduggio piece reveals this dramatic change in direction. Among the York sculptures only *Back Cover Flat* (pl. 152) retains some of the exuberance of the earlier work, but even here activity is contained by the channels and I-beams that form the construction's top and bottom perimeters. Unlike the Veduggio series,

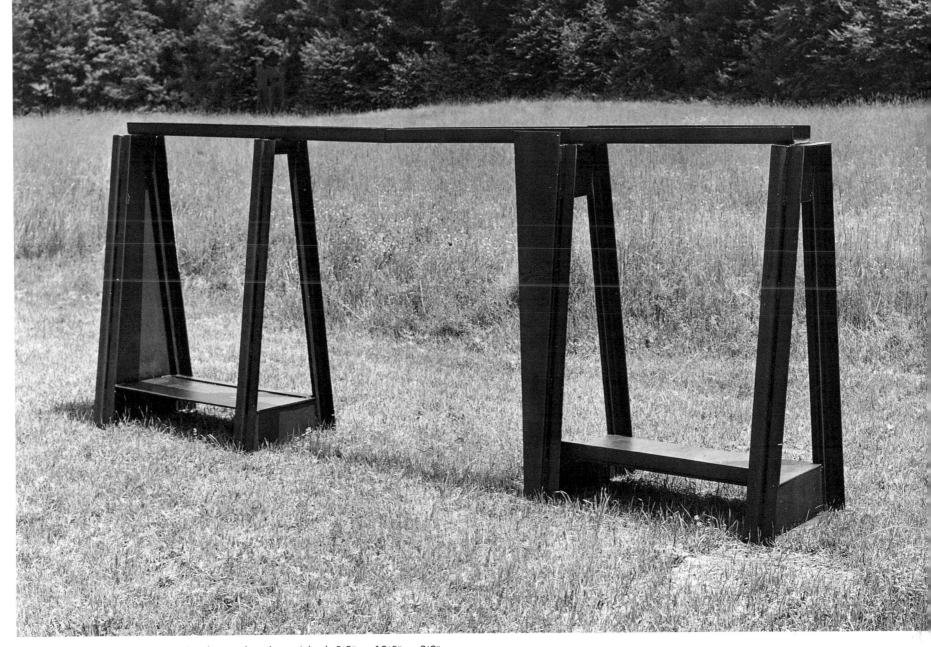

123. *Sailing Tonight*. 1971–74. Steel rusted and varnished. 5'3" × 13'5" × 2'2"

the York sculptures do not invite participation: they are flat, multilayered. They do not touch upon pictorial issues but are about exclusively sculptural concerns: verticality, horizontality, frontality, the diagonal, propping, butting, joining. Somber rather than whimsical, they express the Constructivist component of Caro's nature.

Caro's ability to work with huge plates of steel is evident in the masterful *Dominion-Day Flat* (pl. 153; the title refers to the Canadian holiday celebrated on July 1), as well as in other powerful sculptures in the series such as *Sunday Flat, Double Flat, York Flat,* and *Toronto Flats* (pls. 154, 155, 156, 151). These vast sheets of rusted steel call to mind Morris Louis' bronze veils. But Louis created diaphanous washes with his resistant color, whereas Caro constructs unyielding masses, great impassive curtains of steel that confront the viewer with a sense of durability, of timelessness, of an imposing stateliness.

That Caro was able to conceive the thirty-seven

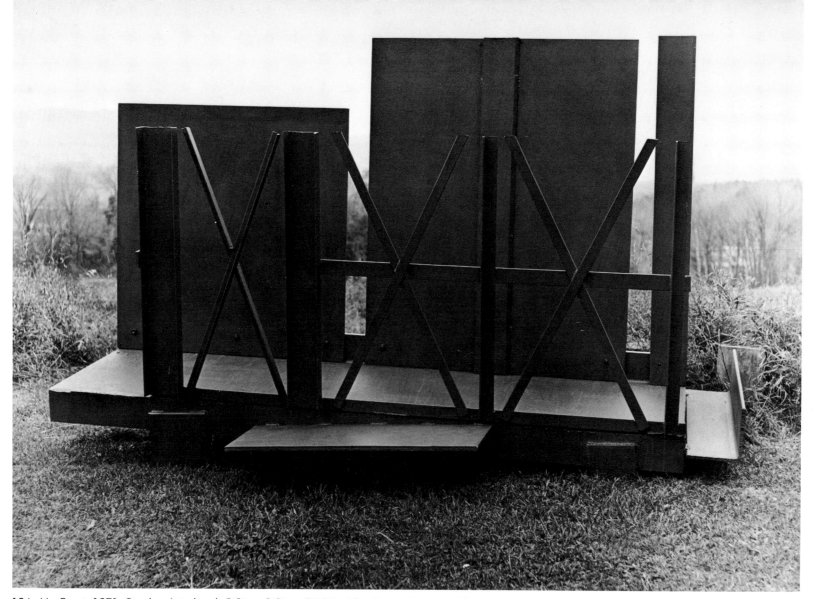

124. *Up Front.* 1971. Steel painted red. 5'9" × 9'2" × 3'10½". The Detroit Institute of Arts

monumental Toronto pieces in the extremely limited period of a single summer, testifies to the continuing high level of his invention and energy. His extraordinary creativity is further confirmed by the variety of his working methods in this period, which in turn influenced the range and variety of his sculpture. For his procedures in the York series differed substantially from those he employed earlier and later. Thus, beginning in 1971 he produced a group of sculptures at Bennington (where, since the sixties, he had spent at least a short period each year) which originate in and elaborate upon the motif of the sawhorse: for exam-

ple, *Silk Road* and *Dark Motive* of 1971-74, referred to above. *Riviera* of 1971-75, although executed in London, is a brilliant re-creation of the sawhorse theme. These experiments were carried forward concurrently with the production of the Veduggio and Durham series. And during these same years he also executed a number of works at Bennington that enlarge upon the configurations of the sixties, works such as the low-lying and seemingly random *Cocaine* (pl. 161) of 1973 and the table-like *Survey* of 1971-73.

While he produced the monolithic sculptures of the York series, Caro was also experimenting in London

125. *Serenade.* 1970–71. Steel painted red. 3'11" × 8'8" × 7'6". Private Collection

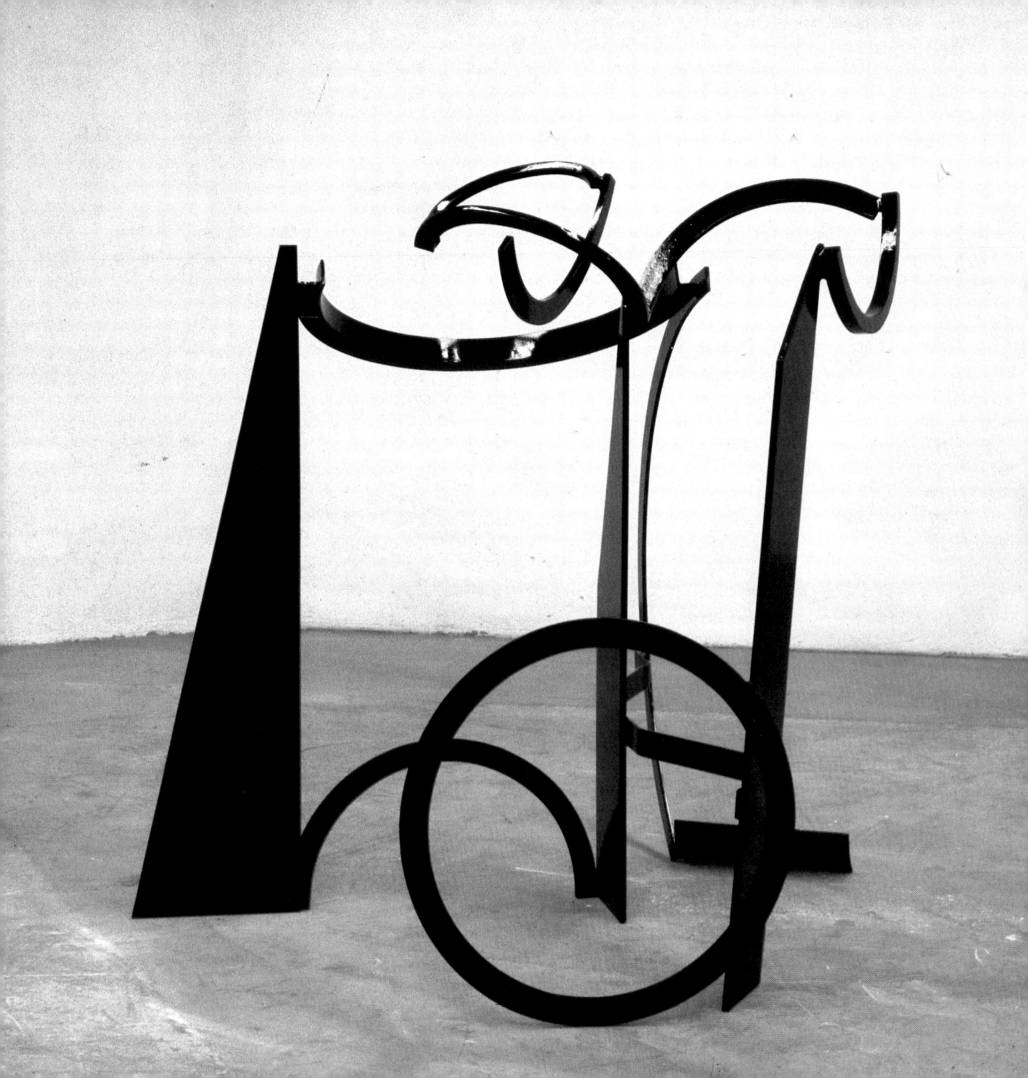

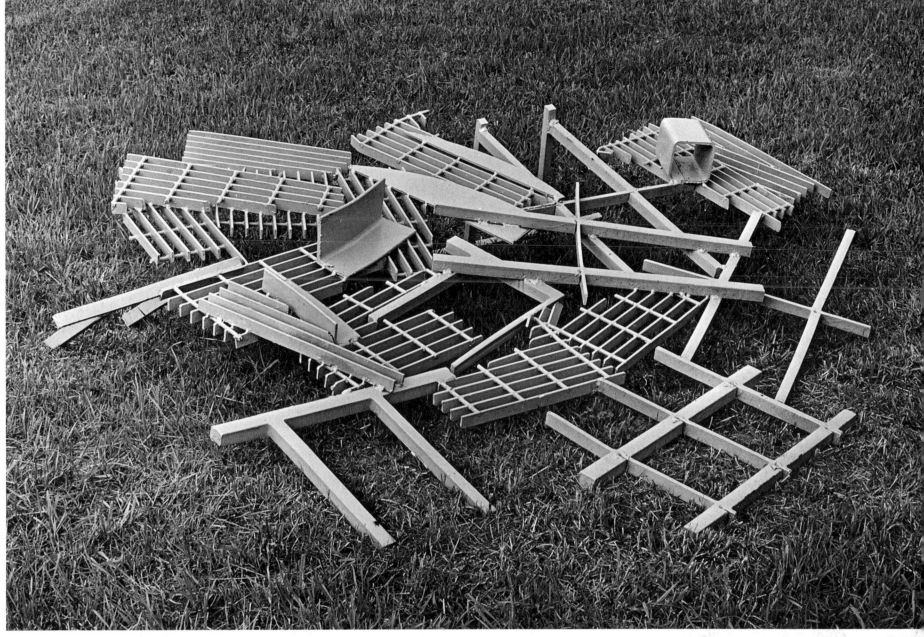

127. *Air.* 1971. Steel painted gray. 1′2″ × 6′ × 5′8″. Private Collection

with lighter pieces such as *First Watch* and *Curtain Road* of 1974 (pls. 166, 167), both independent works rather than members of a series. Although *Curtain Road* shares some of the density of the York sculptures, its impact is considerably lightened by the cluster of steel ribbons at its side. *First Watch*, on the other hand, is closer stylistically to Caro's work of the sixties, despite the use of irregular shapes in place of the standard industrial units characteristic of that period. A number of sculptures of the late 1970s recall earlier pieces: *Potpourri* of 1976-77 (pl. 215) and *Jericho* of 1976-78, for example, resemble to a certain extent *Cherry Fair* of 1971.

When Caro continued to treat the mass and density that were the subjects of his Toronto works, he achieved astonishingly fresh results, as *India, Nectarine, Java,* and *Cliff Song* of 1976 (pls. 219, 220, 221, 222) indicate. Once again he uses large steel plates. The dominant planar element usually establishes the frontality of the work. But there is also a pronounced

126. *Cadenza.* 1970. Steel painted blue
3′7″ × 3′7″ × 3′5″. Private Collection

128. *Cherry Fair.* 1971. Steel painted brown. 3′ × 7′3″ × 6′2″. Private Collection

thrust against this plane, effected by a number of subsidiary forms—baroque embellishments, a panoply of furls, rock-like shapes with craggy, shadowy recesses. The predominant plane is sometimes vertical, sometimes horizontal, often tilted slightly off the straight axis; the opposing forms are blocky, chunky, and, as a rule, diagonal. Thus the drama of these works is quite different from the sober planarity of the equally massive York sculptures.

In the new work Caro manipulates and exploits his materials, as well as his forms, to a much greater degree than before. Earlier, in the Veduggio, Dur-

ham, and York series, he had accepted the physical properties of his materials and expressed them with some restraint, confining himself to an irregular edge, a moderate curl of steel, allowing the metal to rust only slightly before varnishing it. Now he pulls out all the stops. He no longer merely accepts his materials as they are, but now embellishes them. His surfaces are stained, corroded, pitted. The sculptures evoke outcroppings of prehistoric rock pushing through the earth's surface, the hidden recesses of cave formations, the solidified lava of volcanic eruptions. Yet despite the violence of their oppositions and surfaces,

129. *Trianon*. 1971–72. Varnished steel. 5'3" × 3'6" × 8'7"

130. *Paul's Piece.* 1972. Stainless steel. 3'2" × 2'2" × 3'2"

131. *Hosanna.* 1972--73. Unpolished stainless steel. 4'6" × 5'3" × 3'10"

132. *Ripamonte*. 1973--75. Steel rusted and varnished. 3′8″ × 6′1″ × 1′10″

these works are stable, for Caro always remains a master of structure. This is true even of a sculpture as active as *Conspiracy* (pl. 226): the left section contains two stabilizing horizontal units but the right side is so full of movement and suggests so much more volume than the other section that the composition would splinter in two were it not for the central V-shaped form which pulls the two disparate parts together. The left and right sides of *India* (pl. 219), a somewhat more contained sculpture, seem diametrically opposed to one another; once again the in-tersection of the two parts, where diagonals and verticals, volumes and flat planes meet, functions to hold the sculpture together and is crucial to the success of the entire piece. The open, cutout area at this intersection lightens and lights an otherwise extreme-ly dense accumulation of forms—a device Caro uses to similar ends in *Nectarine*.

The upheaval that marks Caro's recent work may be likened to that in Picasso's *Demoiselles d'Avignon* (fig. 9). Although Caro did not refer to this revolu-tionary painting as a specific model, his use of shifting

133. *Fender.* 1972. Steel. 2'7¾" × 8'1" × 2'10". Private Collection

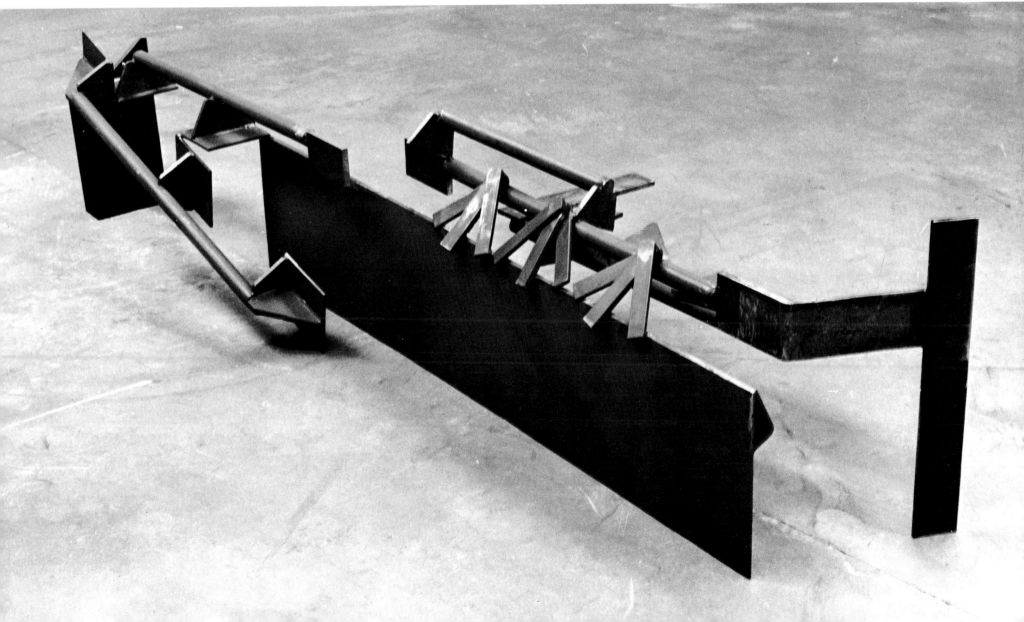

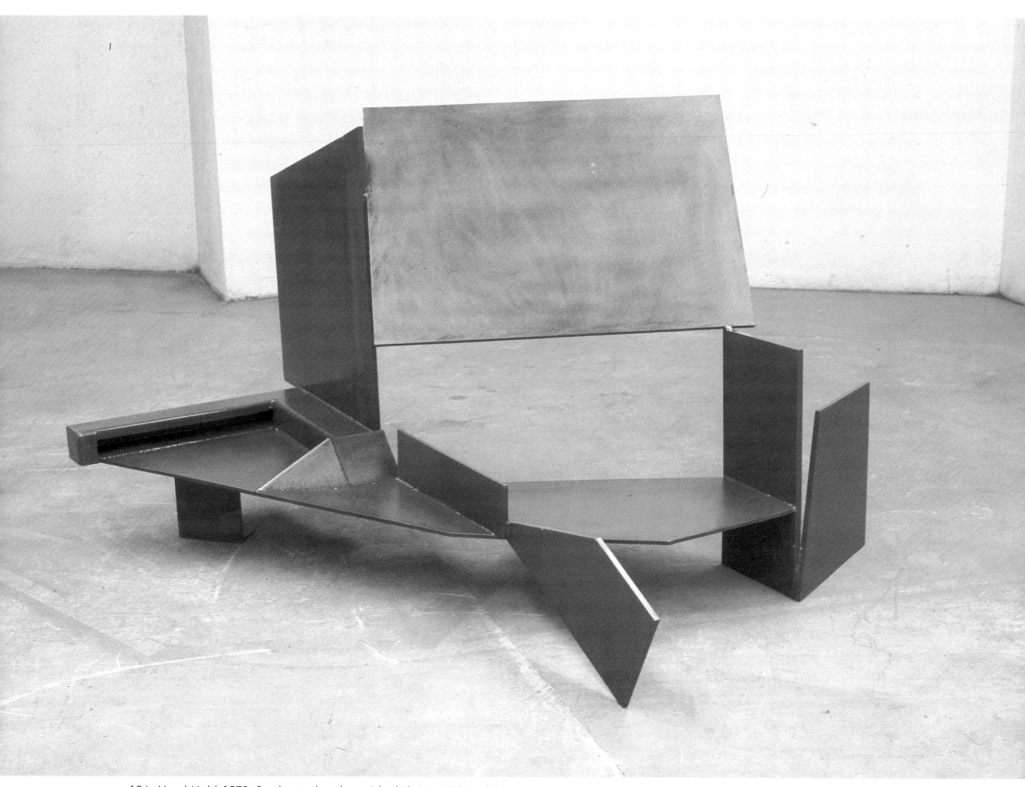

134. *Hand Hold.* 1972. Steel rusted and varnished. 2′4″ × 5′6″ × 5′11″

planes makes the comparison inevitable and calls to mind as well the analytical Cubism of both Picasso and Braque (see for example Braque's *Road at L'Estaque*, fig. 10). And beyond purely abstract considerations, the primitive quality of Caro's forms recalls the primitivism of Picasso. This romanticism, atypical of the characteristically restrained classicist Caro, is reinforced by exotic titles such as *India* and *Java*.

In August of 1977 Caro was invited to be a guest artist at Emma Lake, a summer workshop about one

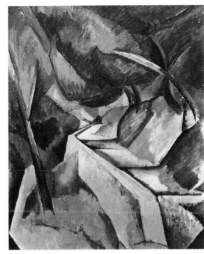

fig. 12. Pablo Picasso, *Les Demoiselles d'Avignon*, 1907. The Museum of Modern Art, New York

fig. 13. Georges Braque, *Road at L'Estaque*, 1908. The Museum of Modern Art, New York

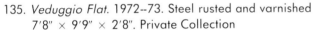

135. *Veduggio Flat*. 1972–73. Steel rusted and varnished 7'8" × 9'9" × 2'8". Private Collection

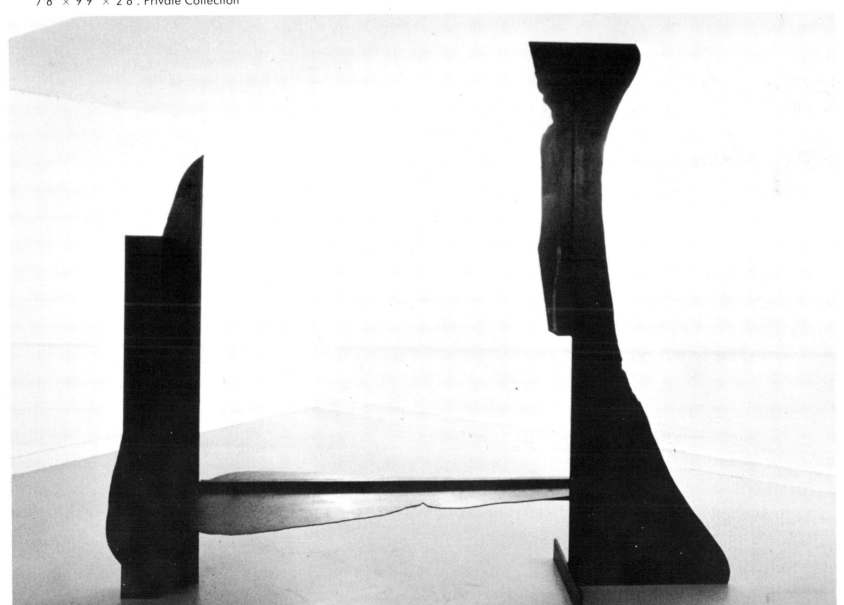

136. *Veduggio Sun.* 1972--73
Steel rusted and varnished
8'4" × 9'9" × 4'8"
Museum of Fine Arts, Dallas

137. *Veduggio Glimpse.* 1972--73
Steel rusted and varnished
1'5" × 9' × 2'6"
Private Collection

138. *Veduggio Sound.* 1972--73
Steel rusted and varnished
7'7" × 6'8" × 4'4"
Kunsthaus, Zurich

139. *Veduggio Plain.* 1972--73
Steel rusted and varnished
·5'3" × 7'6" × 6'6"

136

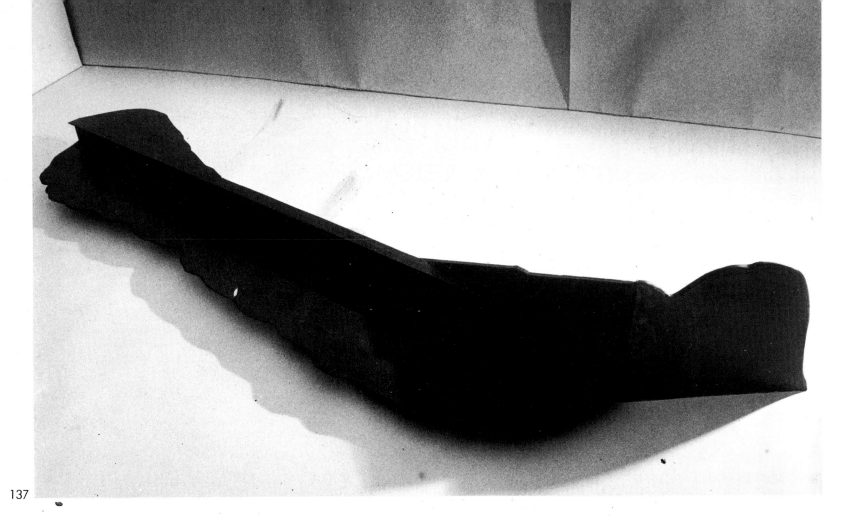

137

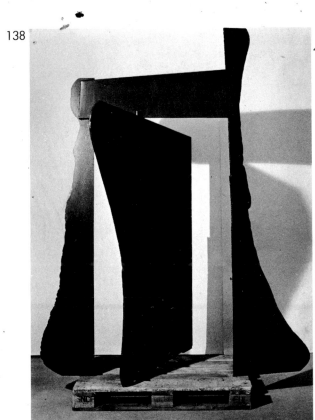

138

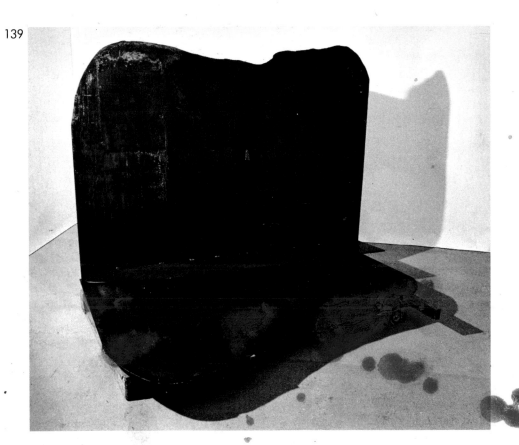

139

hundred and twenty miles north of Saskatoon, run by the University of Saskatchewan. There, with his son Paul, he began a series of sculptures, reminiscent of Picasso's wire constructions of the late 1920s, which he completed upon his return the following May. A number of them were shown in the fall of 1978 at the André Emmerich Gallery in New York. The Emma Lake pieces were radically and refreshingly different from their immediate forerunners. Although large, they are light and airy, constructed of steel tubing, open discs and rectangles, L-shaped channels, and

only an occasional metal plate: consequently they are as open as their predecessors are closed. Although Caro maintains that they are more effective indoors than out-of-doors, their success in either context is due to their openness. Their delicate tracery incorporates the surroundings into the sculpture; the setting is embraced but not violated. Yet the constructions are sufficiently large and self-contained to more than hold their own with their surroundings. The drawing in space perfected in table pieces such as *The Clock* and *Deluge*, is enlarged and transformed in *Emma*

140. *Veduggio Glimmer*. 1973. Steel rusted and varnished. 8″ × 9′6″ × 2′5″
Hirschhorn Museum and Sculpture Garden, Smithsonian Institution, Washington, D.C.

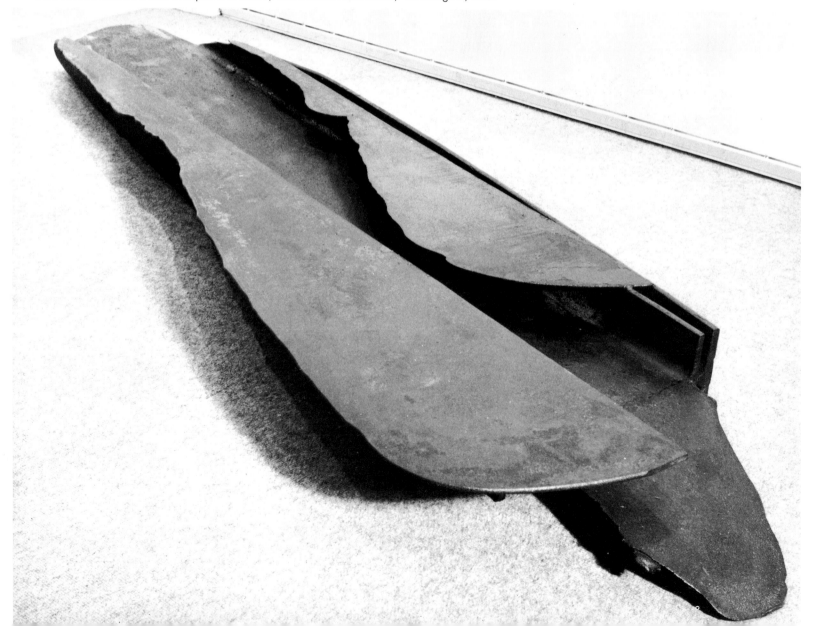

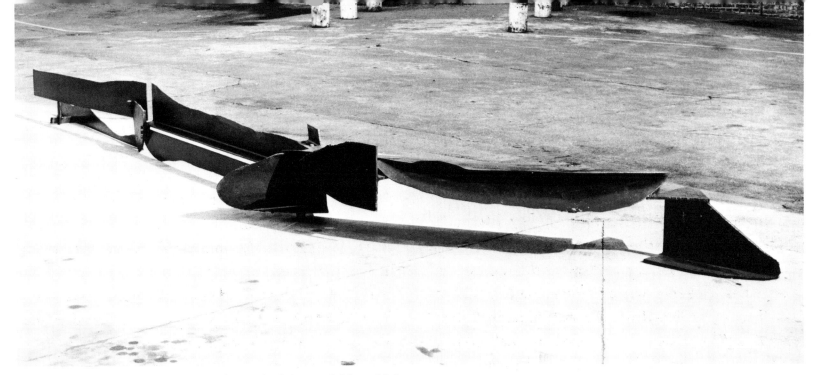

141. *Tim's Trail.* 1973. Steel rusted and varnished. 2'1" × 3'11" × 25'2"

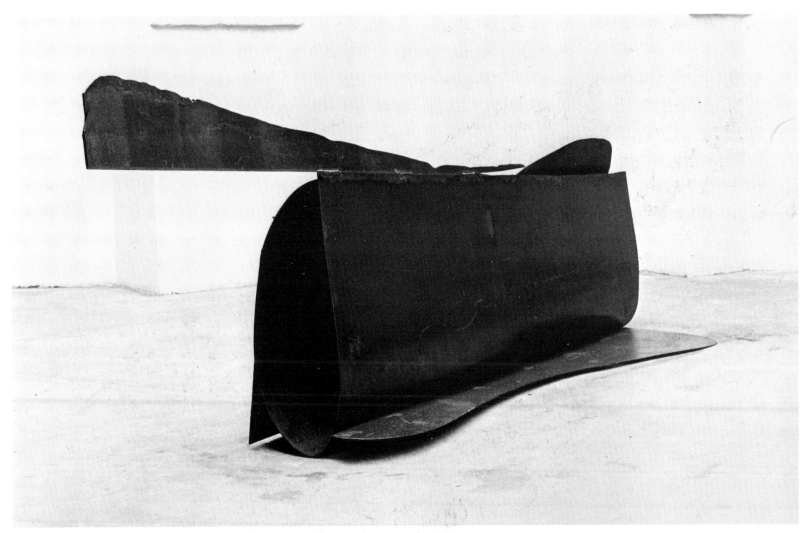

142. *Durham Purse.* 1973--74. Steel rusted and varnished. 4' × 12'3" × 2'6". Museum of Fine Arts, Boston

143. *Durham Steel Flat*. 1973--74. Steel rusted and varnished. 9'3½" × 8'2½" × 5'10½"

144. *Flyleaf.* 1974
Steel rusted and varnished
8'2½" × 6'2½" × 3'4"
Private Collection

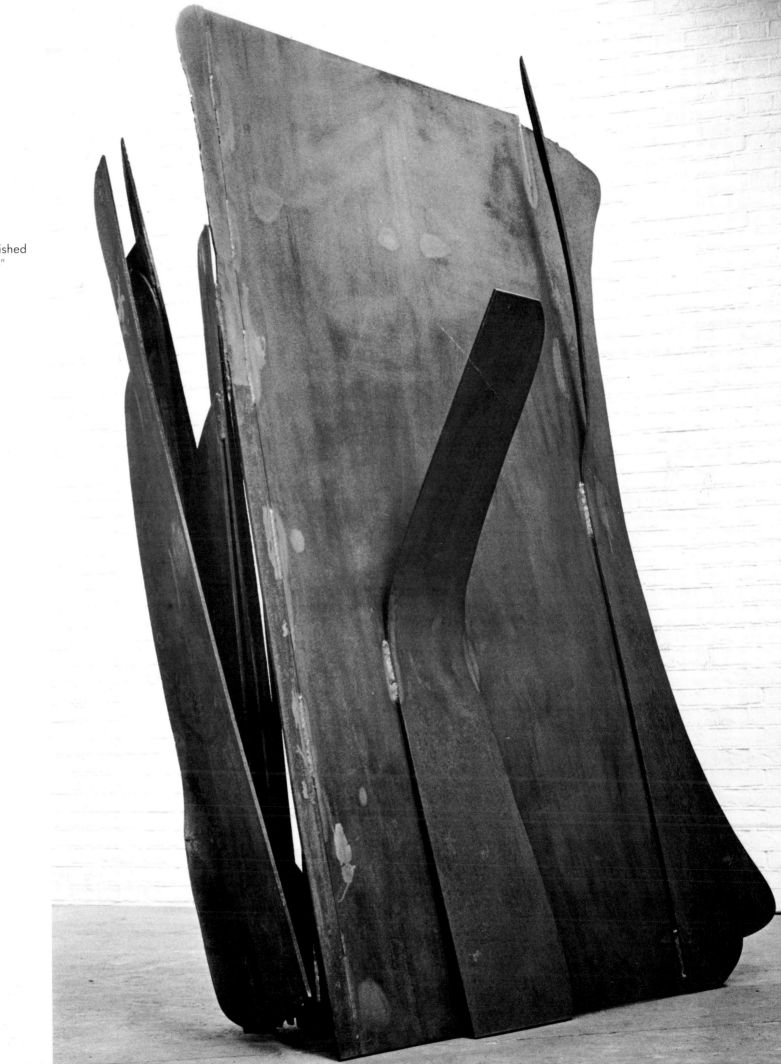

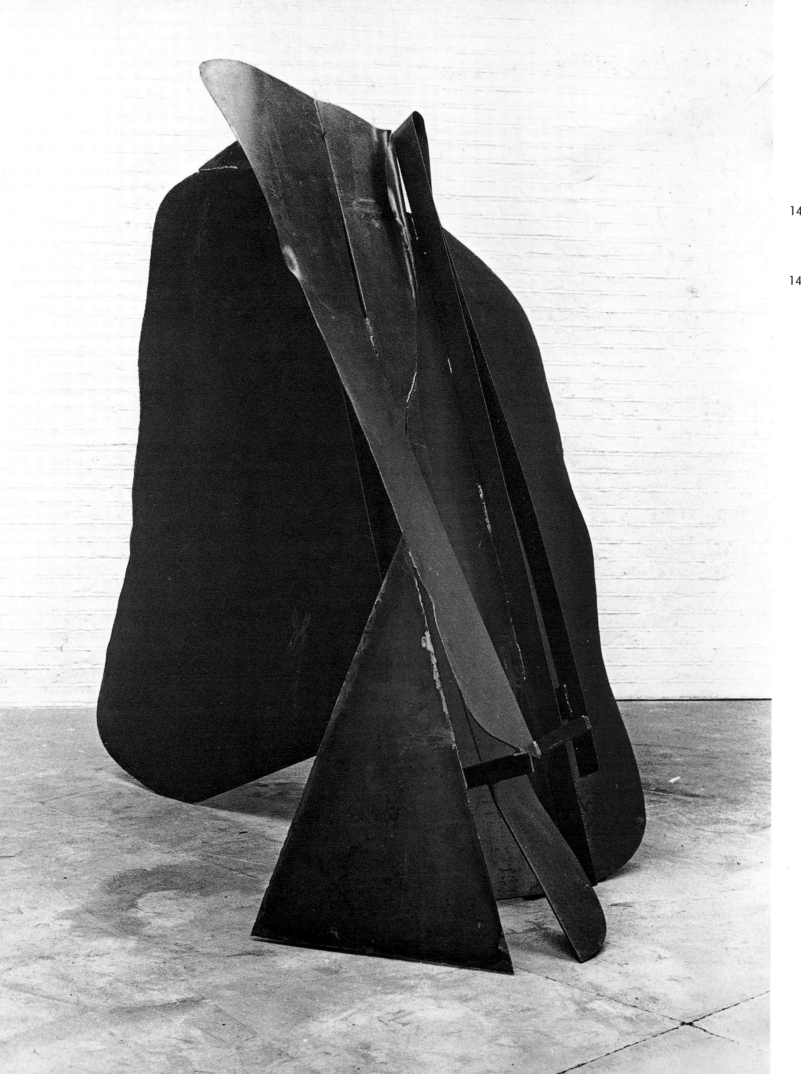

145. *Parade.* 1974
Steel rusted and varnished
7'2" × 4'5" × 8'

146. *Scheherazade.* 1974
Steel rusted and varnished
8'6½" × 13' × 9'.
Private Collection

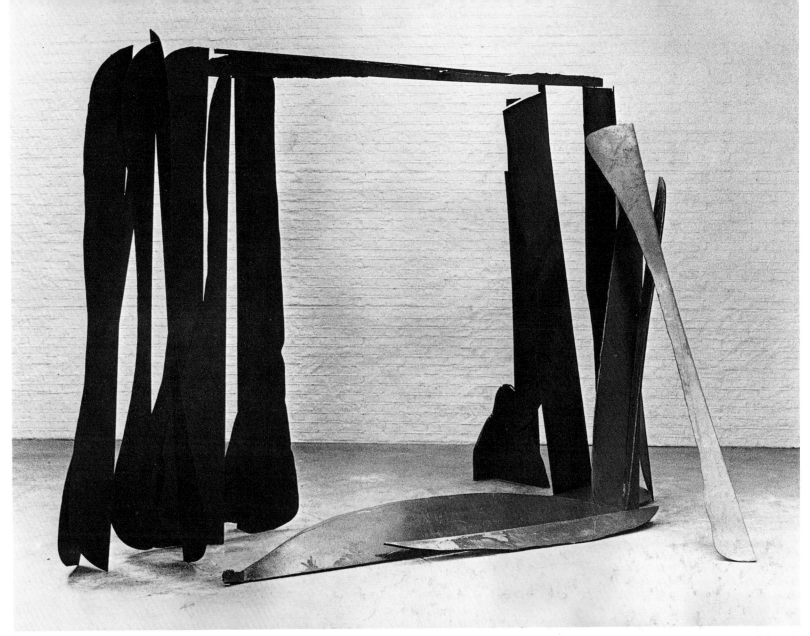

146

Pushframe, Emma Dipper, Emma This, and *Emma That* (pls. 230, 231, 232, 233). Whereas he had employed convex and concave arcs, and maintained the curves of the internal configurations in the external contours of the table pieces, Caro uses both curved and straight elements in the Emma Lake sculptures and varies their silhouettes accordingly. As a result, the new works are less constrained, more energized and dynamic, and therefore lend themselves to the large scale as closed constructions would not.

The dynamism and symmetry of the Emma Lake sculptures make them appear more discursive, far less "composed" than many of the table pieces or earlier large works such as *Orangerie, Georgiana,* and *Sun Feast,* although they are as carefully and consciously ordered. In the Emma Lake series, Caro concentrates primarily on describing volume with line, whereas he had previously been more concerned with disposing flat shapes in relatively shallow space. For the most part he articulates space with rods, channels, tubes (his occasional use of rectangles, triangles or L-shaped channels, as in *Emma This*

147

148

149

147. *Overtime Flat.* 1974. Steel rusted and varnished
9'11" × 6' × 6'9"

148. *Scorched Flats.* 1974. Steel rusted and varnished
2'5" × 19'4" × 11'10"

149. *Surprise Flat.* 1974. Steel rusted and varnished
10' × 10' × 12'2"

150. *Criss Cross Flats.* 1973--74. Steel rusted
and varnished. 9'5" × 13' × 4'3½"
Fine Art Building, York University, Toronto

151. *Toronto Flats.* 1973--74. Steel rusted and varnished
10'10" × 6'3" × 9'11"

and *Emma That*, represents a reversion to earlier for-
mulations). Occasionally, Caro attempts to create a
space that is too explicitly pictorial: in *Emma Lake*
(now destroyed), for example, he used a picture
frame at the front and a circle at the back which
rigidly demarcated space and interrupted its free
flow. But the tenuous balance is magical, the tracery
in space enchanting in other works in the series such
as *Emma Dance, Emma Pushframe,* and, to a lesser
extent, *Emma Dipper.*

In 1978 Caro invented a new format for drawing in
space, a series of writing pieces, a variation on the
table pieces, which he exhibited in London in the fall

150

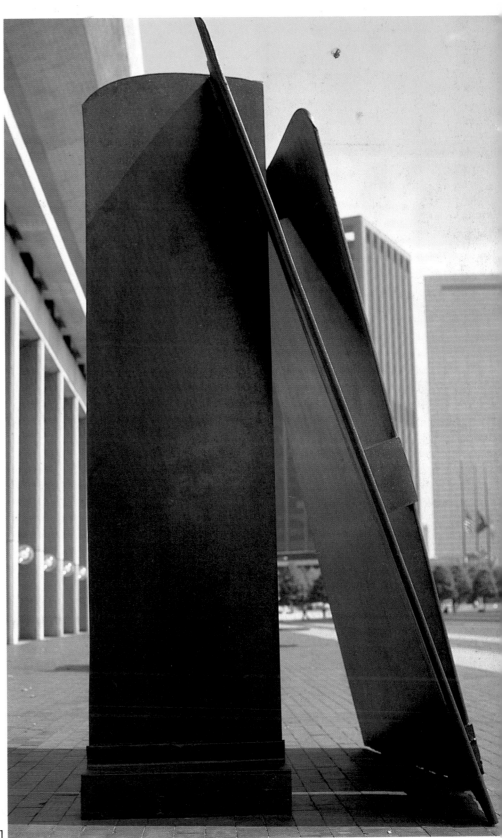

151

152. *Back Cover Flat*. 1974. Steel rusted and varnished. 5'11" × 8'2" × 2'6"

of this same year. Once again found objects are incorporated: wrenches, handsaws, pliers, bolts, compasses proliferate. And like much of his work since 1974, his small pieces sit on top of tables, much as the larger sculpture rests directly on the ground. Most unusual is the reintroduction of color. This color is handled sparingly—the artist's wife, the painter Sheila Girling, paints some areas and uses polish commonly used to blacken grates on others; still other areas are allowed to rust. Miróesque shapes punctuate and enhance these spontaneous little structures: humor, fantasy, and sheer delight abound.

Collage plays a more important role than ever before in a group of works in progress since 1977: here

153. *Dominion Day Flat.* 1974. Steel rusted and varnished. 7'6" × 14'3" × 6'. Private Collection

154. *Sunday Flats.* 1974. Steel rusted and varnished. 6'1" × 13'7" × 3'2". Private Collection

155. *Double Flat*. 1974. Steel rusted and varnished. 7′ × 15′6″ × 3′9″

156. *York Flat.* 1974. Steel rusted and varnished. 7'6" × 19'1" × 4'10"

157. *Northside Flat*. 1974. Steel rusted and varnished. 6'10" × 14'3" × 4'5". Private Collection

found objects cast in bronze are combined by welding with bronze plates and bars. *Buddha Peach*, 1978 (pl. 245), a construction of storage jars cast in bronze and sections of flat bronze sheets, typifies the series. In contrast to much of Caro's earlier work, which tended to be frontal, organized in relation to a "picture plane," *Buddha Peach*, like the other members of the series, should be viewed from a number of vantage points. The sculpture unfolds in three dimensions as the viewer moves around it, as each viewpoint reveals a different face, recalling the simultaneity of analytical Cubism. In this respect and others Caro appears to be returning to some of the issues he confronted in his figurative sculpture of the mid-fifties. Once again he investigates mass and volume, now, however, without sacrificing the integrity of the plane or the spaces around and between sculptural units. In *Buddha Peach*, for example, we are made equally aware of the massive cluster of forms resting on bronze legs as of the space beneath these forms.

158. *Trunk Flat.* 1974. Steel rusted and varnished. 7'9" × 14'4" × 1'10"

Although these recent pieces are generally dense in configuration and massive in feeling, they are relatively small: none exceed human scale, most are no more than three feet high and many are little table-top pieces. Although they are compact and squat, they do not hug the ground and therefore do not resemble the earlier low-lying works. Despite their feeling of weightiness, these sculptures do not seem monumental, for Caro's unerring sense of appropriate size and his ability to communicate scale precisely is equivalent to his exquisite sensitivity to the nature of materials. Bronze is both a traditional and a sumptuous material, but Caro approaches it as if it were neither. Instead of polishing the metal in a conventional man-

159. *Square Feet Flat.* 1974. Steel rusted and varnished. 9'2″ × 9'3″ × 3'8″

160. *Riviera*. 1971–74. Varnished steel
10'7" × 27'1" × 10'. Private Collection

161. *Cocaine*. 1972–73. Steel
2' × 13'4" × 2'6".

160

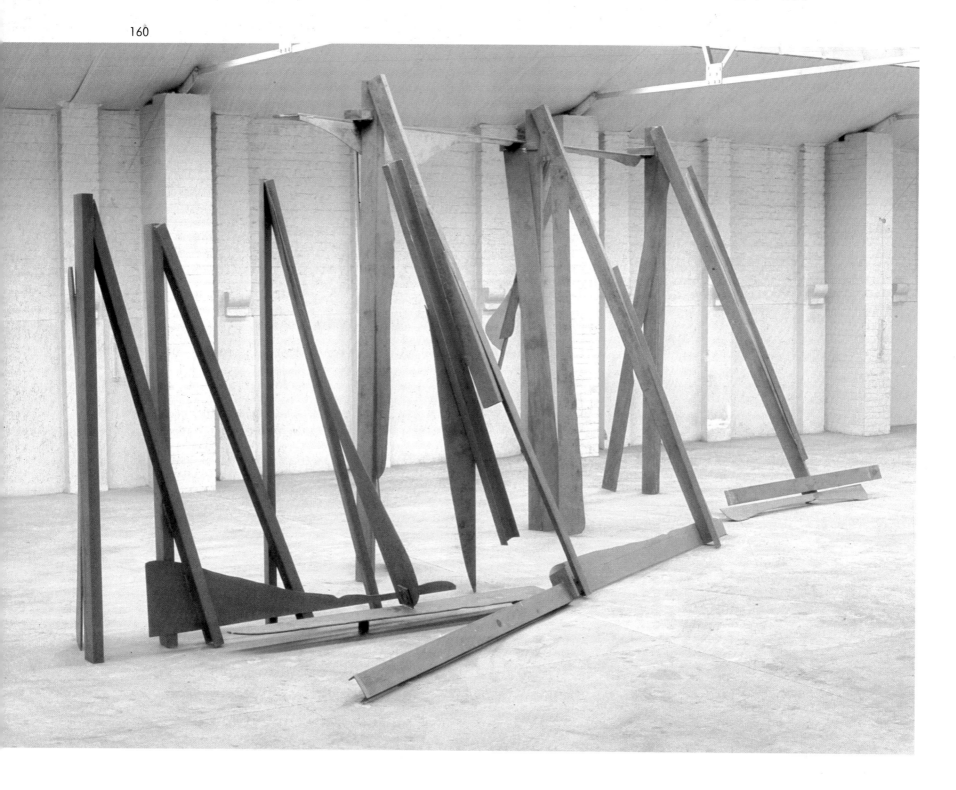

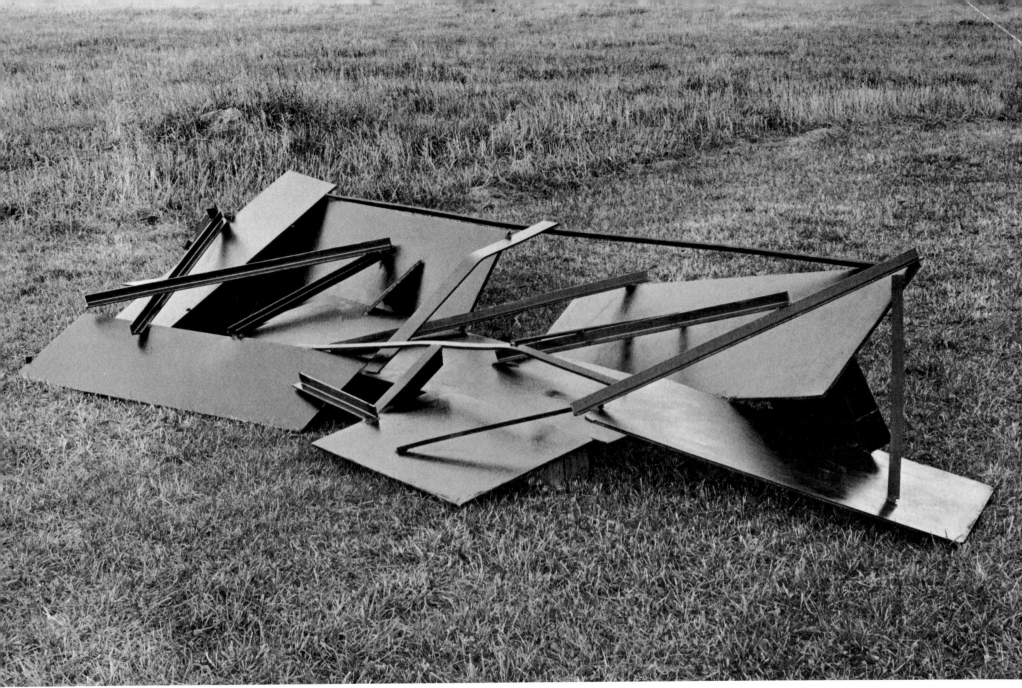

161

ner he leaves it in its rough, natural state. Therefore the eye does not slide over Caro's surfaces as it would over the smooth exterior of a Brancusi *Bird in Space*, for example. As a result, Caro slows down the process of viewing, encouraging us to explore every nook and cranny, every weld, every curve, every angle; the more one explores, the more one discovers and thus the viewing experience is immeasurably enriched.

Sculptures such as Brancusi's simplified abstrac-

tions, Tony Smith's cubes, or Judd's stacks, are conceived as self-contained objects; they are apprehended as totalities. By contrast, the experience of viewing a Caro is not holistic; his constructions can be comprehended only through prolonged viewing, through the study of individual parts and the gradual synthesis of these elements. Only by dissecting and reassembling the image are we able to grasp it as a unified whole.

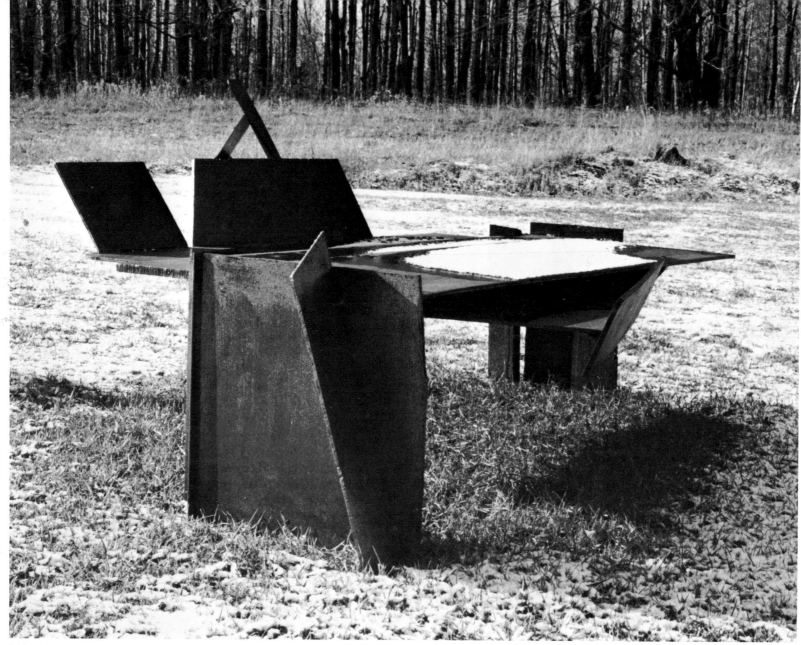

162. *Survey*. 1971–73. Steel rusted and varnished. 2'5" × 7'2" × 5'9½". Private Collection

Unquestionably, in working with a traditional material like bronze, Caro has referred to traditional sculpture. Interestingly, Donatello is perhaps the sculptor Caro most admires and comparison of a recent Caro bronze with a Donatello, reveals a number of parallel concerns. Although Donatello portrays a subject drawn from nature, his sculpture is far from simply representational; he considers abstract problems which Caro also addresses, such as the measure and balance of forms, the nuance of surface and texture, and the way static forms create an active space around them. It is undeniable that Caro has been inspired by Donatello, but he has also been inspired by more recent sculpture, such as that of Gonzalez. It is equally undeniable that he has not violated his own aesthetic, as works like *Buddha Pear* and *Buddha Lemon* (pls. 247, 246) make abundantly clear. In both sculptures Caro uses forms he has employed before—certain curves, arcs, fan-like shapes, discs, and ovals are reminiscent of works of the late

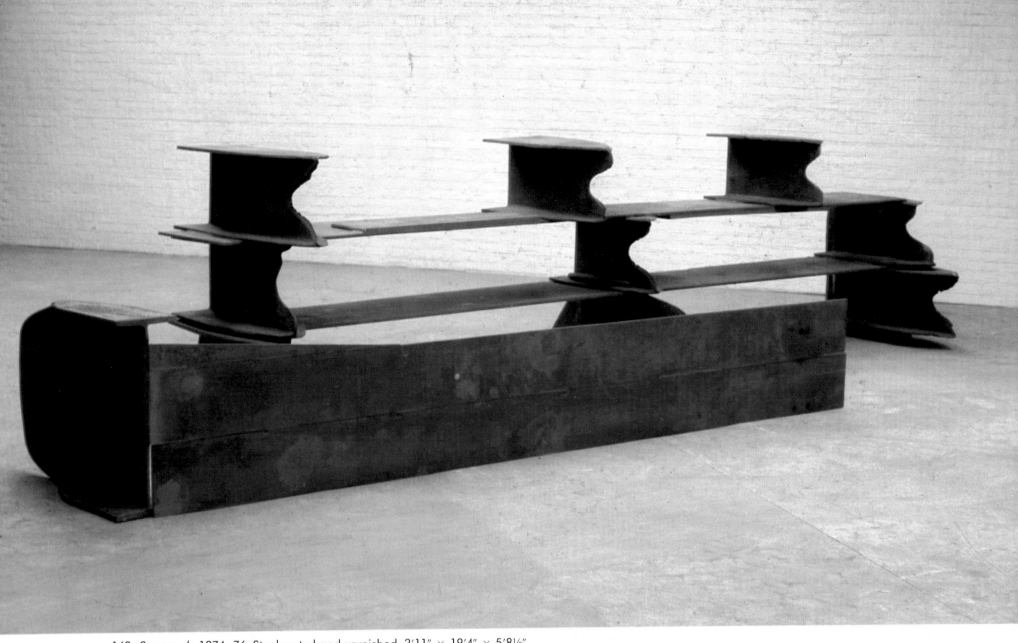

163. *Savannah.* 1974–76. Steel rusted and varnished. 3'11" × 19'4" × 5'8½"

sixties such as *Orangerie, Sun Runner,* and *Georgiana,* while I-beams, Zs, zigzags, and L-shapes recall the sculpture of the early sixties. However, as always, the characteristics of Caro's forms are dictated by the particular nature of his materials, and thus the squat and chunky shapes of this series are peculiarly appropriate to bronze, rather than to the steel of the preceding decade.

In other examples of the series, such as *Bonanza* and *Black Raspberry Marble* (pls. 250, 251), Caro holds rounded shapes and flat rectangular planes in an effective tension. As in Cubist collage, the curved forms act as transitions between the planes. This resemblance to Cubist collage is especially striking in reproductions, where the sense of texture, weight, and three-dimensionality is mitigated. *Ice-House* (pl. 252), comprising a vertical rectangular plate, two V-shaped units serving as legs, numerous plates of regular and irregular configuration which form a table-like element, several bowls cast in bronze, and a

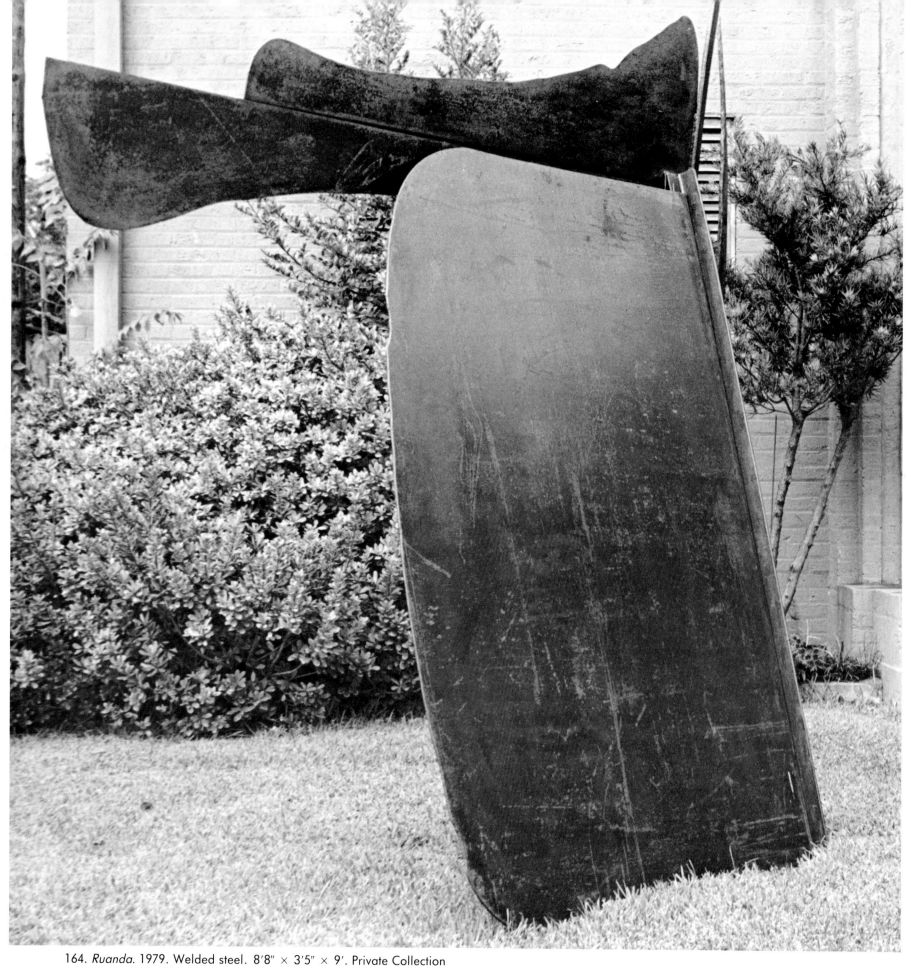

164. *Ruanda.* 1979. Welded steel. 8'8" × 3'5" × 9'. Private Collection

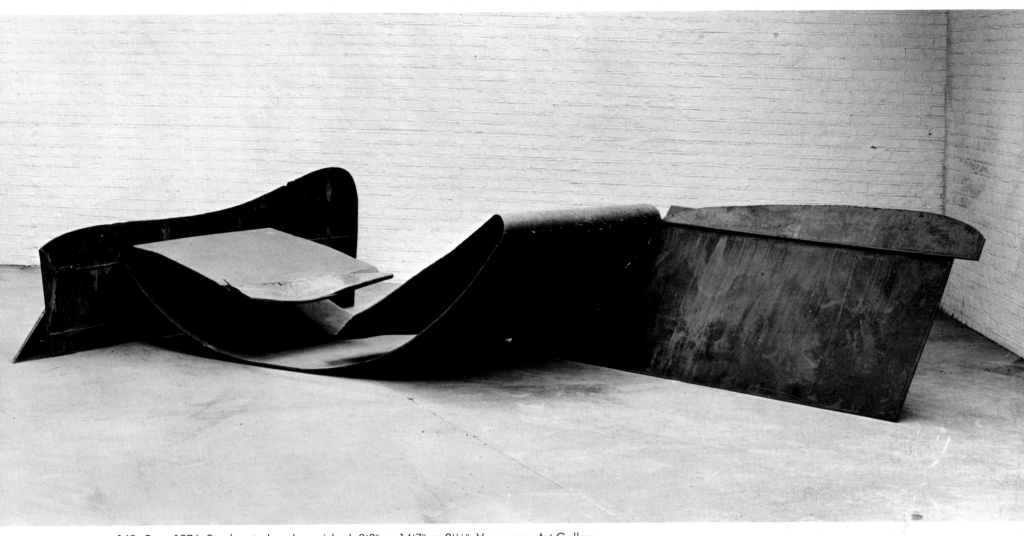

165. *Bow.* 1974. Steel rusted and varnished. 3'3" × 14'7" × 9'1/2". Vancouver Art Gallery

few dramatically placed circular shapes, is more complex than other sculptures of the series. A complex but highly organized totality, it is the most abstract of the constructions in this group because Caro has disguised the identity of the bowls, making them difficult to recognize. Like the other recent works under discussion, *Ice-House* is a unique statement, classifiable as part of a series only in that it shares with the other works similar components and the use of bronze. Nonetheless, it is as rewarding to compare

these sculptures to one another as it is to experience their individual characteristics in isolation. It is also fascinating to view them in relation to the contemporaneous writing pieces, in which Caro also incorporates space but in a very different manner.

In 1977 Caro was commissioned to execute a sculpture for the new wing of the National Gallery in Washington, D.C. The architect, I.M. Pei, envisioned the East Wing as both foil and complement to the marble Beaux-Arts structure of the main building.

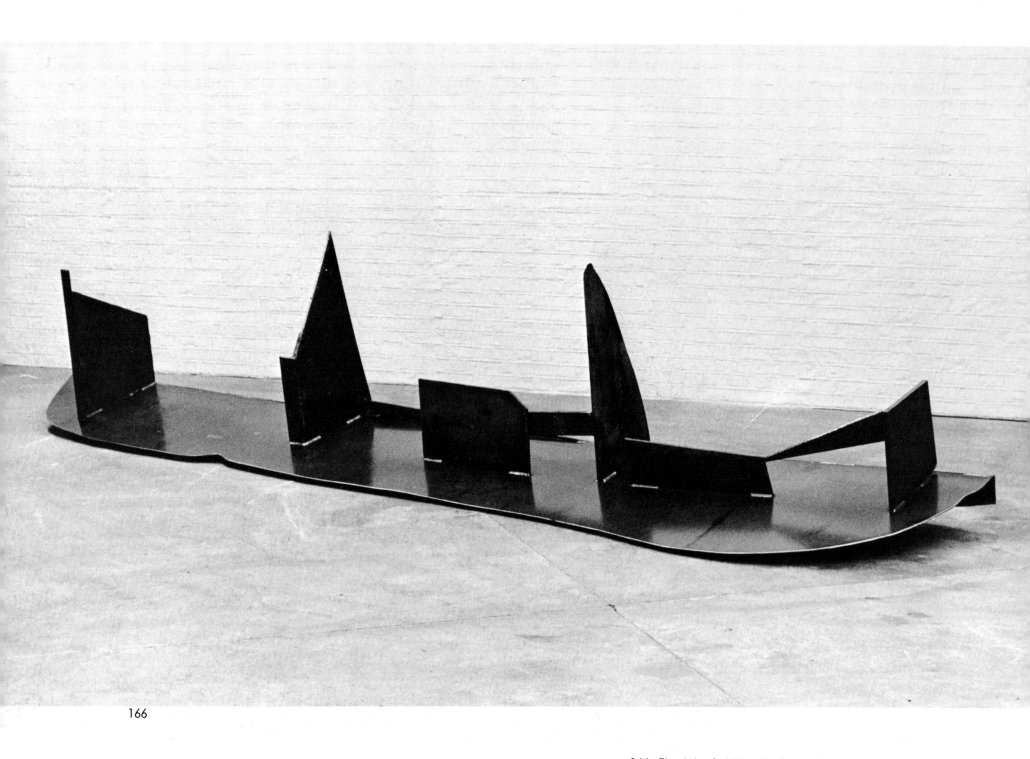

166

166. *First Watch*. 1974. Steel rusted and varnished
3'5" × 3'6" × 15'8". Private Collection

167. *Curtain Road*. 1974
Steel rusted and varnished. 6'6" × 15'8" × 9'1"

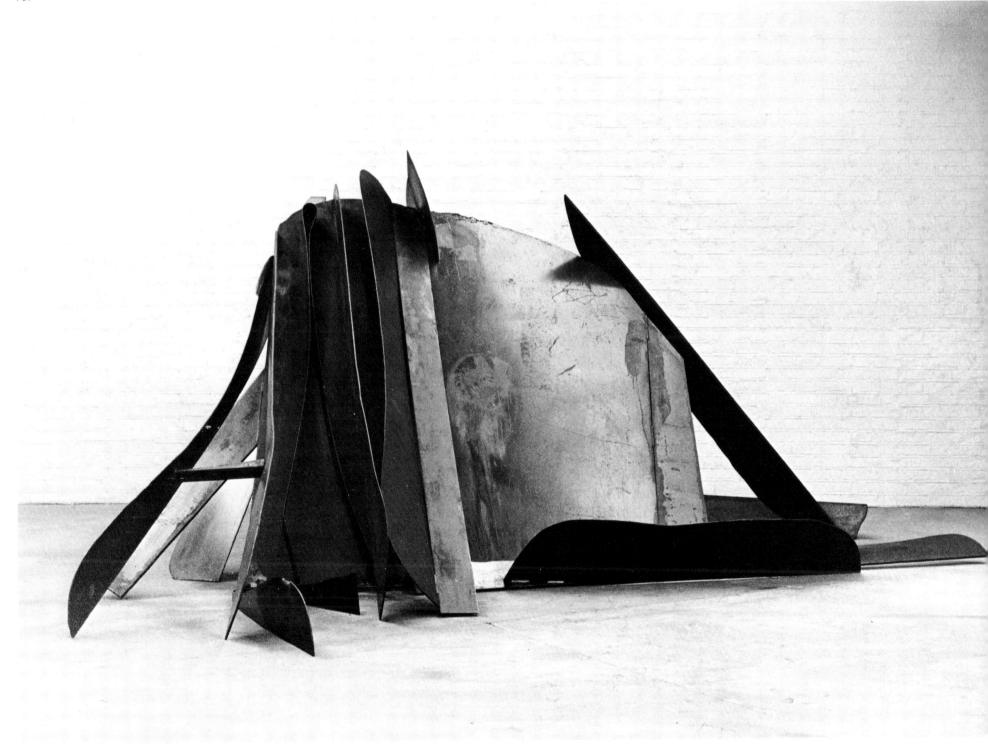

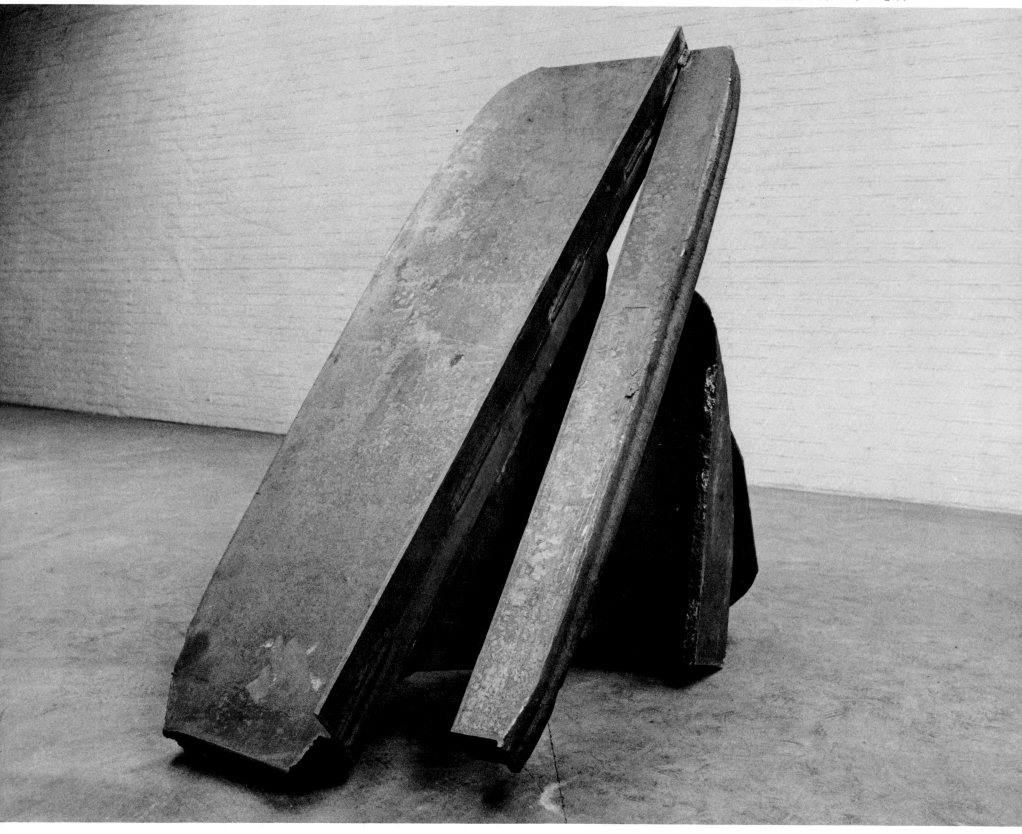

168–169. *Caramel*. 1975. Steel. 4'10" × 5' × 2'11"

138

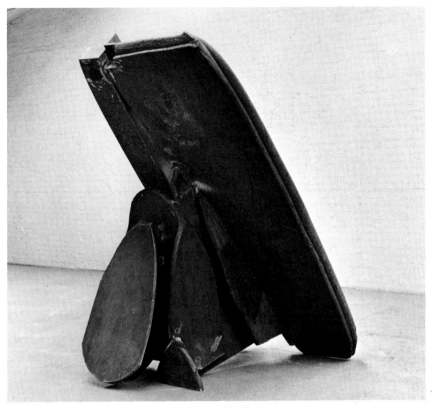

169

Pei's design consisted of a structure notable for its diagonal rather than rectangular plan, for its vast open concourses and imposing vistas, and for its precious materials. In concept and design it could not have seemed less suitable for the intimate—if imposing—sculpture for which Caro was noted. Unfazed, Caro set about creating a new work for the new space—a shelf carved into the marble interior —offering the viewer a sighting of the work from several vistas (pls. 289-298).

Although Caro had done much preparatory work at home in London, work began inside the building (it is only on site that scale can properly be grasped) on February 14 of 1978 and was completed that same year. Caro was aided in the construction by a crew

that consisted of James Wolfe and Bill Noland and welders Carlos Mata and Mark Johnson. Like most of his previous sculpture, the ledge piece was a triumph of precise planning and inspired improvisation. Caro overcame the small space with a work that competes with the grandiosity of the building and more than holds its own with several other larger, decidedly more rhetorical works. Caro articulated the delicate tracery that was to characterize his writing pieces, while taking into account the particular nature and scale of the new space. By a process of gradual elimination, alteration, and refinement, Caro altered the configuration of the work so radically that it scarcely bore any resemblance to the initial conception. At issue was the real effect of the space on the

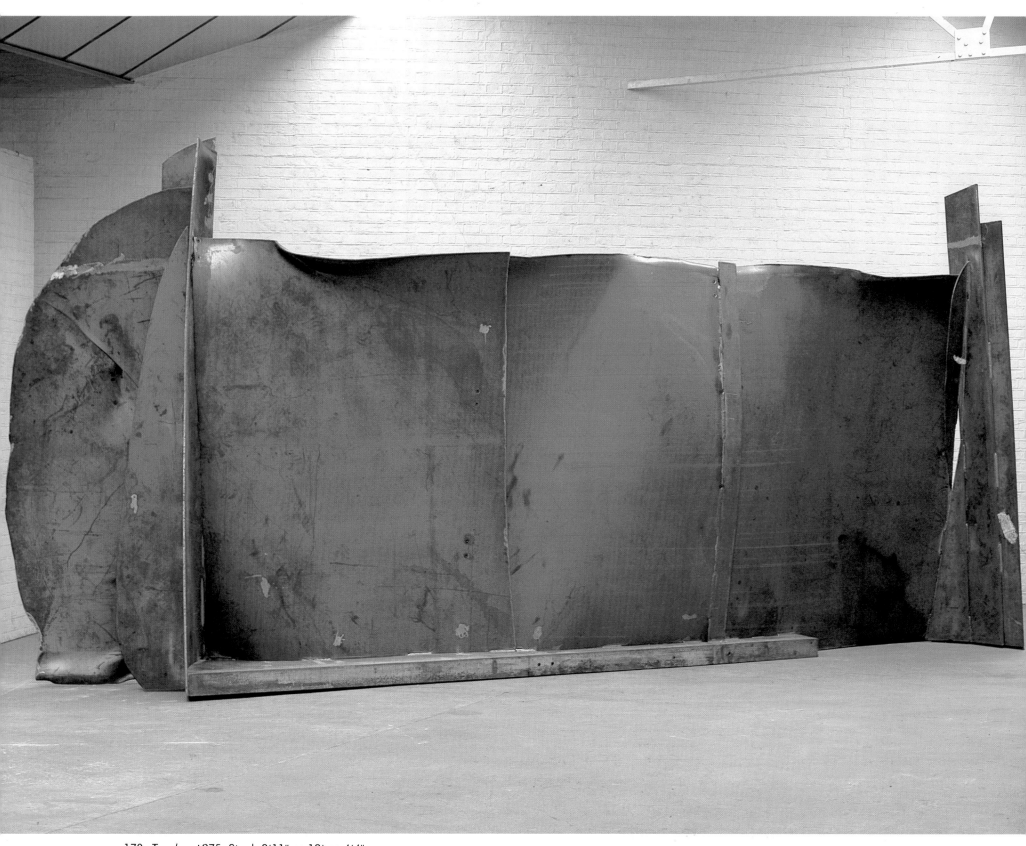

170. *Tundra.* 1975. Steel. 8'11" × 19' × 4'4"

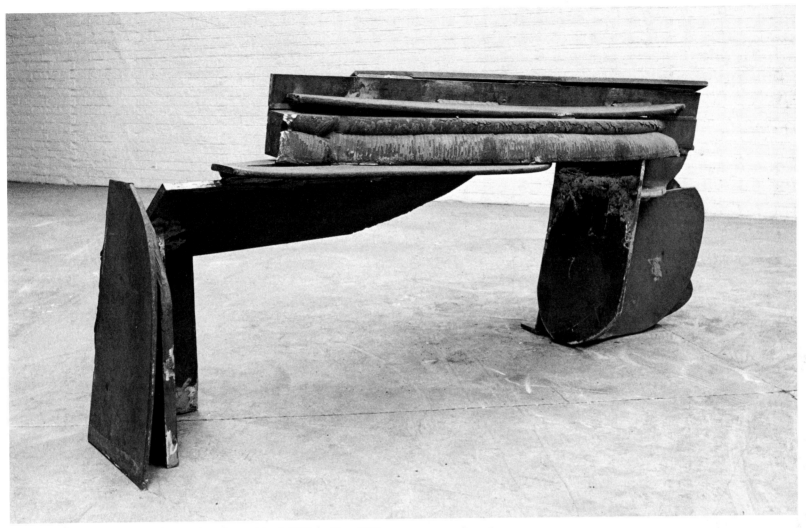

171. *Frangipane.* 1975. Steel rusted and varnished. 2′8″ × 7′ × 2′2″

work, an effect which Caro could not determine until he actually experienced it. The final version has a cohesiveness, a play of massed elements and open spaces that makes both a difficult space and the sculpture itself come alive. The result is yet another extension of his seemingly boundless ingenuity.

Like his friend and colleague, Kenneth Noland, Caro has been concerned with formalist issues central to the most advanced abstract sculpture and painting of our time. Caro's sculpture has extended the nature of steel, tested gravity and balance and weightlessness, and expanded the very concept of what sculpture is about. His inspired example has set a standard for numerous younger artists working in Britain and the United States. In his extraordinary accomplishment Caro has affirmed his belief that the more sculpture speaks to us of material and process, structure and space, the less it becomes an appendage of the real world, the more it informs and enhances our experience of life.

Notes

1. Unless otherwise noted, statements by the artist are extracted from an interview with Noel Channon that was broadcast in Great Britain on Granada Television in September 1974.

2. Taylor, Basil: "Art," *The Spectator*, September 2, 1955.

3. Sylvester, David: "Round the London Galleries," *The Listener*, September 1, 1955.

4. Tuchman, Phyllis: "An Interview with Anthony Caro," *Artforum*, New York, June 1972, p. 56. (Reprinted in Richard Whelan, *Anthony Caro*, Harmondsworth--Middlesex, Penguin, 1974, pp. 115--131.)

5. Alloway, Lawrence: "Interview with Anthony Caro," *Gazette*, London, no. 1, 1961.

6. William Tucker: *The Language of Sculpture*, Thames and Hudson, London, 1974, p. 56.

7. Mullins, Edwin: "Art," *Sunday Telegraph*, London, November 7, 1965.

8. Russell, John: "The Man Who Gets There First," *Sunday Times*, London, October 31, 1965.

9. Herrera, Hayden: "Anthony Caro," *Art News*, New York, May 1974, pp. 92--95.

10. Feaver, William: "Anthony Caro," *Art International*, Lugano, May 1974, pp. 24--25, 33--34.

PLATES

172

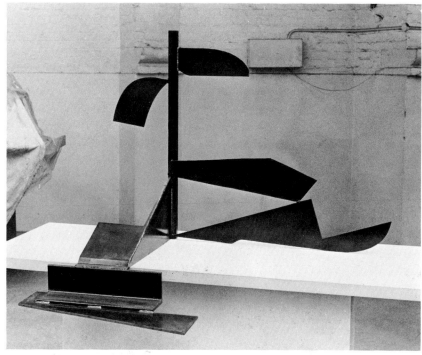

173

174

175

172. *Table Piece CVI*. 1971. Varnished steel.
3′7″ × 4′8″ × 3′4″

174. *Table Piece CLXVIII*. 1973–74. Varnished steel.
4′1″ × 2′6″ × 1′6″. Private Collection

173. *Table Piece CXVI*. 1973. Steel rusted and varnished.
2′8″ × 3′ × 2′1½″ Private Collection

175. *Table Piece CXVII*.1973. Steel rusted and varnished.
1′2″ × 3′11″ × 2′5″

176. *Table Piece CXXXIX*. 1973. Varnished steel.
8″ × 5′8″ × 1′10½″. Private Collection

178. *Table Piece CLVI*. 1973. Varnished steel.
1′4″ × 1′10½″ × 5′1″

177. *Table Piece CLXII*. 1973. Varnished steel.
1′5″ × 4′4″ × 1′6½″

179. *Table Piece CXIII*. 1973--77. Steel rusted and varnished.
2′5½″ × 1′11″ × 1′7½″. Private Collection

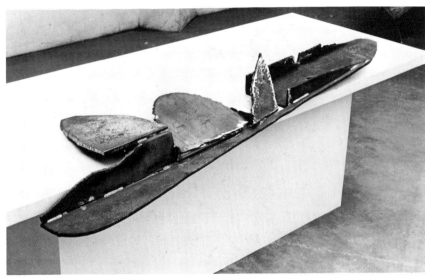

176

177

178

179

180

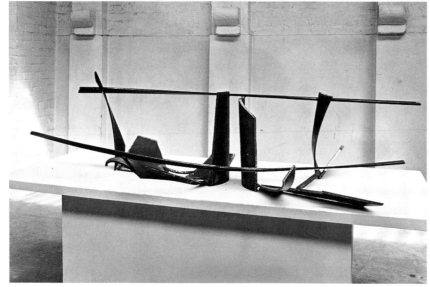

181

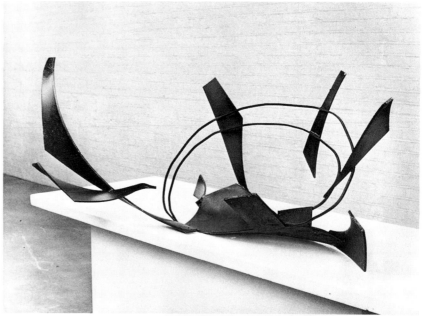

182

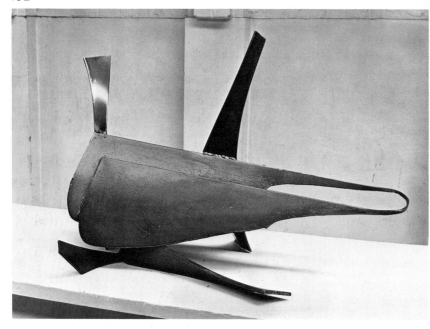

183

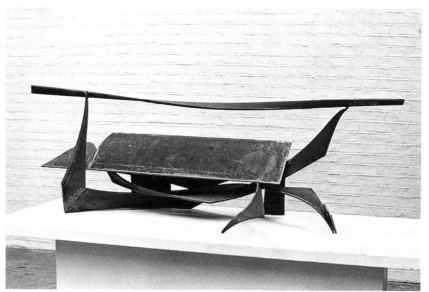

180. *Table Piece CCXVI.* 1975. Steel rusted and varnished
 1'9½" × 6'2" × 3'6"

182. *Table Piece CCXLIII.* 1975. Steel rusted and varnished
 2'6" × 4'2" × 2'3"

181. *Table Piece CCXXXII (The Dance).* 1975. Steel rusted
 and varnished. 2'1½" × 5'10" × 2'8"

183. *Table Piece CCXXXIX.* 1975. Steel rusted and varnished
 1'11" × 6' × 2'5". Private Collection

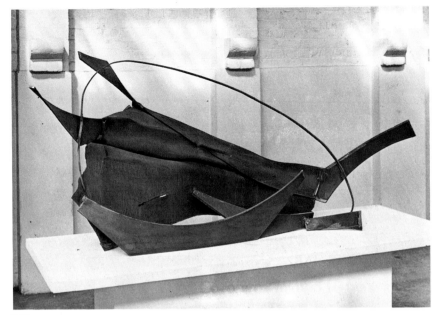

184

184. *Table Piece CCXLVI.* 1975
 Steel rusted and varnished.
 3'2" × 7' × 1×8"
 Private Collection

185. *Table Piece CCLIII.* 1975
 Steel rusted and varnished.
 2'1½" × 5'11" × 2'3"

186. *Table Piece CCXXXIII.* 1975
 Steel rusted and varnished.
 2'1" × 6' × 1'10"

187. *Piece CCLXVI.* 1975.
 Steel rusted and varnished.
 2'8" × 6'9" × 3'9"

188. *Table Piece CCCVIII.* 1976--77
 Steel and sheet steel rusted
 and varnished. 2'2" × 3'9" × 1'5"

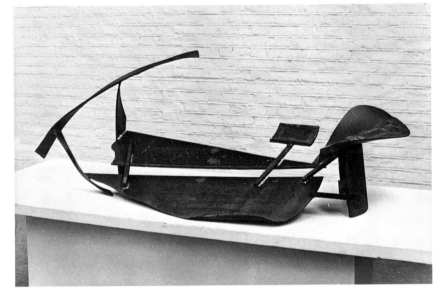

185

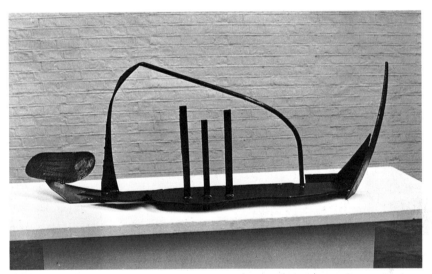

186

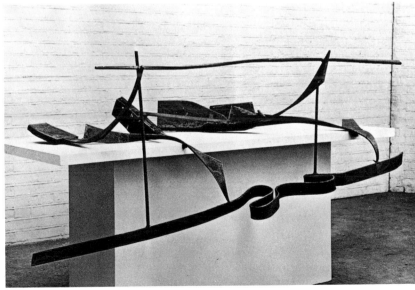

187

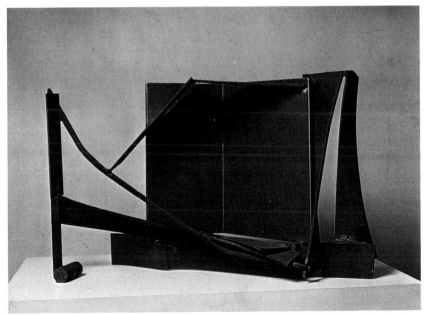

188

189

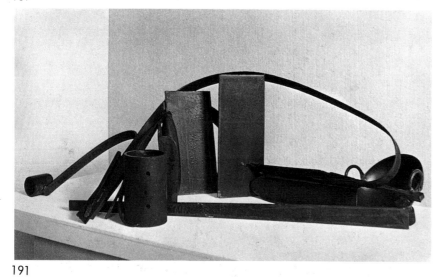

190

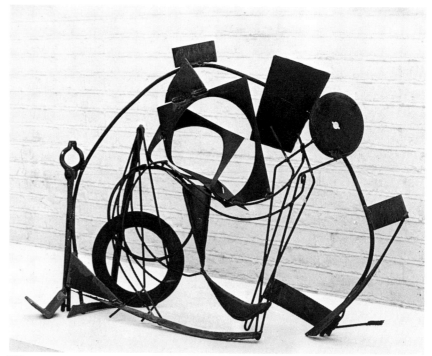

191

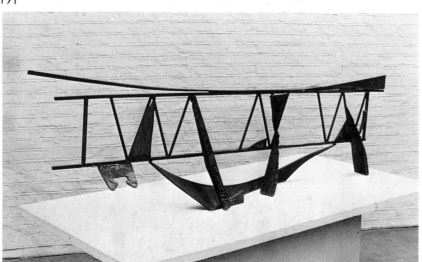

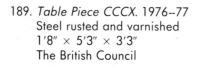

192

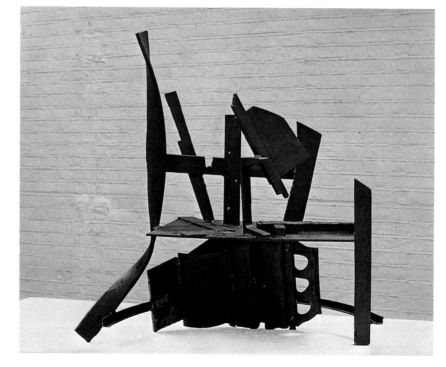

189. *Table Piece CCCX*. 1976--77
Steel rusted and varnished
1'8" × 5'3" × 3'3"
The British Council

190. *Table Piece CCCXIII*. 1976--77
Steel and sheet steel rusted
and varnished. 2'6" × 3'4" × 1'2"
Private Collection

191. *Table Piece CCCLI*. 1976--77
Steel rusted and varnished
2'2" × 6'10½" × 10"

192. *Table Piece CCCLXXIV*. 1977
Steel rusted and varnished
2'10" × 2'9" × 1'10"

193

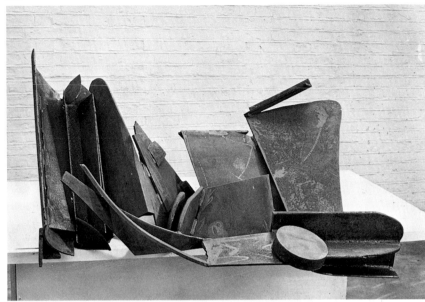

194

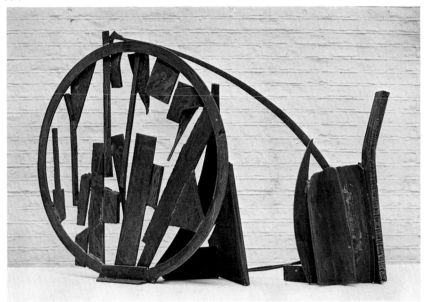

195

196

193. *Table Piece CCCLXVI*. 1977
Steel and sheet steel rusted
and varnished. 2' × 4'2" × 3'5"

194. *Table Piece CCCLXXI*. 1977
Steel rusted and varnished
2'9" × 4'3" × 1'1".
University of East Anglia,
Earlham Hall, Norwich, England

195. *Table Piece CCCLXXV*. 1977
Steel rusted and varnished
1'4" × 3'10" × 2'2"

196. *Table Piece CCCLXXXIII (Oven)*. 1977
Steel rusted and varnished
3'5" × 2'4" × 1'10"

197--198. *Stainless Piece I (Books)*. 1974--75
Stainless steel, painted by Kenneth Noland
10½″ × 1′4″ × 2′3″. Private Collection

199

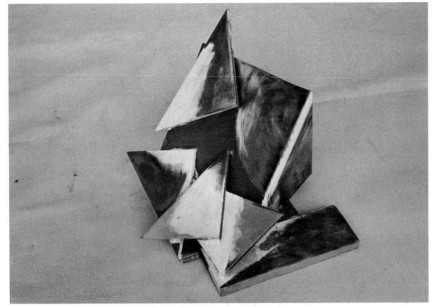

200

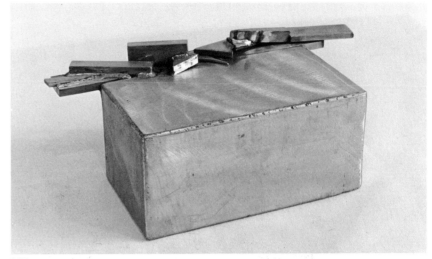

201

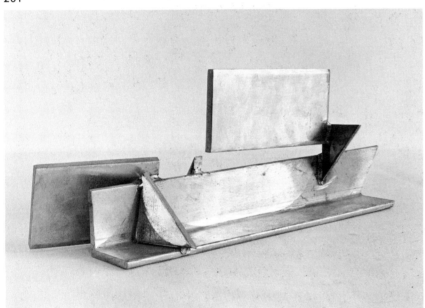

202

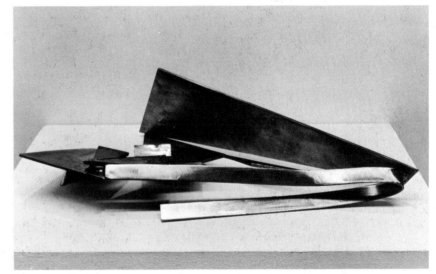

203

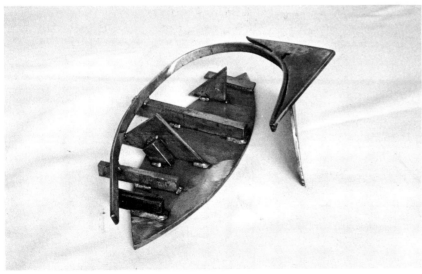

199. *Stainless Piece A.* 1974–75
Stainless steel, painted by Kenneth Noland
11¼″ × 10″ × 1′3½″. Private Collection

200. *Stainless Piece G.* 1974–75
Stainless steel. 7¾″ × 1′8″ × 10½″

201. *Stainless Piece G-G.* 1975–77
Stainless steel. 7¾″ × 1′11½″ × 6⅝″

202. *Stainless Steel Piece H-H.* 1975–77
Stainless steel. 10″ × 2′6″ × 9″

203. *Stainless Piece J.* 1974–75
Stainless steel. 6½″ × 1′6″ × 1′7″
Private Collection

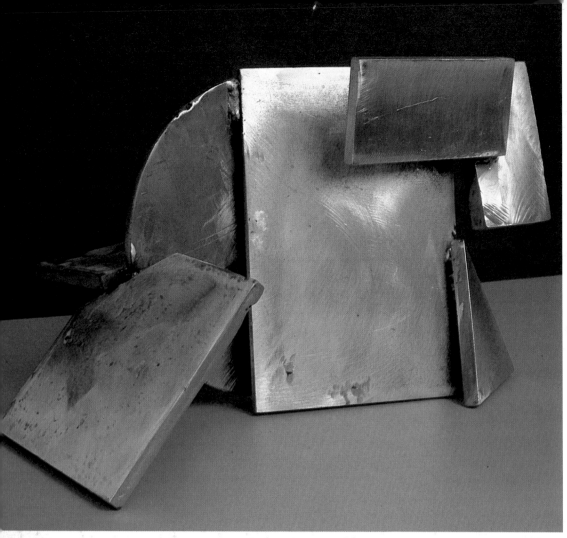

204

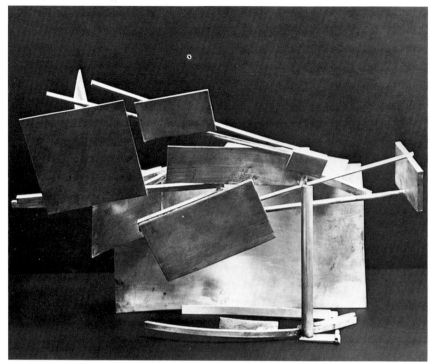

205

206

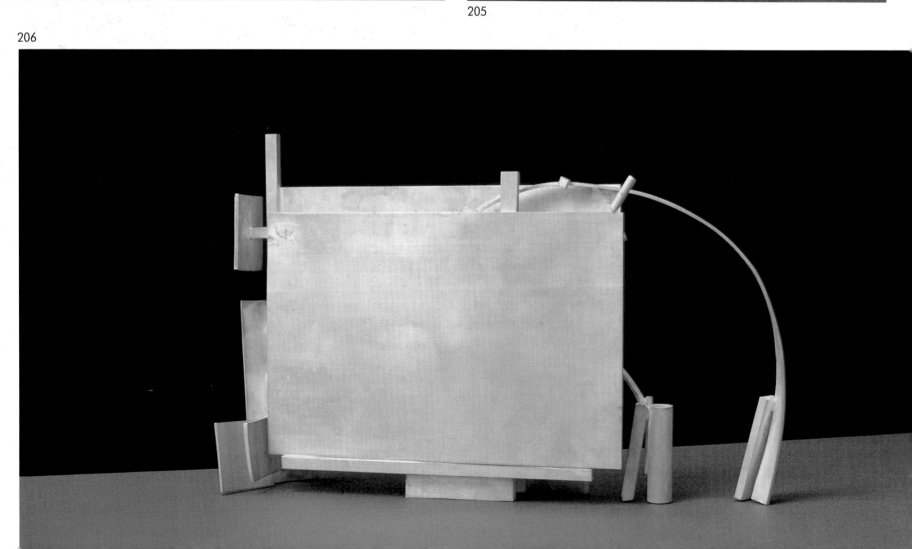

204. *Stainless Piece R--R.* 1977--78
Stainless steel
11½″ × 1′6½″ × 11¼″

205. *Silver Piece 5.* 1976--77
Silver
10⅝″ × 1′5¾″ × 6⅝″
Private Collection

206. *Silver Piece 6.* 1975--77
Silver
10½″ × 1′4½″ × 3½″
Private Collection

207. *Silver Piece 8 (Melon).* 1976--78
Silver
1′3½″ × 1′10½″ × 5″
Private Collection

208. *Silver Piece 9 (Clover).* 1976--78
Silver
9½″ × 1′6″ × 8″

207

208

209. *Can Co. Camelback.* 1976
Stoneware
2'3" × 1'3" × 1'2"

210. *Can Co. Nightwatch.* 1976
Stoneware
2'10" × 1' × 10"

211. *Can Co. Castle.* 1975
Stoneware,
2' × 1'10" × 10"

212. *Jackpot.* 1975–77
Steel rusted and varnished
5'1½" × 4'3" × 4'1"
Private Collection

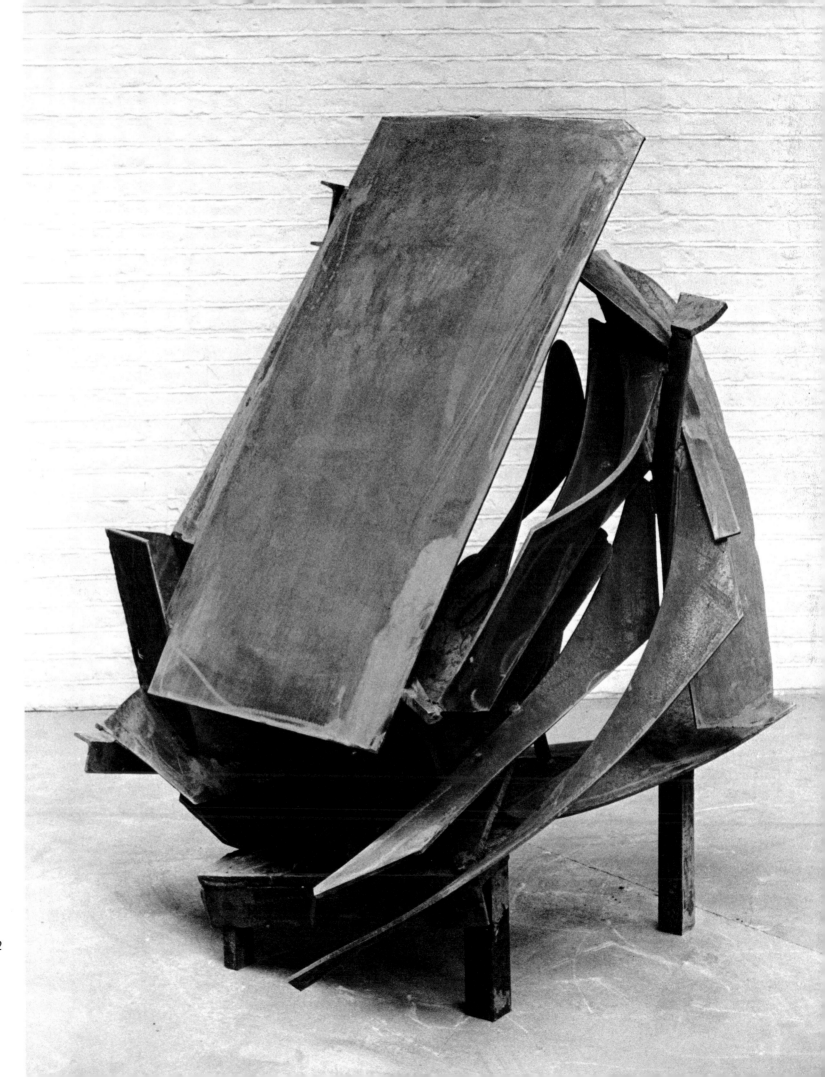

212

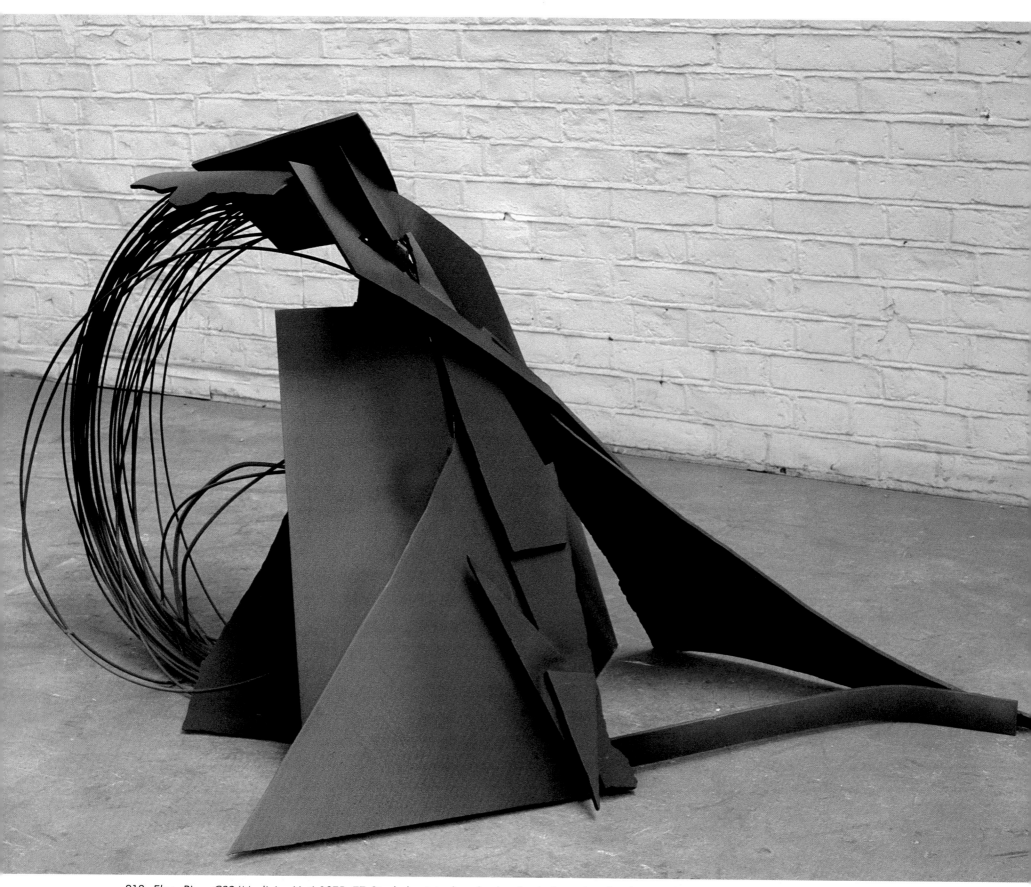

213. *Floor Piece C92 (Medicine Hat)*. 1975–77. Steel, sheet steel, and galvanized wire, painted and sprayed gray. 2'6" × 5' × 3'3"

214. *Chorale.* 1975–76. Steel rusted and varnished. 5'11" × 10'3" × 4'. Private Collection

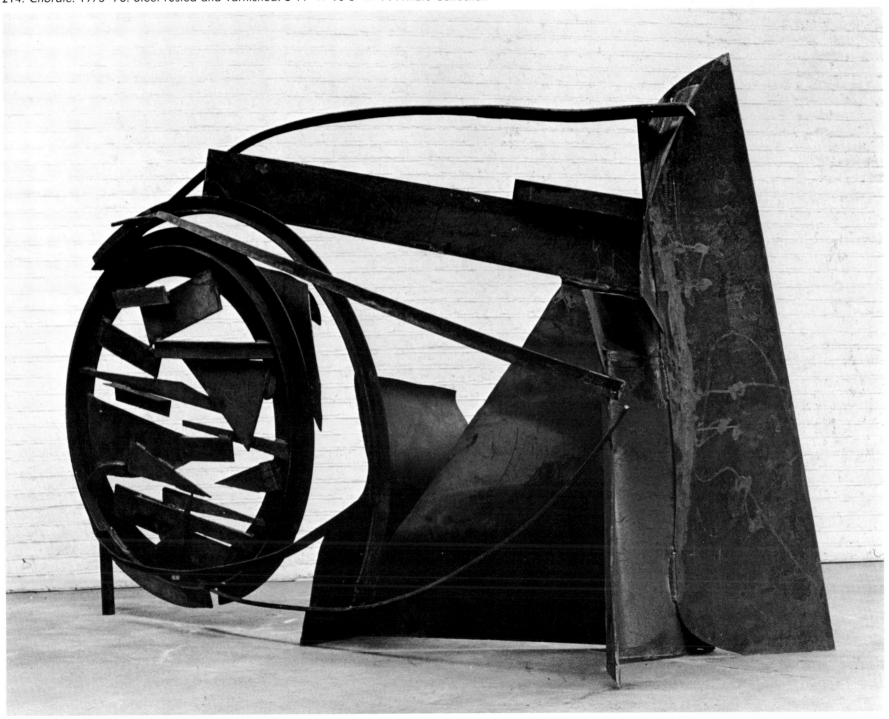

215. *Potpourri*. 1976–77. Steel rusted and varnished. 4'9" × 11' × 8'8". Private Collection

216. *Mousse.* 1975--77. Steel and sheet steel rusted and varnished 3' × 5' × 2'6"

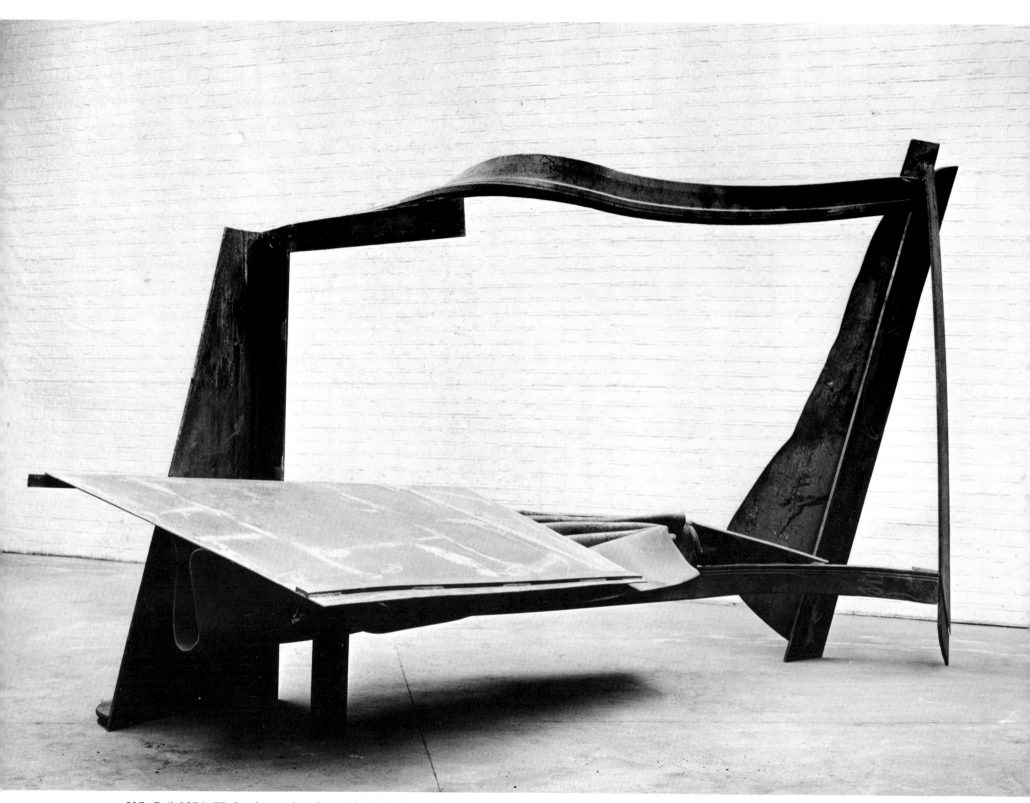

217. *Foil.* 1976–77. Steel rusted and varnished. 6'10" × 13' × 6'6"

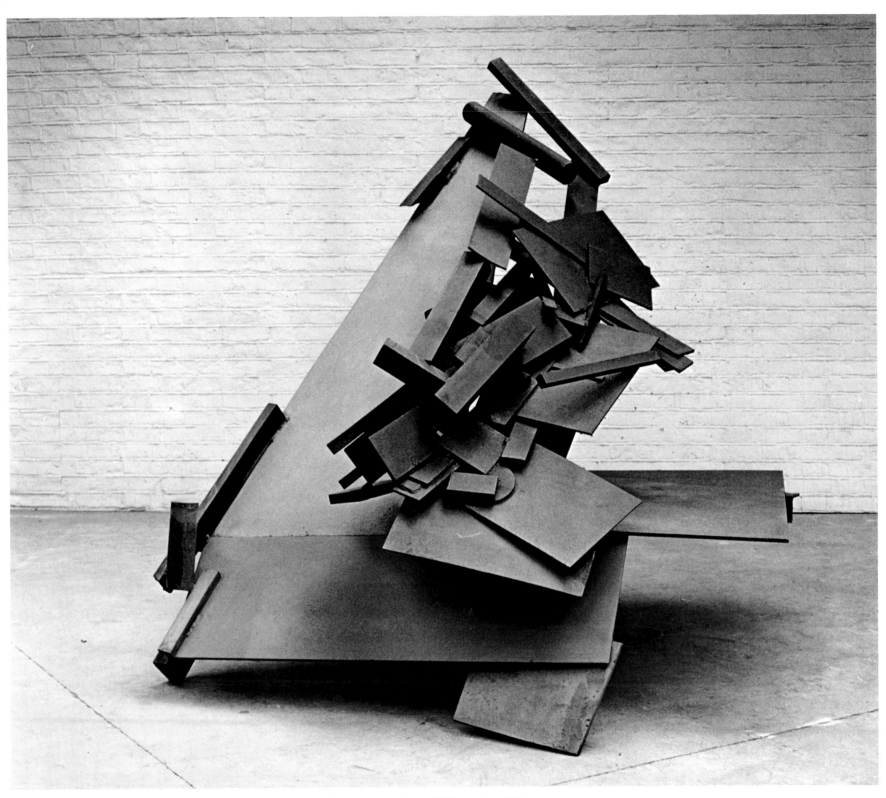

218. *Jericho*. 1976–78. Steel rusted, varnished, and painted gray and yellow. 5'11" × 6' × 5'3"

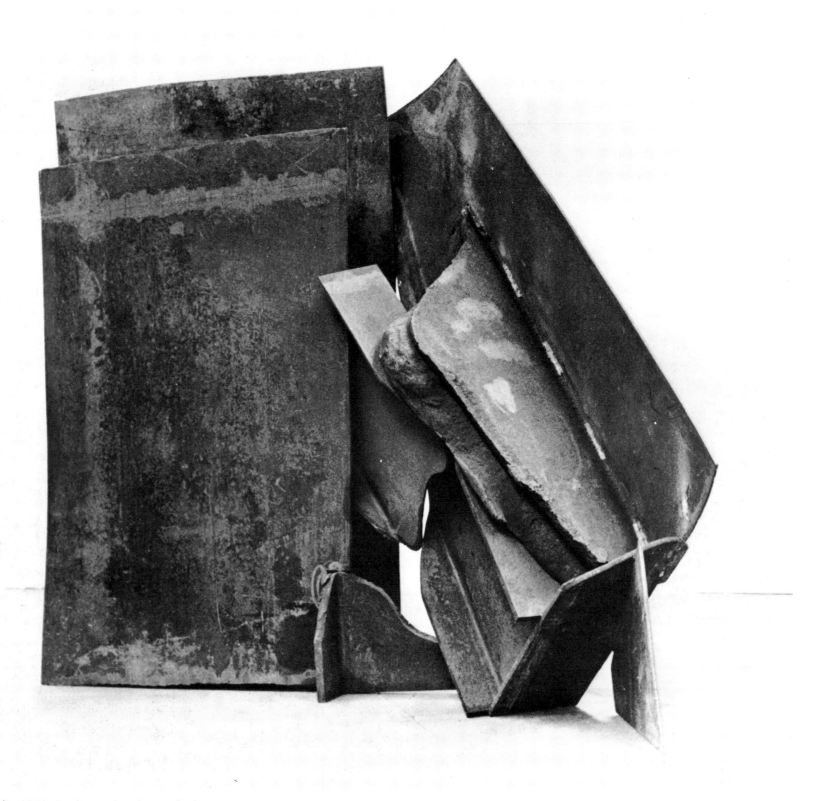

219. *India*. 1976. Steel rusted and varnished. 7'9" × 10' × 5'. Virginia Wright Fund, Seattle

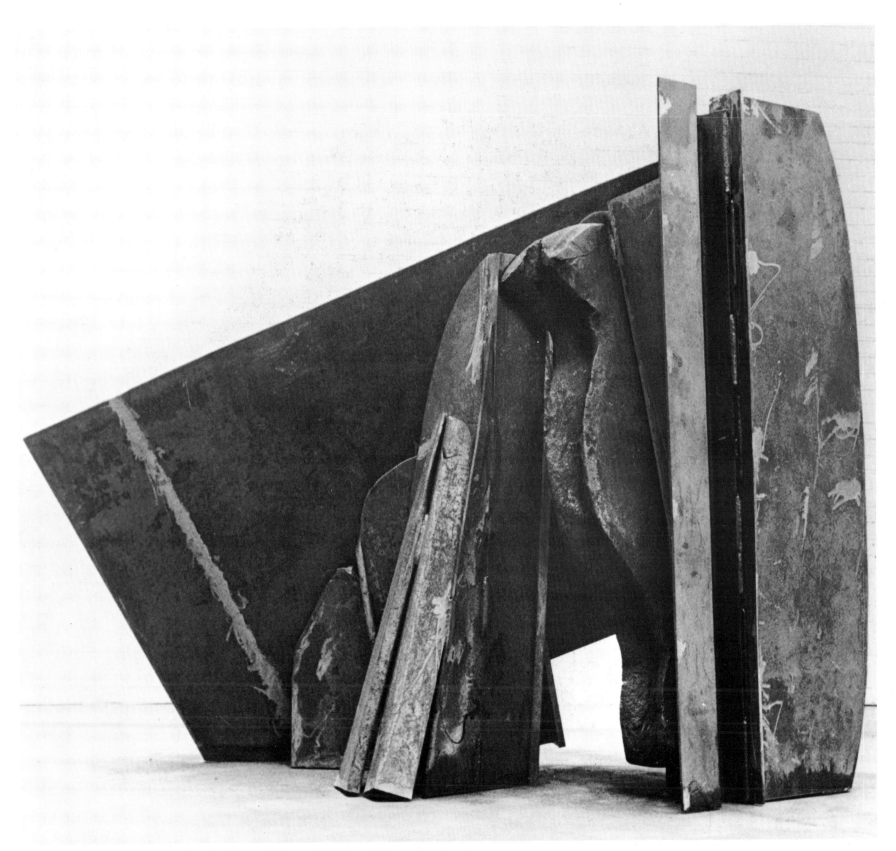

220. *Nectarine*. 1976. Rusted steel. 6'7" × 8'11" × 4'3". New Gallery, Cleveland

221. *Java*. 1976. Rusted steel. 5'5" × 2'11" × 7'2". Private Collection

222. *Cliff Song*. 1976. Steel rusted and varnished. 6'5½" × 11'7" × 4'3"

LIFT

223. *Midnight Gap.* 1976–78
 Steel rusted, varnished, and painted green
 5'11" × 11'10" × 9'2"
 Vancouver Art Gallery

224. *Fathom*. 1976. Steel rusted and varnished. 6'9" × 25'5" × 5'8"

225. *Trot.* 1976–77. Steel rusted and varnished. 2′11″ × 3′10″ × 2′3″

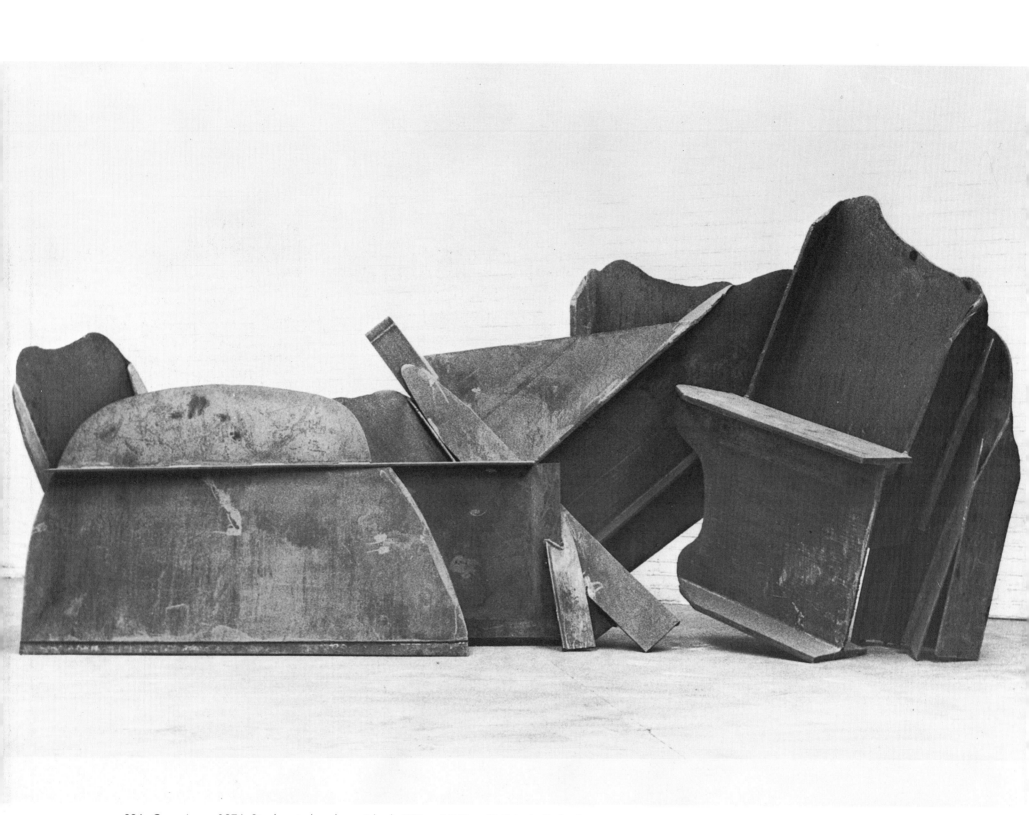

226. *Conspiracy*. 1976. Steel rusted and varnished. 6'9" × 16'6" × 5'. Private Collection

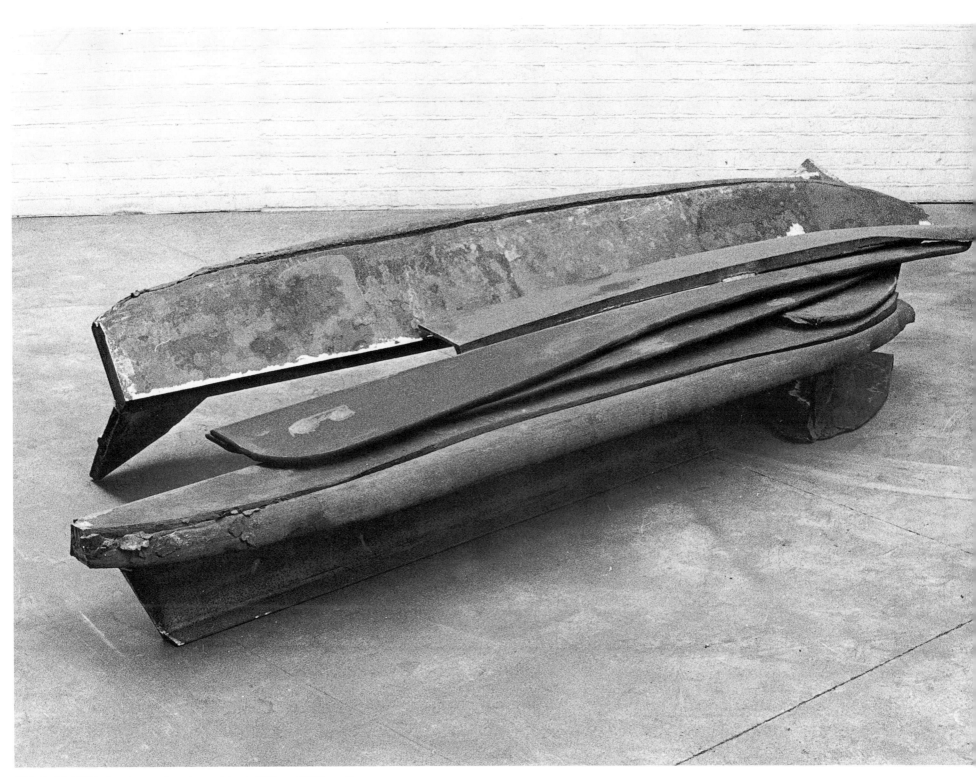

227. *Laid*. 1976. Steel rusted and varnished. 2'1" × 10'3" × 4'

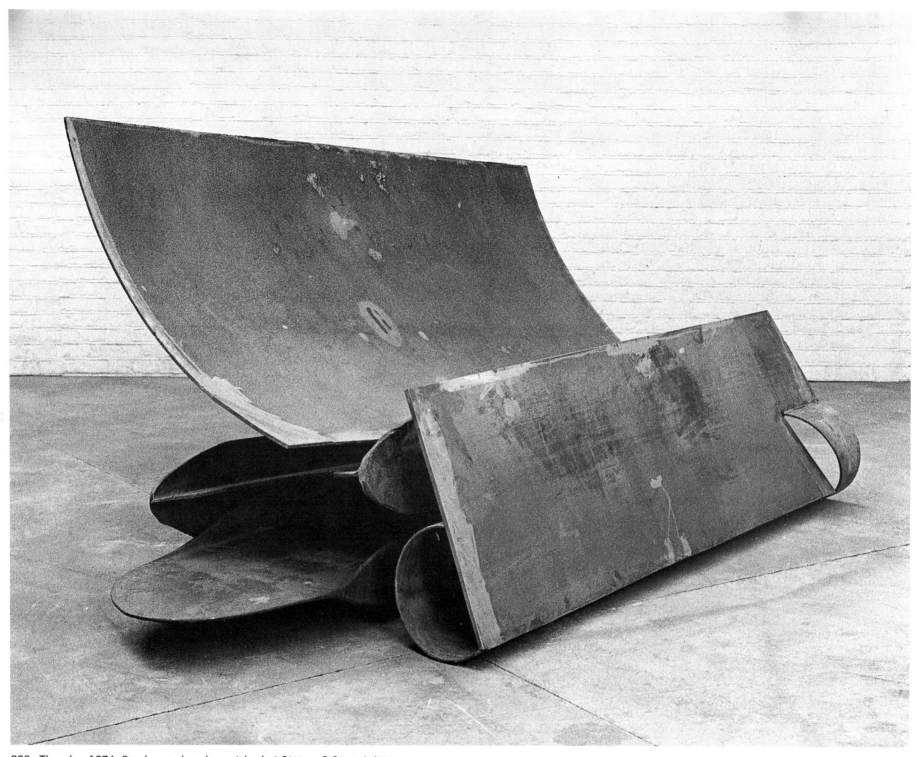

228. *Thunder*. 1976. Steel rusted and varnished. 4'2½" × 8'8" × 4'6½"

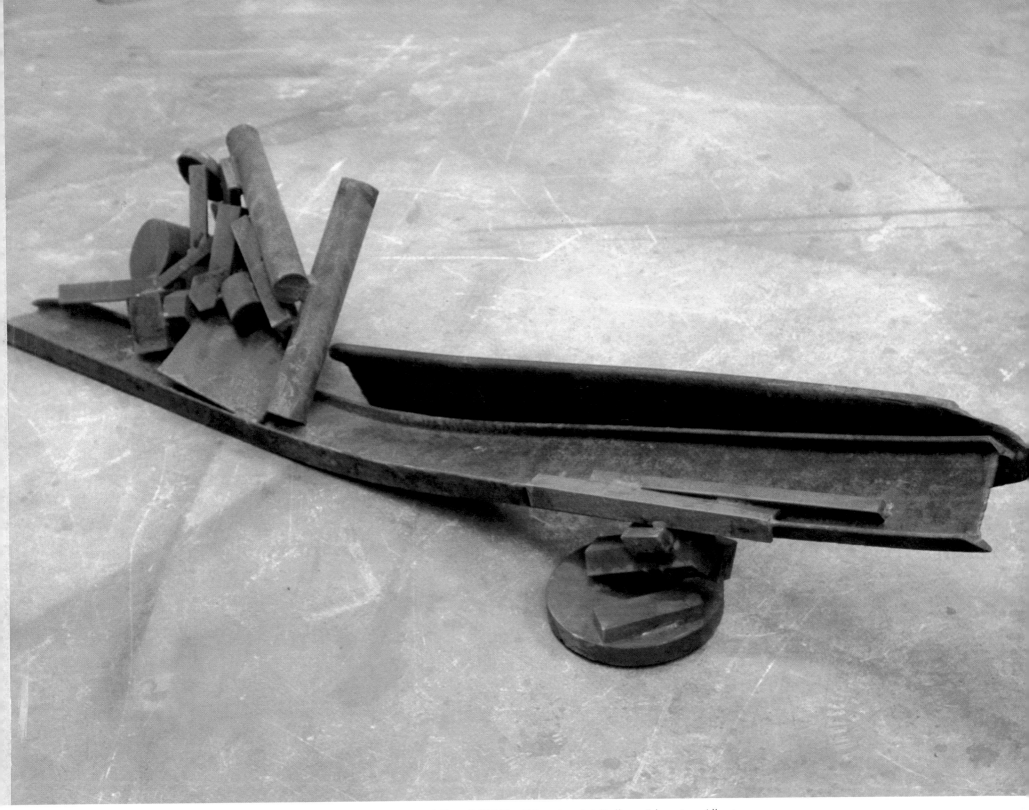

229. *Slide Left*. 1976. Steel rusted and varnished. 1′4½″ × 6′5″ × 1′11″. The Edmonton Art Gallery, Edmonton, Alberta

230. *Emma Pushframe.* 1977--78. Steel rusted, painted, and blacked. 7′ × 9′ x 11′3″

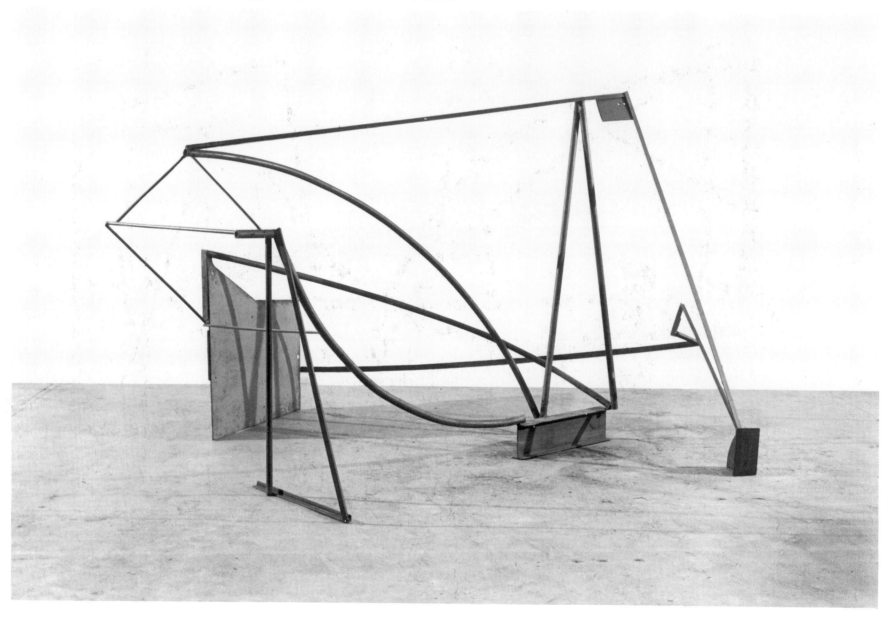

231. *Emma Dipper.* 1977. Steel rusted and painted gray. 7' × 5'7" × 10'6"

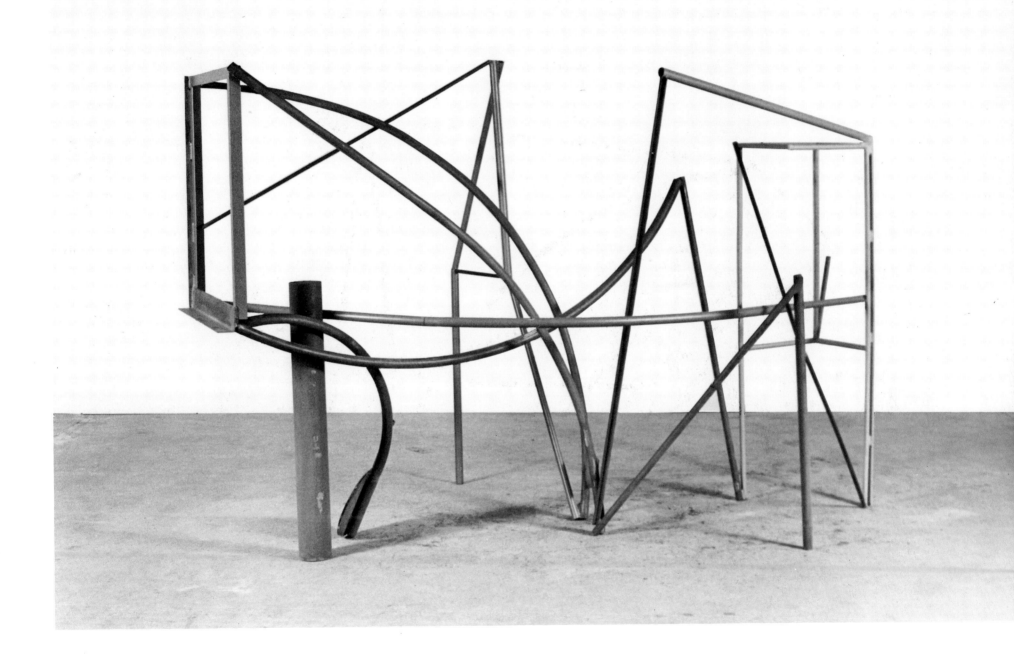

232. *Emma This.* 1977. Steel rusted, painted red, and blacked. 4'11" × 8'6" × 6'1"

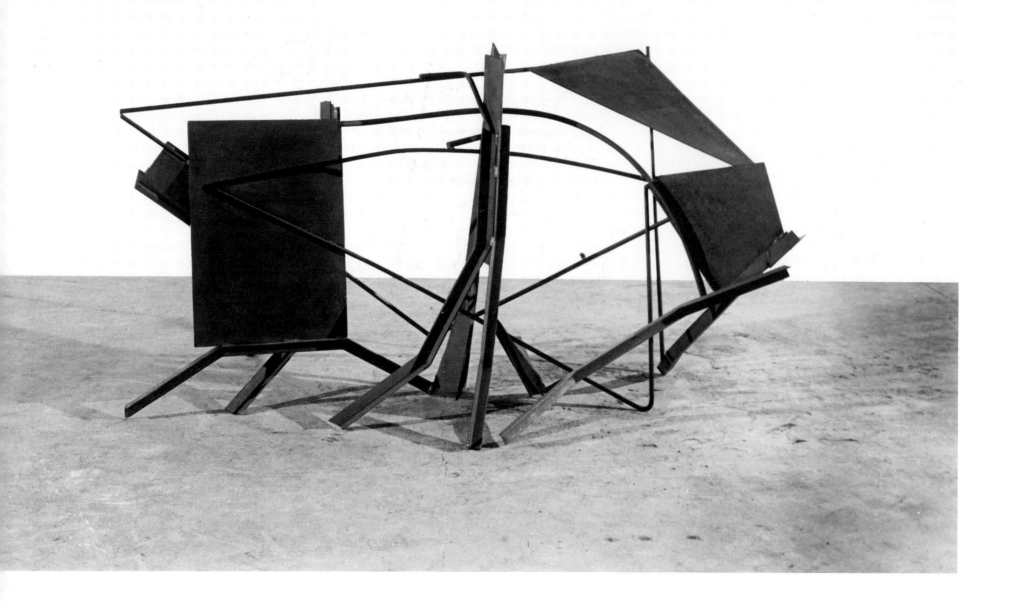

233. *Emma That.* 1977. Steel rusted, painted, and blacked. 4'4½" × 4'8" × 9'1"

234. *Emma Dance*. 1977. Steel rusted, painted, and blacked. 7'10½" × 8'2" × 9'5"

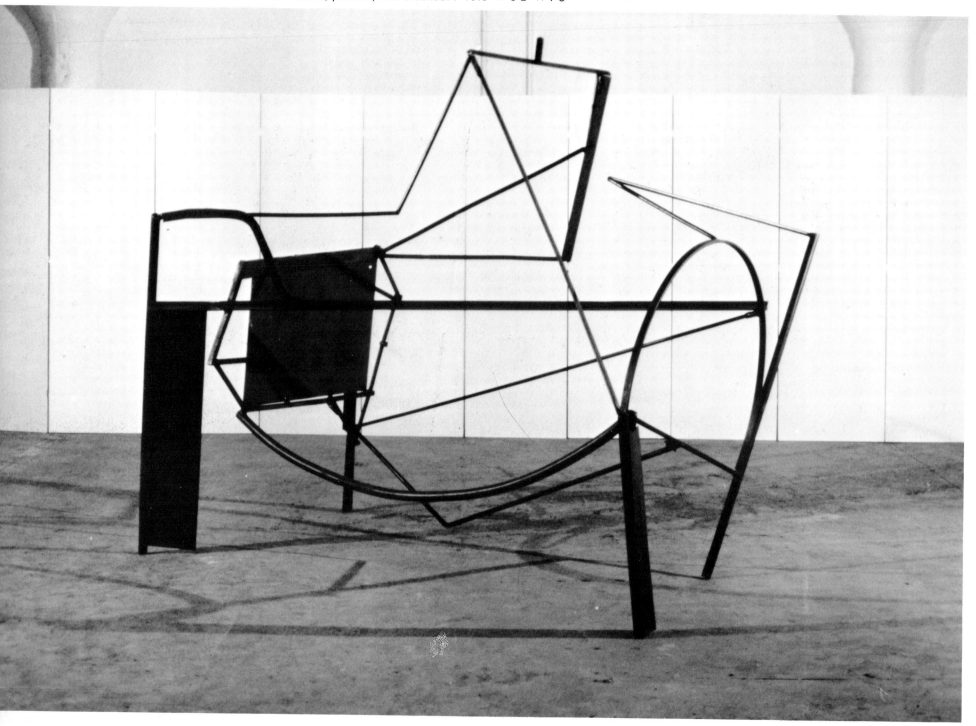

235. *Emma Landing.* 1977. Steel rusted, painted, and blacked. 6′ × 10′ × 10′. Private Collection

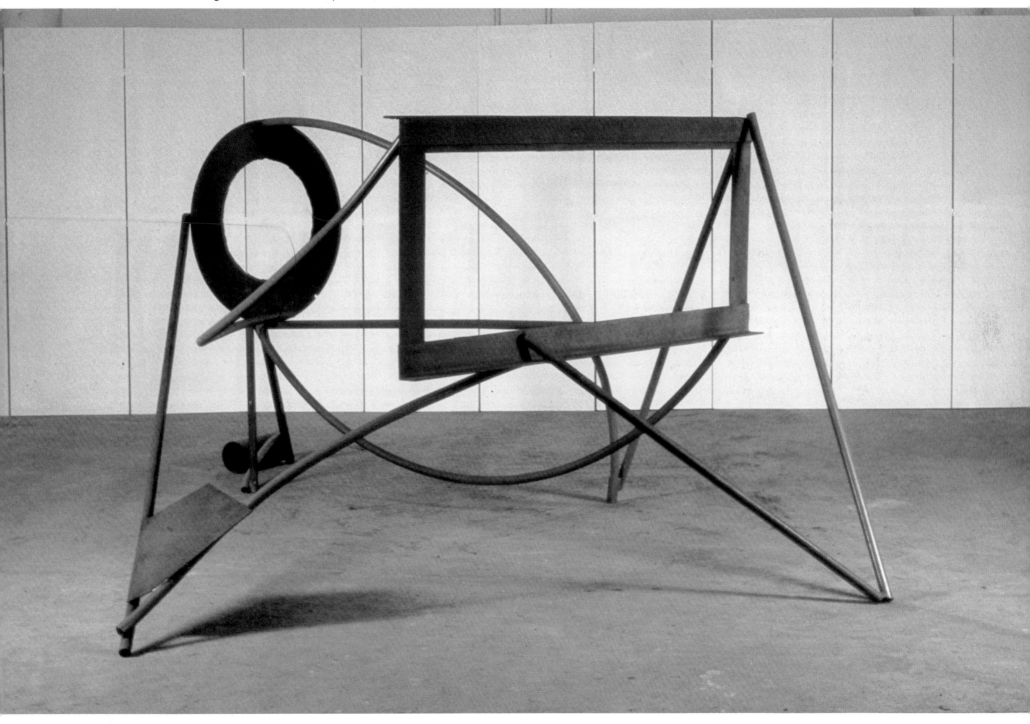

236

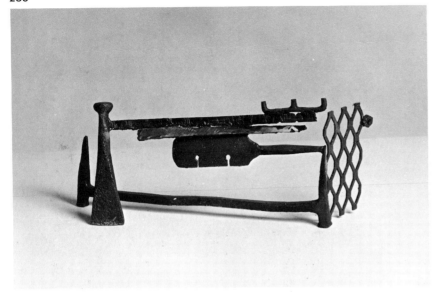

237

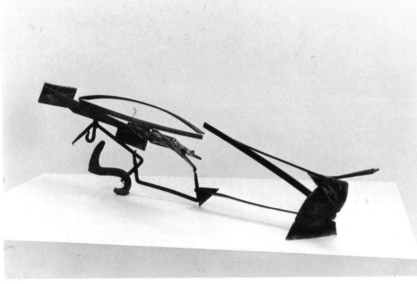

239

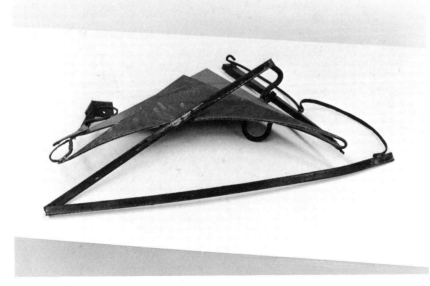

238

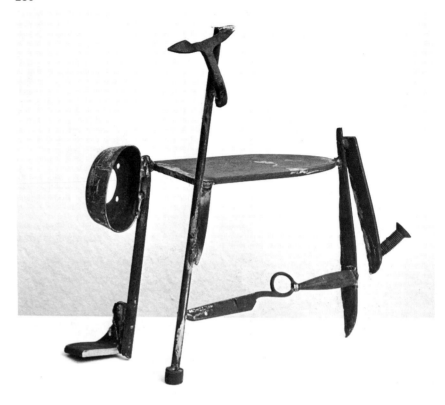

236. *Writing Piece "Tips."* 1978
Steel rusted and painted. 7″ × 1′5″ × 7″. Private Collection

237. *Writing Piece "Why."* 1978
Steel rusted, painted, and blacked. 1′2″ × 4′4″ × 9″
Private Collection

238. *Writing Piece "On."* 1978
Steel rusted, painted, and varnished. 6½″ × 2′6″ × 1′8″
Private Collection

239. *Writing Piece "Hi."* 1978
Steel painted and blacked. 1′8½″ × 2′ × 11″. Private Collection

240. *Writing Piece "Pint."* 1979
Steel rusted, varnished, and painted in parts
1′6½″ × 1′10″ × 9″. Private Collection

241. *Writing Piece "Early."* 1979
Steel rusted, heightened with paint, and blackened
1′11″ × 2′1″ × 1′2½″
Acquavella Art Gallery, New York

242. *Writing Piece "Now."* 1979
Steel rusted, varnished, and painted in parts. 2′7″ × 10″ × 10″
Private Collection

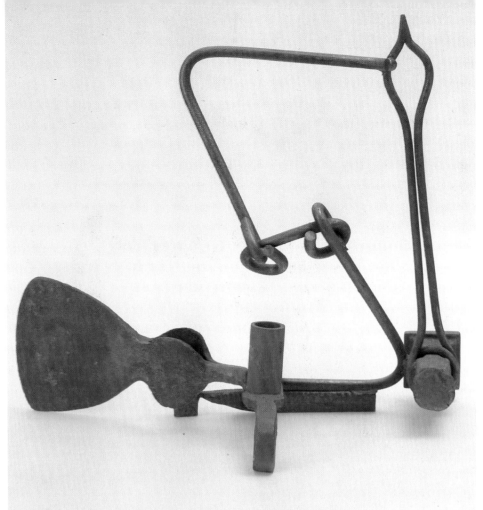

240

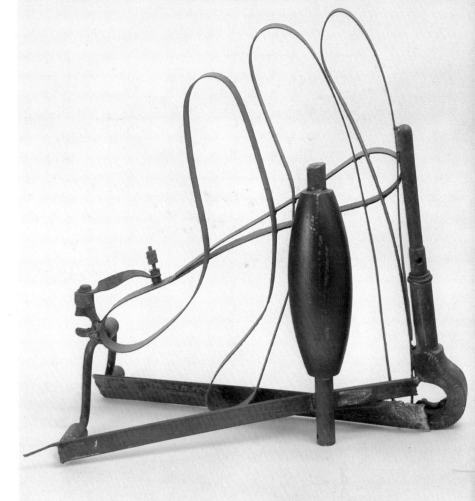

241

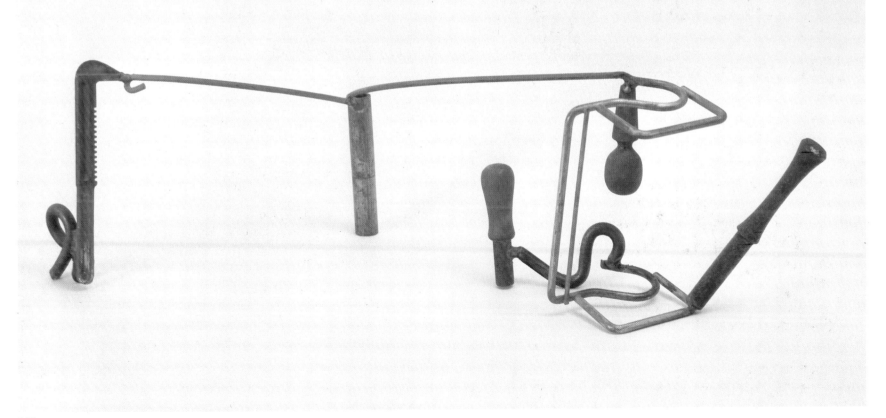

242

243

244

243. *Writing Piece "Good."* 1979
Steel rusted, varnished,
and painted in parts
2'1½" × 1'2" × 1'7"
Private Collection

244. *Writing Piece.* 1979
Steel
1'4" × 4' × 10"

245. *Buddha Peach.* 1977–78
Welded bronze,
cast bronze, plate, and bar
3'1½" × 2' × 1'8"

245

246. *Buddha Lemon.* 1977–78
Welded bronze,
cast bronze, plate, and bar
3'2¾" × 1'11½" × 1'10½"

247. *Buddha Pear.* 1977–78
Bronze cast and welded
2'10" × 2'3½" × 1'10"
Private Collection

248. *Buddha Taffy Apple.* 1977–78
Bronze cast and welded
2'7½" × 2'½" × 2'1½"

249. *Twin Peaks.* 1977–78
Bronze cast and welded
3'2" × 1'7" × 1'4½"

250. *Bonanza.* 1977–78
Bronze cast and welded
3'9½" × 1'11½" × 1'10"

251. *Black Raspberry Marble.* 1976–77
Bronze cast and welded
3'5½" × 3'1" × 1'10"

250

251

252. *Ice House*. 1977–78. Bronze cast and welded. 2'7½" × 3'2" × 2'8"

253. *Park*. 1977. Steel rusted and varnished. 3′ × 4′3″ × 2′4″. Private Collection

254. *Rhombus*. 1977. Steel rusted and varnished. 2'9" × 5'4" × 2'2"

255. *Floor Piece D21 (Viola)*. 1977–78. Steel painted green and gray and varnished. 1'10½" × 5'7" × 1'6". Private Collection

256

257

258

194

259

256. *Bordeaux Cherry.* 1977--78
Welded bronze,
cast bronze, plate, and bar
2'11½" × 2'1" × 2'2"

257. *Bordeaux Cherry.* Another view

258. *Bordeaux Cherry.* Another view

259. *Ice Breaker.* 1978--79
Welded bronze,
cast bronze, plate, and bar
3'1" × 4'9½" × 3'5"

260. *Ice Flower.* 1979--80
Bronze plate and
bronze cast and welded
2'10" × 3'2½" × 2'8"

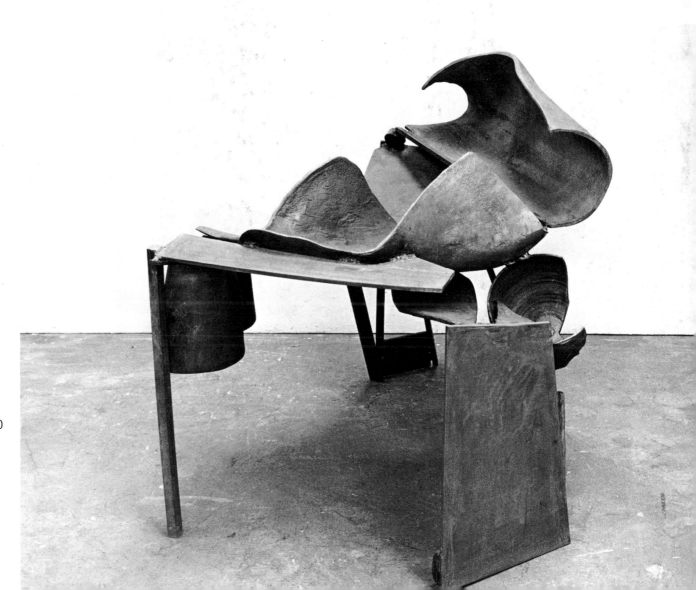

260

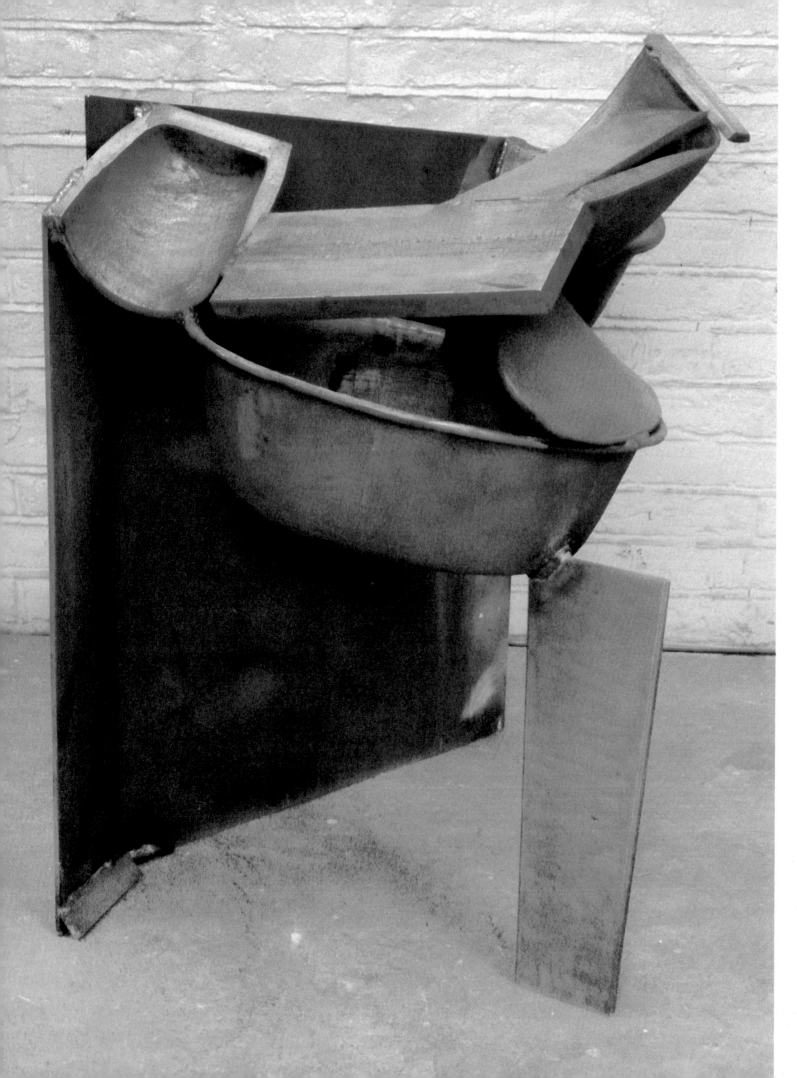

261

261. *Iceland Poppy.* 1979--80
Bronze cast and welded
3'1" × 2'5" × 2'5"

262. *Double Moonbeam.* 1979--80
Bronze cast and welded
5'10½" × 4'3" × 3'3"
Private Collection

263. *Etruscan.* 1978--79
Bronze cast and welded
9½" × 2' × 11½"

264. *Poire.* 1978–79
Bronze cast and welded
1'1½" × 2'1" × 1'
Private Collection

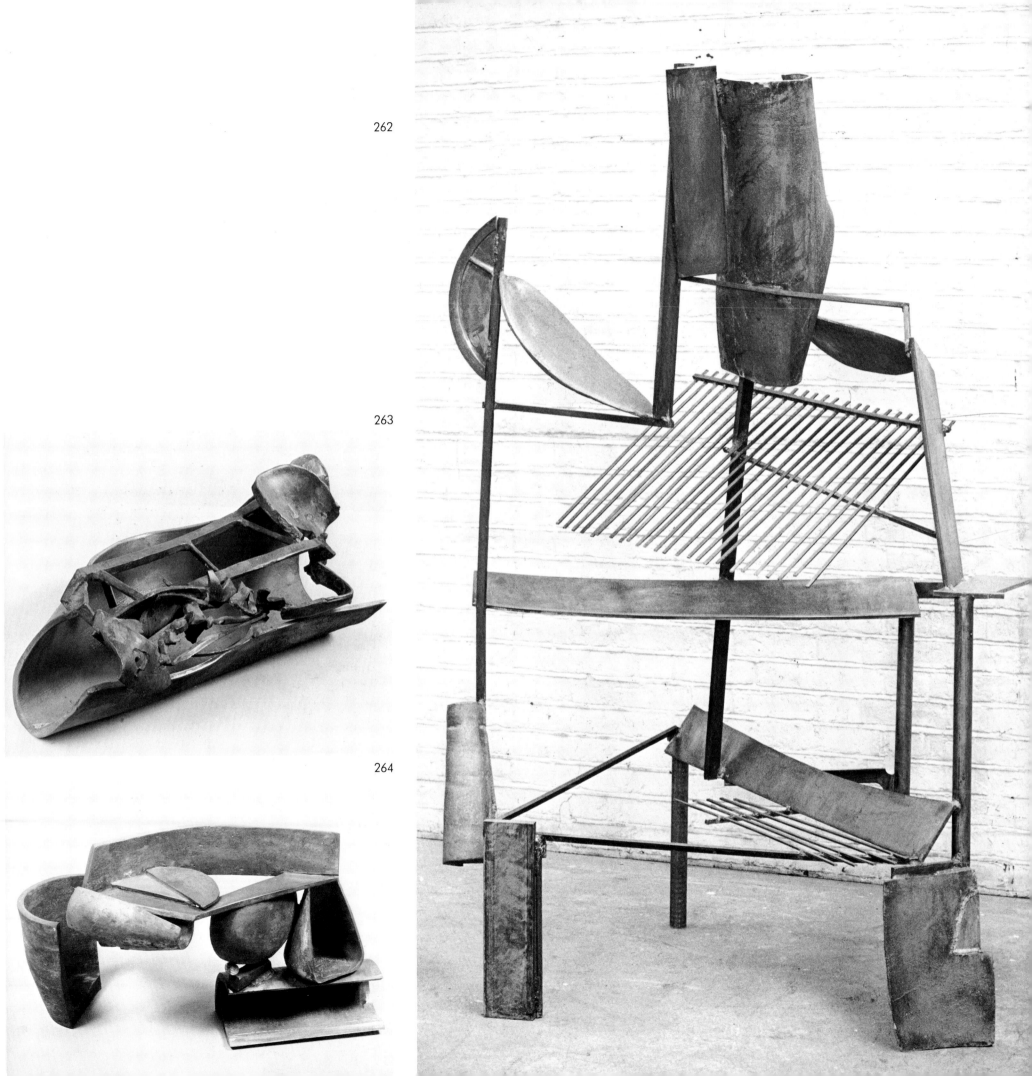

262

263

264

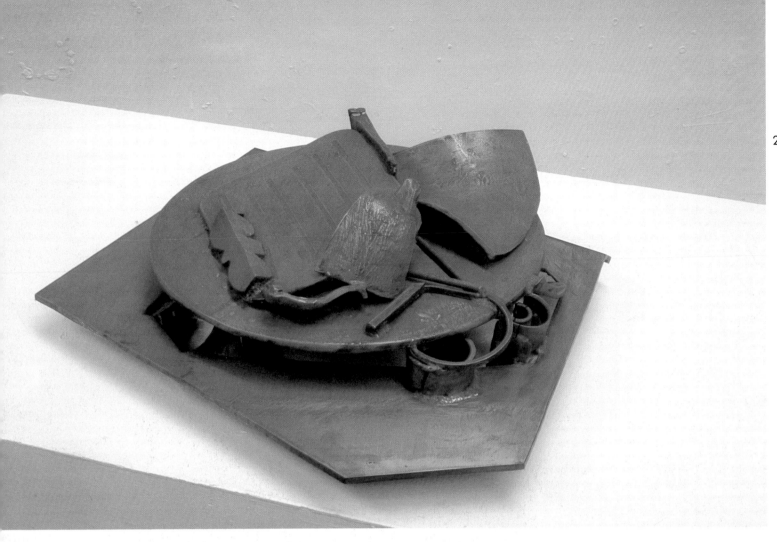

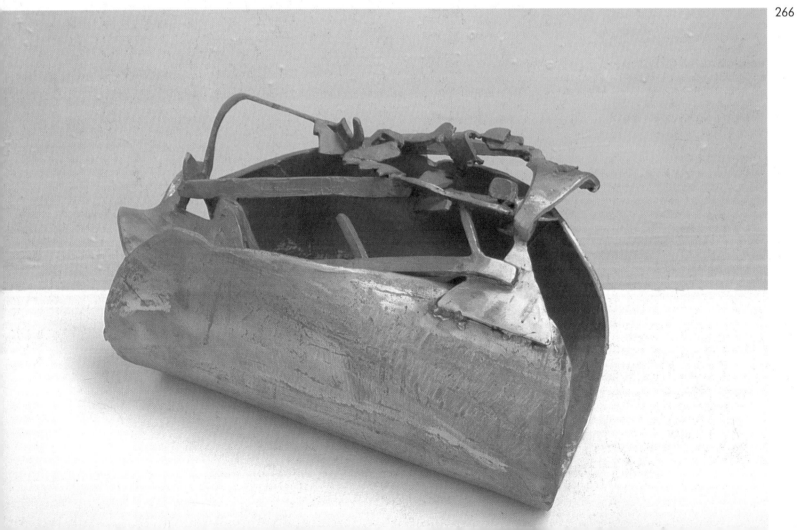

265. *Lotus*. 1979--80.
Sheet bronze
and bronze cast and welded
9″ × 2′ × 2′½″

266. *Diamond Drop*. 1979--80
Bronze cast and welded
11″ × 1′8½″ × 11″
Private Collection

267. *The Mosque*. 1978--79
Brass plate
and bronze cast and welded
2′9½″ × 3′1″ × 2′5½″
Private Collection

268. *Mint Palace*. 1979–80. Bronze plate and bronze cast and welded. 3'2" × 4'4" × 3'3". Private Collection

269. *Poles Apart.* 1980. Sheet bronze and bronze cast and welded. 2'10" × 4'4½" × 3'5½". Private Collection

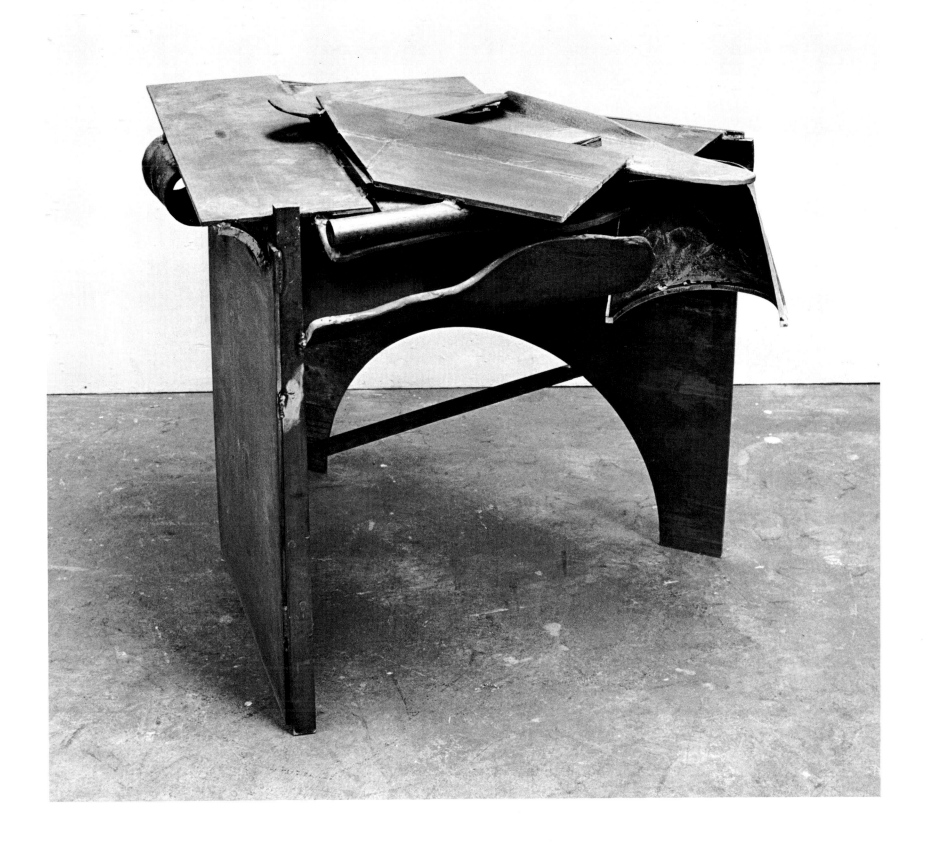

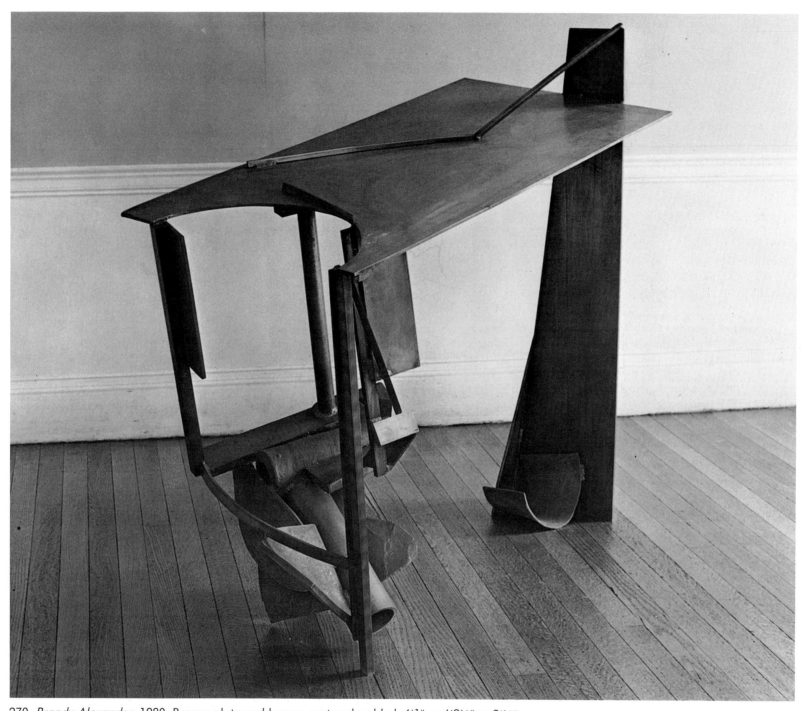

270. *Brandy Alexander*. 1980. Bronze plate and bronze cast and welded. 4'1" × 4'2½" × 2'½"

271. *Brandy Alexander.* Another view

272. *Quarter Past.* 1980
Brass plate and bronze cast and welded. 1'8" × 3' × 1'8½". Private Collection

273. *Half Leap.* 1980
Brass plate and bronze cast and welded. 2'7½" × 2'6" × 1'8½"

272

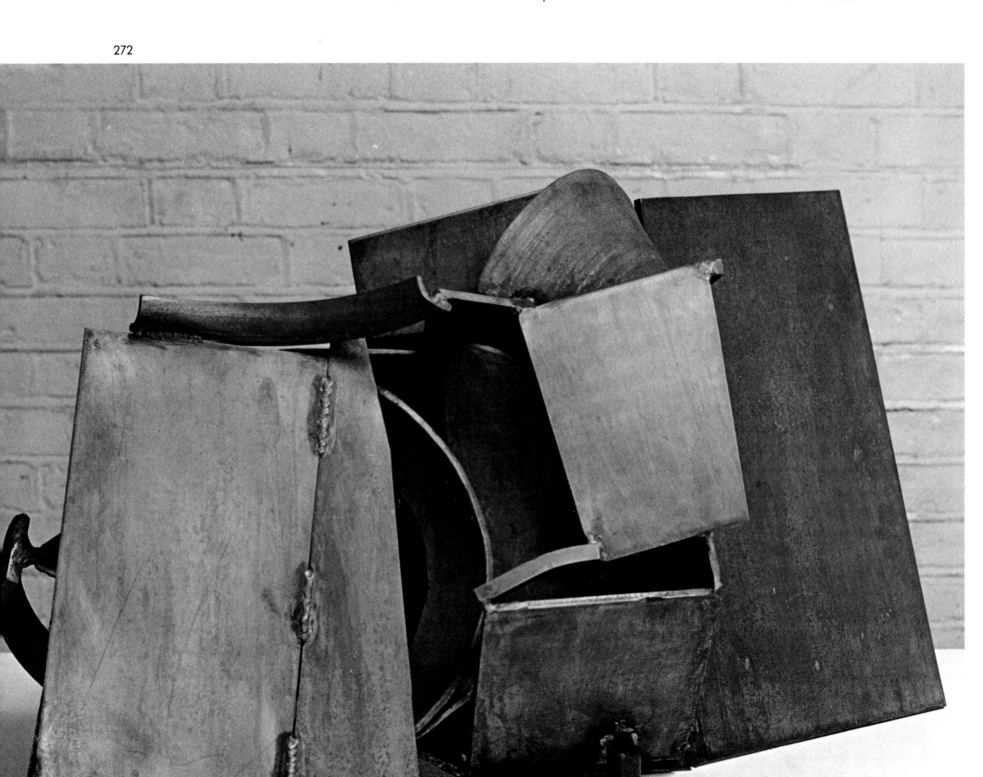

273

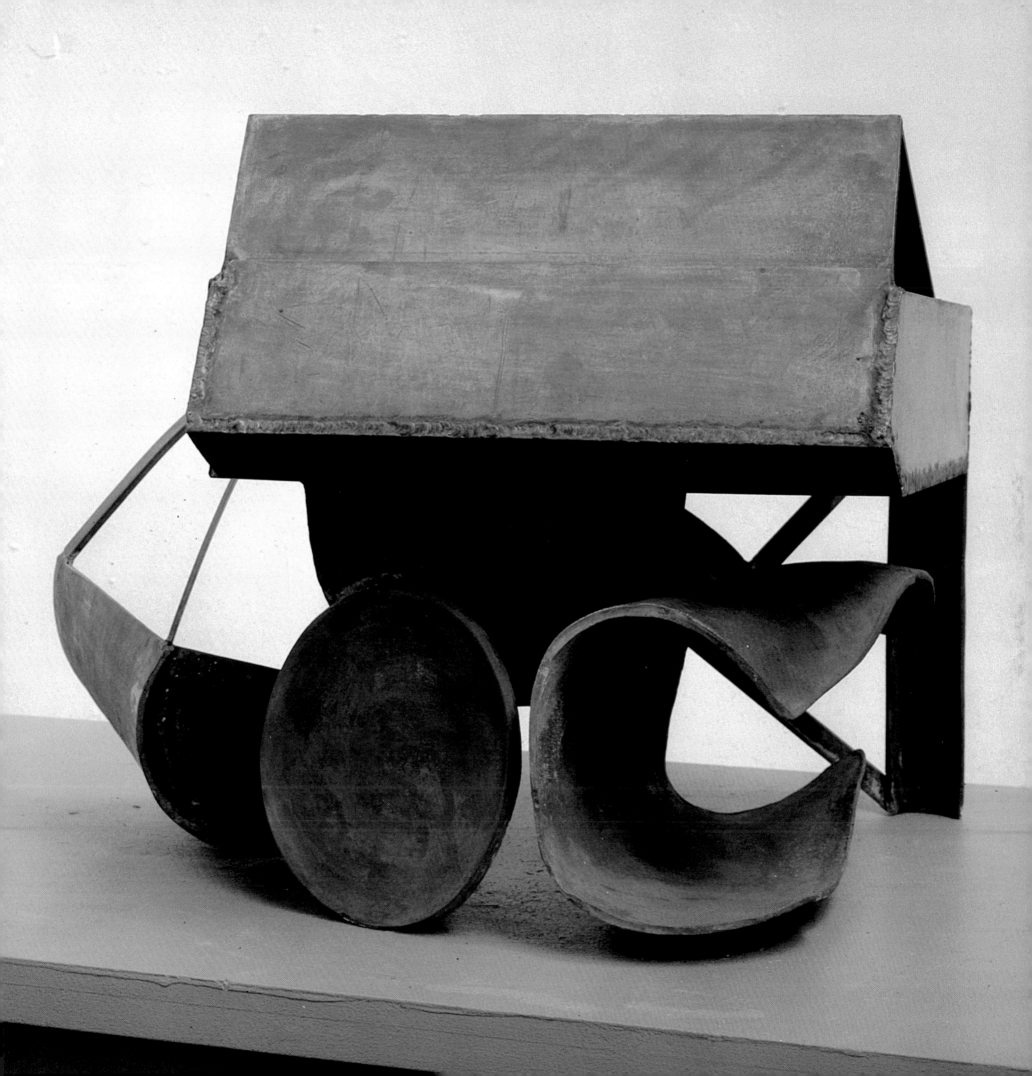

274. *Water Street Starter.* 1980
 Bronze plate and bronze cast and welded
 1'10" × 2' × 1'5". Private Collection

275. *Quarterings.* 1980
 Brass plate and bronze cast and welded. 2'3" × 2'8" × 2'4"

274

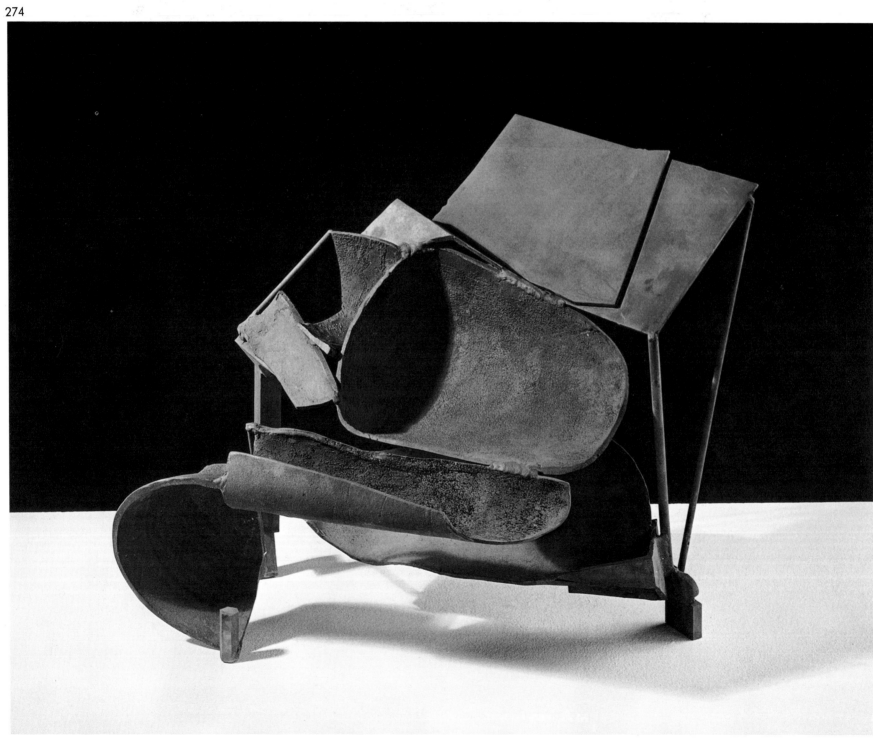

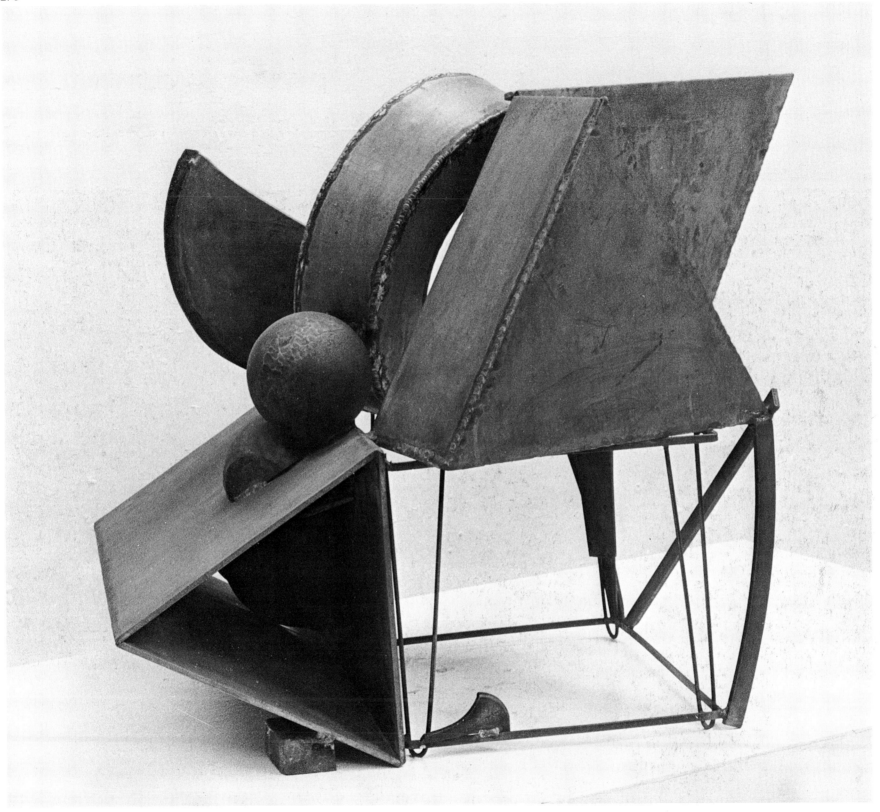

276. *Ragtime.* 1980
Lead and wood, painted
1'3½" × 1'2" × 1'1¼"

277. *Dodge.* 1980
Lead and wood, painted
10½" × 1'11" × 1'3"

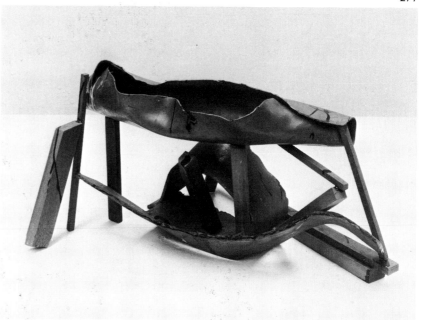

276

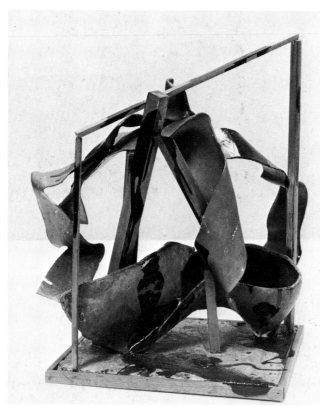

279

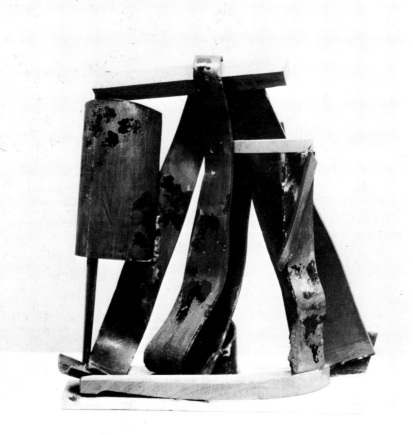

278

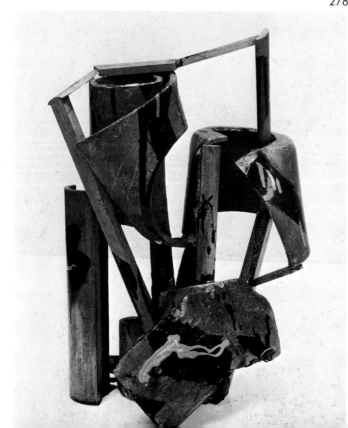

278. *Couple.* 1980
Lead and wood, painted
1'7" × 1'1" × 8"

279. *On the Up.* 1981
Lead and wood, painted
2'1" × 1'11" × 8½"

280. *Ceiling Piece D.* 1979
Steel rusted and varnished
4'8" × 3'6" × 2'

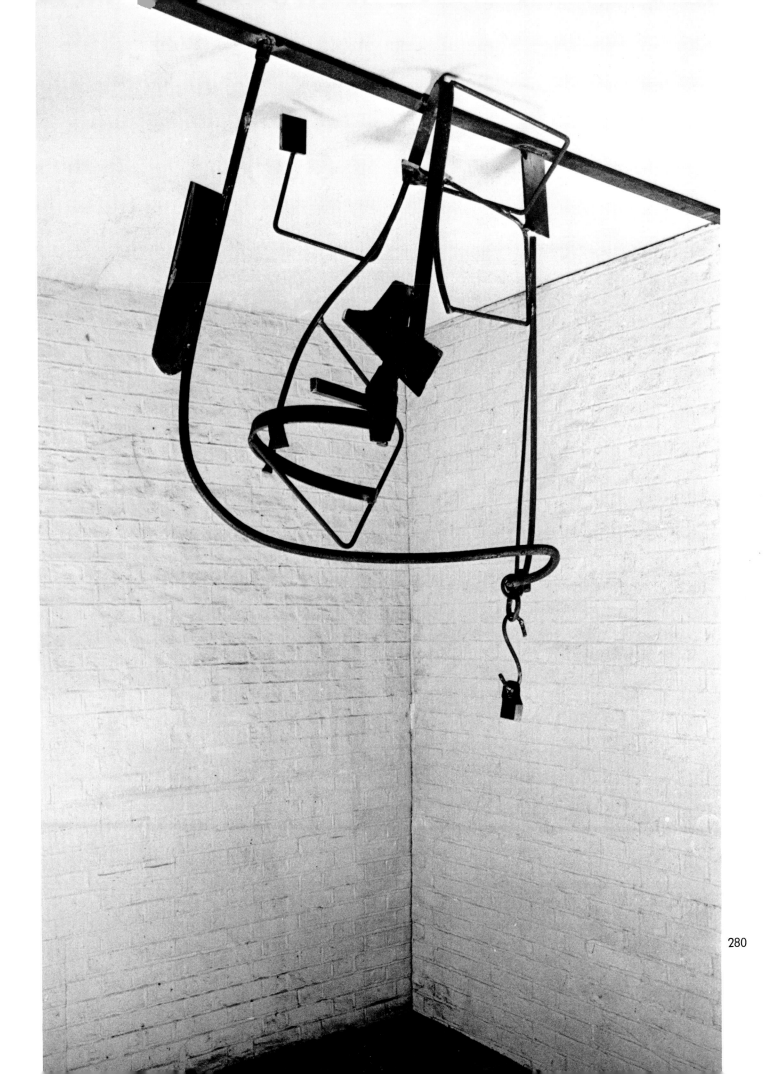

280

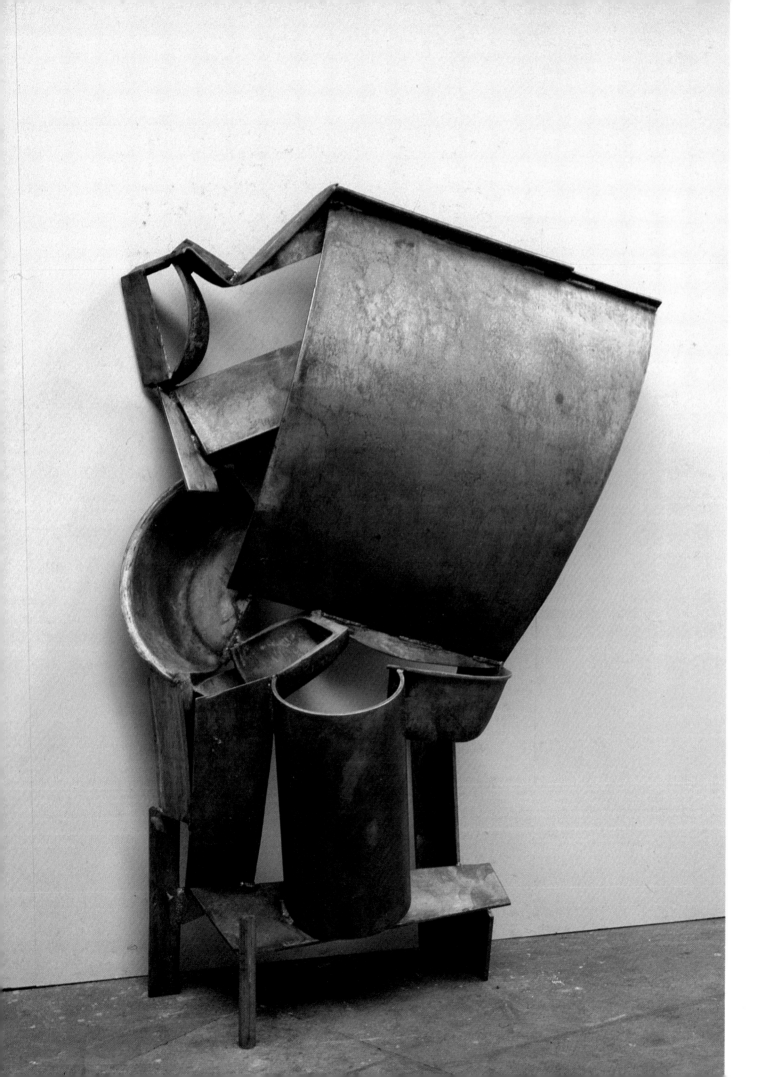

281. *Bronze Relief "Bend."* 1981
Bronze
5'10" × 4'2" × 2'8"

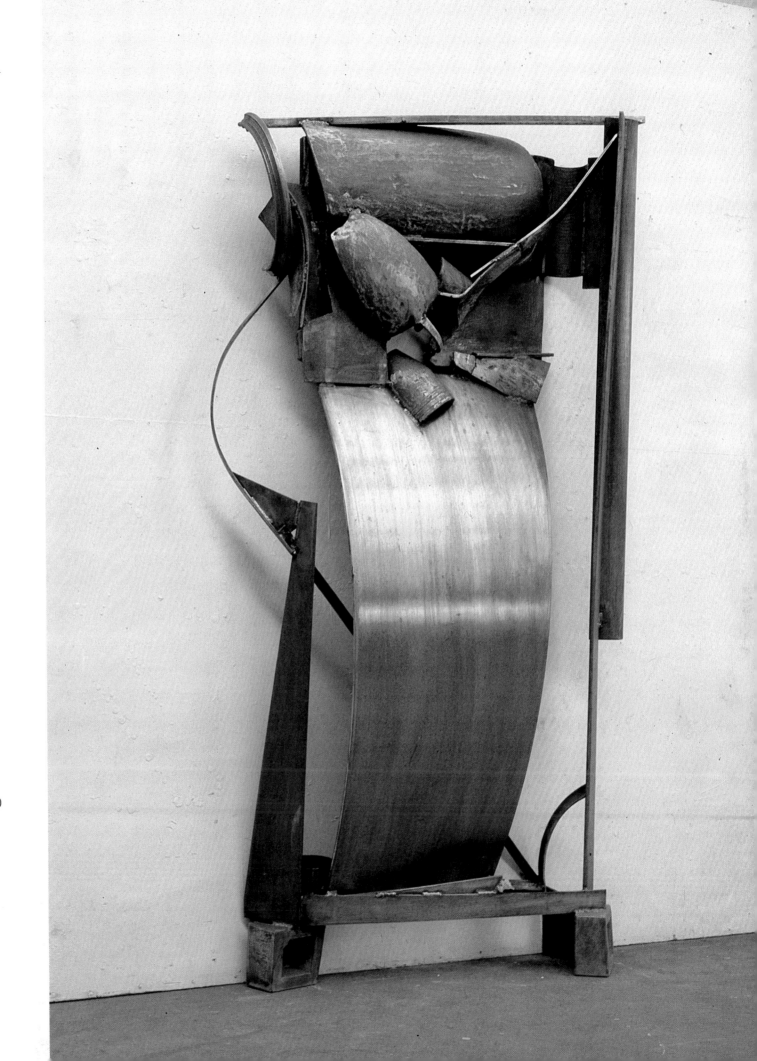

282. *Bronze Relief No. 1.* 1980
Bronze
6′5½″ × 3′8″ × 1′1″

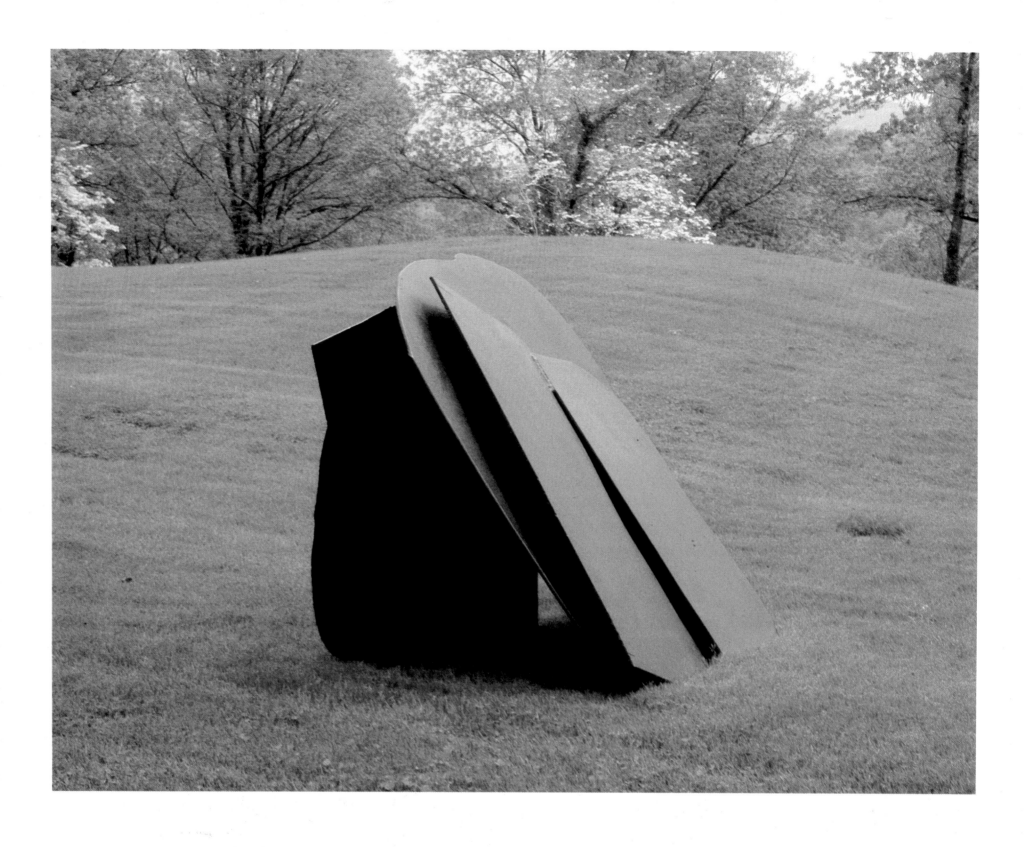

283. *Bloor Flats*. 1974. Steel rusted and varnished. 5'7" × 6'2" × 5'4"

284. *Fossil Flat*. 1974. Steel rusted and varnished. 6'1" × 4'5" × 7'2"

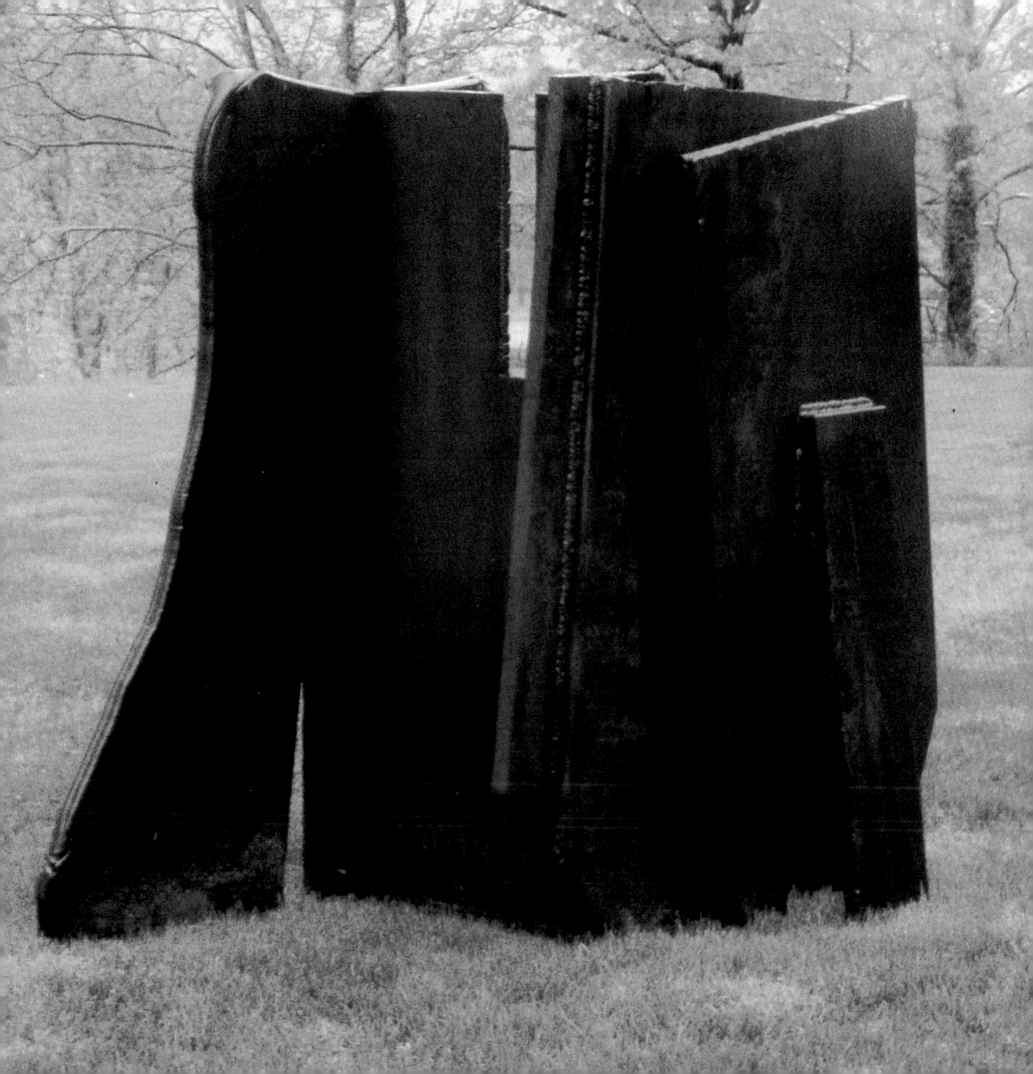

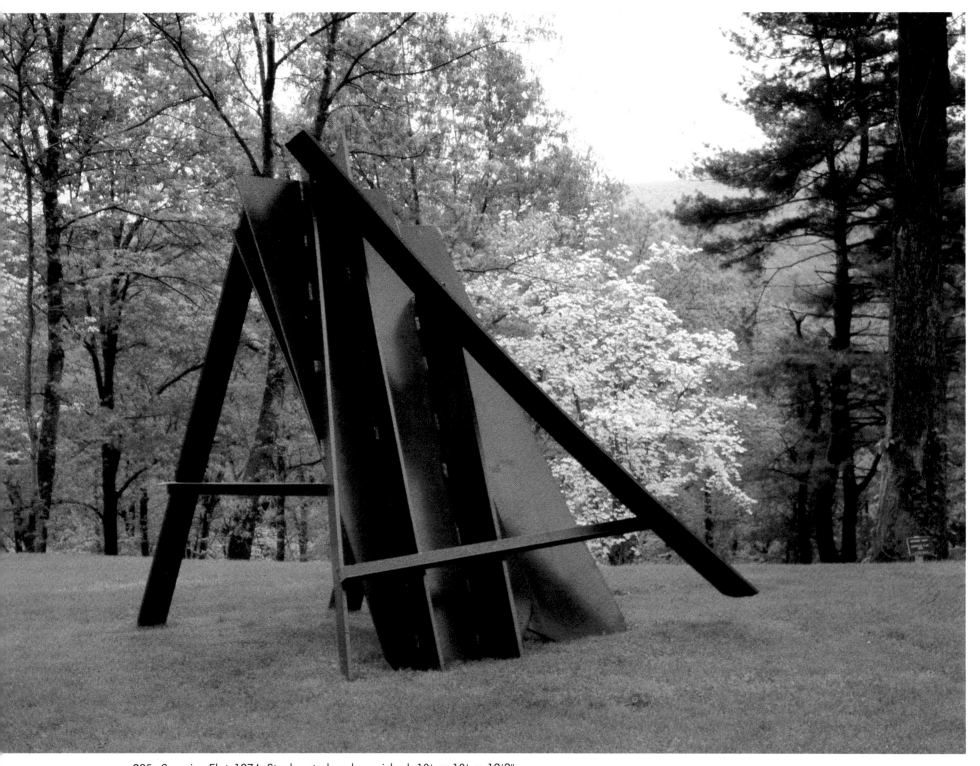

285. *Surprise Flat.* 1974. Steel rusted and varnished. 10′ × 10′ × 12′2″

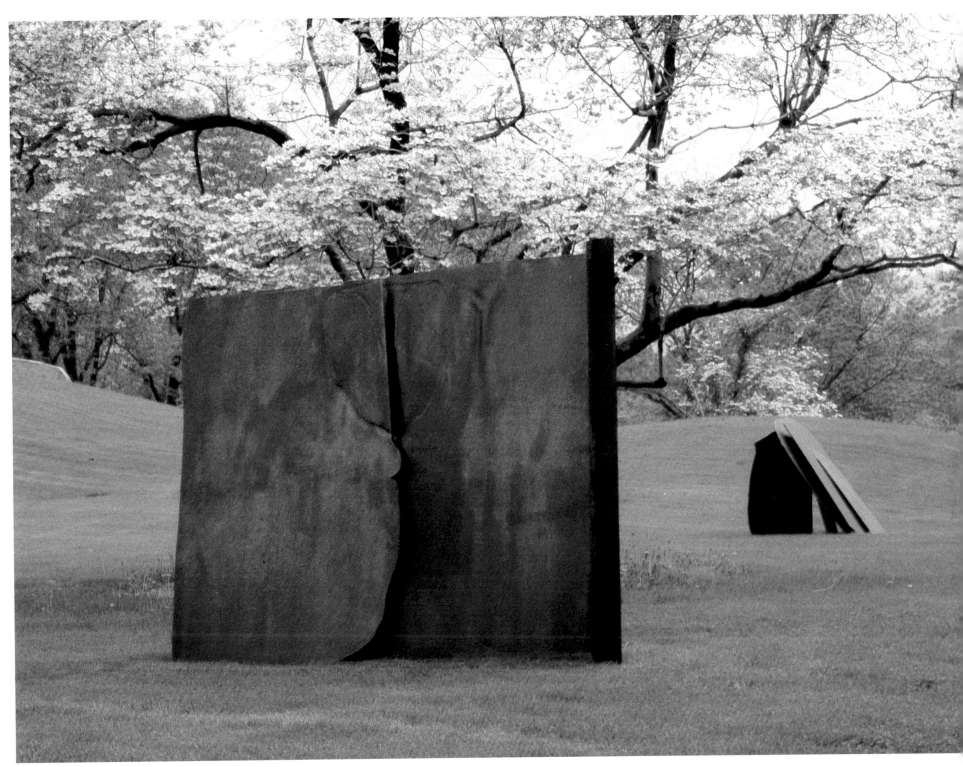

286. *Yonge Street Flat*. 1974. Steel rusted and varnished. 7'6" × 9'1" × 3'3"

287. *Pin up Flat.* 1974. Steel rusted and varnished. 6'7" × 8'7" × 5'7"

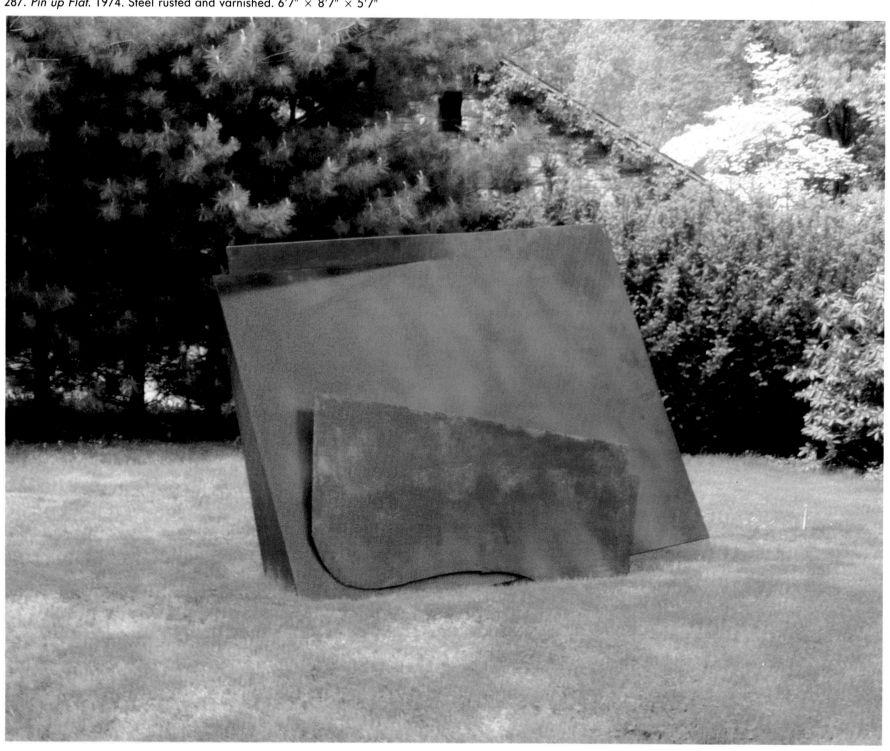

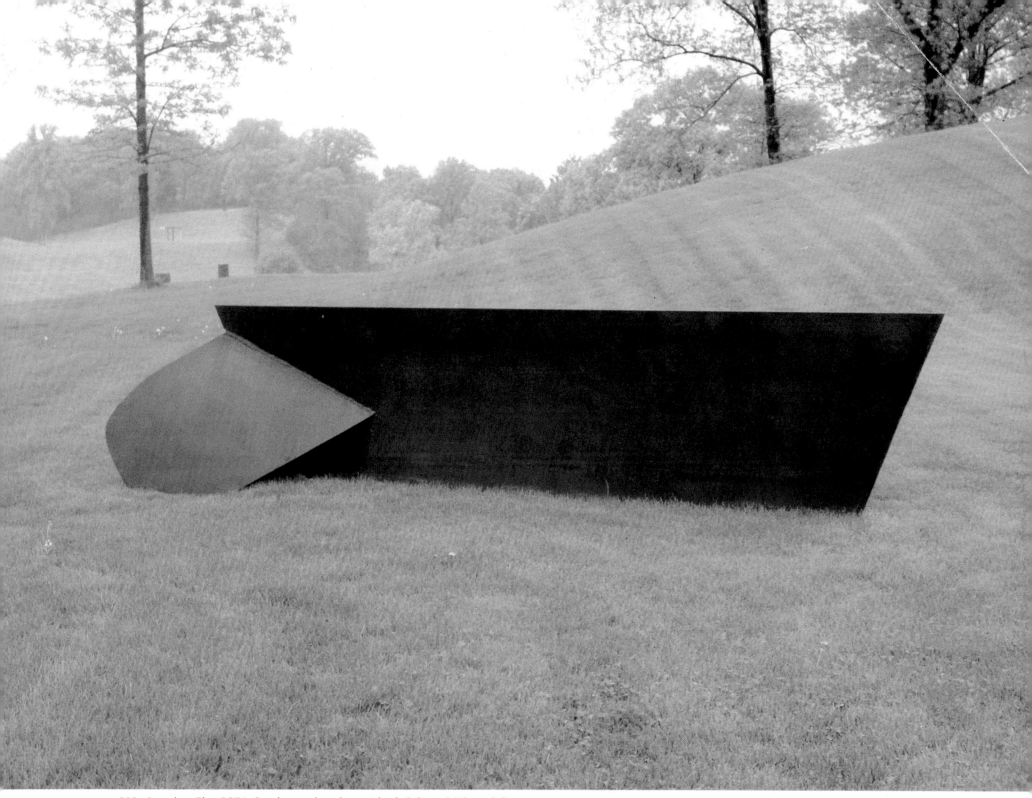

288. *Streaker Flat*. 1974. Steel rusted and varnished. 3'9" × 16'9" × 3'9"

289–298
Caro and crew installing
Ledge Piece in the east wing
of the National Gallery of Art,
Washington D.C. 1978

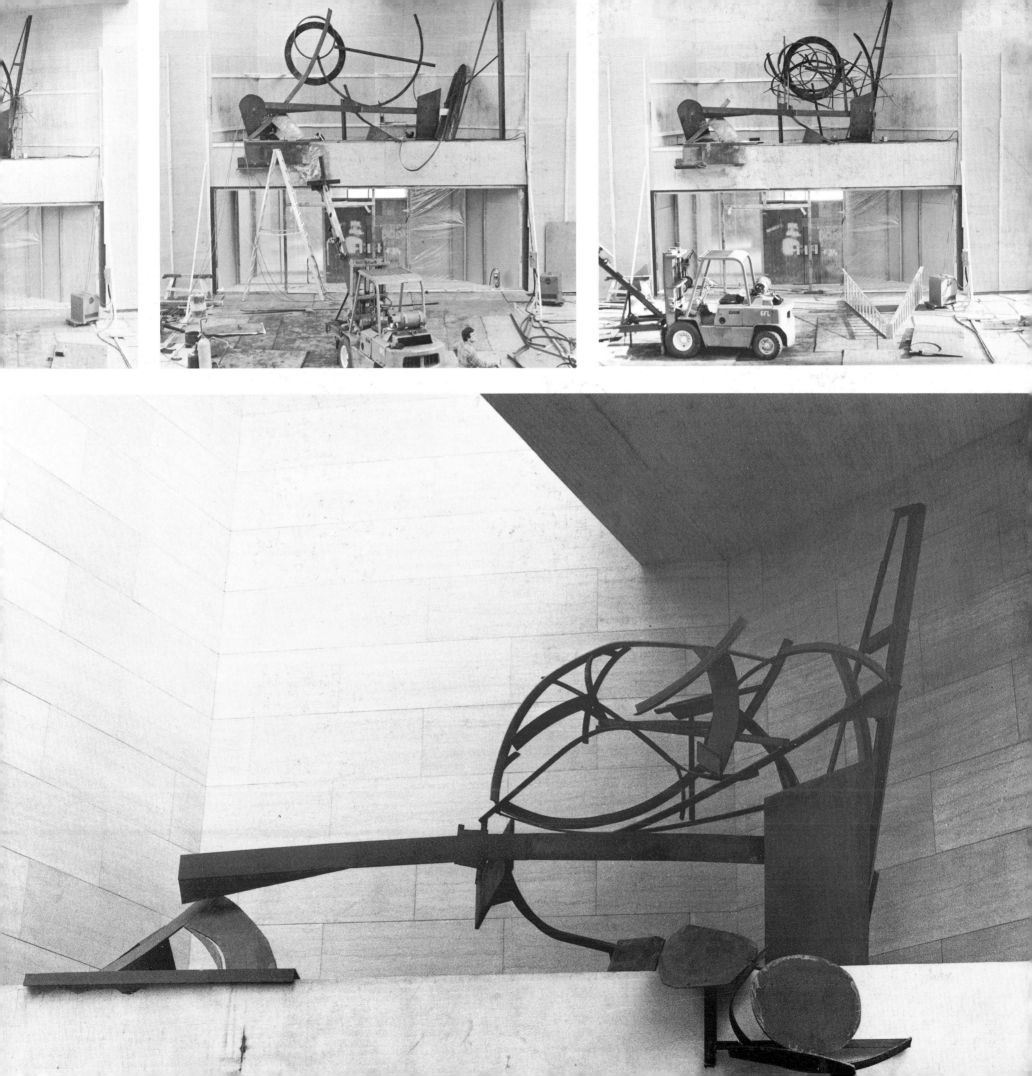

Selected Bibliography

1955

Sylvester, David. "Round the London Galleries," *The Listener*, Sept. 1, 1955.

Taylor, Basil. "Art," *The Spectator*, Sept. 2, 1955.

———. "Young Men's Sculpture," *The Times* (London), Aug. 12, 1955.

1956

Alloway, Lawrence. "Caro and Gravity," foreword to exhibition catalogue, Galleria del Naviglio, Milan, 1956.

Crosby, Theo. "Anthony Caro at Galleria Naviglio, Milan," *Architectural Design*, Mar. 1956, p. 107.

1957

Alloway, Lawrence. "Art News from London," *Art News*, Mar. 1957, p. 21.

Bone, Stephen. "Artists' Contrast: Redvers Taylor and Anthony Caro," *Manchester Guardian*, Jan. 9, 1957.

Forge, Andrew. "Round the London Galleries," *The Listener*, Jan. 17, 1957.

Rouve, Pierre. "Personality," *Art News and Review*, Jan. 19, 1957, p. 3.

Solomon, Alan. "Sculpture in a Big Way," *The Times* (London), Jan. 15, 1957.

Wallis, Nevile. "Different Worlds," *The Observer* (London), Jan. 13, 1957.

1960

Caro, Anthony. "The Master Sculptor," *The Observer* (London), Nov. 27, 1960.

Maillard, Robert, ed. *Dictionary of Modern Sculpture*. New York: Tudor, 1960, p. 51.

Melville, Robert. "Exhibitions," *Architectural Review*, Nov. 1961, pp. 351–52, 354.

Seuphor, Michel. *The Sculpture of This Century*. New York: Braziller, 1960, pp. 147, 150, 248.

1961

Alloway, Lawrence. "Interview with Anthony Caro," *Gazette* (London), no. 1, 1961, p. 1.

Sylvester, David. "Aspects of Contemporary British Art," *Texas Quarterly* (University of Texas, Austin), Autumn 1961, pp. 118–28.

Trier, Eduard. *Form and Space: Sculpture of the Twentieth Century*. New York: Praeger, 1968, pp. 44, 280–81, 326.

1962

Alloway, Lawrence. "Notes from London: Painted Sculpture by Anthony Caro," *Metro* (Milan), 1962, pp. 102, 104–07.

1963

Amaya, Mario. "The Dynamics of Steel," *Financial Times* (London), Sept. 24, 1963.

Baro, Gene. "A Look at Reminiscence," *Arts Magazine*, Nov. 1963, pp. 44–47.

Fried, Michael. "Anthony Caro," introduction to exhibition catalogue, Whitechapel Gallery, London, 1963. Reprinted, *Art International*, Sept. 25, 1963, pp. 68–72.

Lynton, Norbert. "Two Radicals," *New Statesman*, Oct. 11, 1963.

Martin, Robin. "The Sculpture of Anthony Caro," *Peace News* (London), Nov. 22, 1963.

Meville, Robert. "Constructions at Whitechapel Art Gallery," *Architectural Review*, Dec. 1963, pp. 431–32.

Mullins, Edwin. "Time of the Modern," *Sunday Telegraph* (London), Oct. 6, 1963.

Newton, Eric. "Anthony Caro's Sculpture at the Whitechapel Gallery," *The Guardian* (London), Sept. 19, 1963.

Reichardt, Jasia. "Colour in Sculpture," *Quadrum* (Brussels), no. 18, 1965, pp. 71–78.

Russell, John. "England: The Advantage of Being Thirty," *Art in America*, Dec. 1963, pp. 92–97.

———. "New Areas of Awareness," *Sunday Times* (London), Sept. 22, 1963.

Solomon, Alan. "Caro's New and Original Sculpture," *The Times* (London), Oct. 4, 1963.

———. "Out-and-Out Originality in our Contemporary Sculpture," *The Times* (London), Aug. 20, 1963.

Spencer, Charles S. "Caro at the Whitechapel Gallery," *Arts Review*, Sept. 21, 1963, p. 5.

Storey, David. "When Artists Sell Out," *The Observer* (London), Sept. 29, 1963.

Wallis, Nevile. "Anthony Caro," *The Spectator*, Sept. 4, 1963.

Walter, Rivhard. "Wanted: New Words for Caro," *Daily Mail* (London), Sept. 19, 1963.

1964

Canaday, John. "Summary, Recent Art-Show Openings," *New York Times*, Dec. 5, 1964.

Lynton, Norbert. "Latest Developments in British Sculpture," *Art and Literature* (Lausanne), Summer 1964, pp. 195–211.

Spencer, Charles S. "An Introduction to Abstract Art," *The Artist* (London), Feb. 1964, pp. 122–25.

———. "Sculptor for Humanity," *Jewish Chronicle* (London), Feb. 14, 1964.

Thompson, David. "A Decade of British Sculpture," *Cambridge Opinion*, 1964.

———. "Conversation with Anthony Caro, Ken Noland and Jules Olitski," *Monad* (London), Jan. 1964, pp. 18–22.

1965

Baro, Gene. "Britain's New Sculpture," *Art International*, June 1965, pp. 26–31.

———. "Britain's Young Sculptors," *Arts Magazine*, Dec. 1965, pp. 13–17.

Benedikt, Michael. "Anthony Caro," introduction to exhibition catalogue *Seven Sculptors*. Institute of Contemporary Art, University of Pennsylvania, Philadelphia, 1965.

Booker, Emma. "Anthony Caro," *Vogue* (London), Nov. 1965, pp. 94–95.

Campbell, Lawrence. "Anthony Caro," *Art News*, Jan. 1965, p. 19.

Cheek, Leslie, III. "Sculptor Achieves Tonnage," *Washington Post*, Feb. 21, 1965.

Coutts-Smith, Kenneth. "Anthony Caro," *Arts Review*, Nov. 13, 1965, p. 9.

Dunbar, John. "Anthony Caro: The Experience is the Thing," *Scotsman* (Edinburgh), Nov. 20, 1965.

Dunlop, Ian. *Evening Standard* (London), Nov. 4, 1965.

Forge, Andrew. "Some New British Sculptors," *Artforum*, May 1965, pp. 31–35.

Fried, Michael. "Anthony Caro and Kenneth Noland: Some Notes on Not Composing," *Lugano Review*, Summer 1965, pp. 198–206.

Gosling, Nigel. "Cairo to Caro," *The Observer* (London), Nov. 7, 1965.

Greenberg, Clement. "Anthony Caro," *Arts Yearbook 8: Contemporary Sculpture*, New York, 1965, pp. 106–09. Reprinted, foreword to exhibition catalogue, Rijksmuseum Kroller-Muller, Otterlo, Holland, 1967, and in *Studio International*, Sept. 1967, pp. 116–17.

Grinke, Paul. "Caro's Achievement," *Financial Times* (London), Nov. 13, 1965.

Hodin, J. P. "The Avant-Garde of British Sculpture and the Liberation from the Liberators," *Quadrum* (Brussels), 1965, pp. 55–70.

Judd, Donald. *Arts Magazine*, Jan. 1965, pp. 53–54.

Lynton, Norbert. "Caro Exhibition," *The Guardian* (London), Nov. 16, 1965.

———. *Art International*, Dec. 1965, pp. 23–30.

———. *The Modern World*. New York: McGraw-Hill, 1965, pp. 158, 164.

Mullins, Edwin. "Art," *Sunday Telegraph* (London), Nov. 7, 1965.

Reichardt, Jasia. "Colour in Sculpture," *Quadrum* (Brussels), no. 18, 1965, pp. 70–78.

Richardson, John. "Carissimo," *New Statesman*, Nov. 12, 1965.

———. "Early One Morning," *New Statesman*, Feb. 28, 1965.

Robertson, Bryan. *The New Generation*, exhibition catalogue. London. Whitechapel Gallery, 1965.

———. "A Revolution in British Sculpture," *The Times* (London), Mar. 9, 1965.

Russell, John. "Art News from London: Anthony Caro," *Art News*, Dec. 1965, pp. 36, 54, 55.

———. "The Man Who Gets There First," *Sunday Times* (London), Oct. 31, 1965.

Solomon, Alan. "Importance of the Ground in Sculpture of Anthony Caro," *The Times* (London), Nov. 4, 1965.

Stevens, Elisabeth. "Caro Has a Way with Steel and Bends it to His Will," *Washington Post*, Feb. 28, 1965.

Stone, Peter. "New Mysticism," *Jewish Chronicle* (London), Nov. 12, 1965.

Thompson, David. "After the Twisted Iron, the Girder Sections," *Sunday Times* (London), Feb. 28, 1965.

———. "British Sculpture Up," *New York Times*, Mar. 28, 1965.

Whittet, G. S. *Studio International*, Dec. 1965, pp. 241–45.

———. "Sculpture: Intellectuals without Trauma," *Time Magazine*, Mar. 12, 1965, p. 66.

1966

Baro, Gene. "British Sculpture: The Developing Scene," *Studio International*, Oct. 1966, pp. 171–81.

Beeren, W. A. L. *Museumjournaal* (Otterlo), Nov. 1966, pp. 144–55.

Devlin, Polly. "The Merchants of Venice," *Vogue* (London), May 1955, pp. 112–13.

Forge, Andrew. "Interview with Anthony Caro," *Studio International*, Jan. 1966, pp. 6–9.

Fulford, Robert. "When Sculptor Caro Works . . . Everybody Works," *Toronto Daily Star*, May 13, 1966.

Genauer, Emily. "Anthony Caro," *World Journal Tribune*, Nov. 25, 1966.

Greenberg, Clement. "David Smith," *Art in America*, Jan.–Feb. 1966, pp. 27–32.

Hodin, J. P. "Documentation: Anthony Caro," *Quadrum* (Brussels), no. 20, 1966, pp. 142–43.

Hudson, Andrew. "Bellwether of a Really New Sculpture," *Washington Post*, Oct. 2, 1966.

———. "Caro's Four Sculptures Seem Just Like a Crowd," *Washington Post*, Oct. 2, 1966.

———. "English Sculptors Outdo Americans," *Washington Post*, May 8, 1966.

Hughes, Robert. "Caro Generation," *Sunday Times* (London), April 10, 1966.

Kramer, Hilton. "'Primary Structures'—The New Anonymity," *New York Times*, May 1, 1966.

———. "Sculpture: Talent Unfolds on Horizon," *New York Times*, Nov. 26, 1966.

Lucie-Smith, Edward. "Anthony Caro at Venice," *Art and Artists*, June 1966, pp. 24–27.

Malcolmson, Harry. Review of Caro exhibition, David Mirvish Gallery, Toronto, *The Telegram* (Toronto), May 21, 1966.

———. "A Chasm between Artistic Points of View," *The Telegram* (Toronto), June 4, 1966.

Menna, Filiberto. "La Scultura di Anthony Caro," *Marcatre* (Milan), Dec. 1966–Mar. 1967, pp. 154, 156–57.

Metz, Kathryn. "The 33rd Venice Biennale of Art," *Arts and Architecture*, Sept. 1966, pp. 32–34.

Robertson, Bryan. "Raspberry Ripple," *The Spectator*, Sept. 9, 1966.

Russell, John. "Portrait: Anthony Caro," *Art in America*, Sept.–Oct. 1966, pp. 80–87.

"Sculpture: The Girder Look," *Time Magazine*, July 22, 1966, p. 63.

Solomon, Alan. "The Green Mountain Boys," *Vogue* (New York), Aug. 1, 1966, pp. 104–09, 151–52.

Thompson, David. "Venice Biennale: The British Five," *Studio International*, June 1966, pp. 233–43.

1967

Amaya, Mario. "Caro and Paolozzi in Holland," *Financial Times* (London), May 17, 1967.

Ammann, Jean-Christophe. "Anthony Caro und die junge englische Skulptur," *Werk* (Winterthur), Oct. 1967, pp. 641–46.

Benedikt, Michael. "New York Letter: Some Recent British and American Sculpture," *Art International*, Jan. 1967, pp. 56–62.

Bowen, Dennis. "Anthony Caro," *Arts Review*, Nov. 25, 1967, p. 442.

Brett, Guy. "Anthony Caro's New Sculpture," *The Times* (London), Nov. 6, 1967.

Bruce-Milne, Marjorie. "Constructed, Built, Assembled, Arranged . . . ," *Christian Science Monitor*, Nov. 20, 1967.

Campbell, Lawrence. "Reviews and Previews: Anthony Caro," *Art News*, Jan. 1967, p. 11.

Fried, Michael. "Art and Objecthood," *Artforum*, Summer 1967, pp. 12–23. Reprinted, *Minimal Art; a Critical Anthology*, Gregory Battcock, ed. New York: E. P. Dutton & Co., 1968, pp. 116–47.

———. "New Work by Anthony Caro," *Artforum*, Feb. 1967, pp. 46–47.

Fry, Edward F. "Sculpture of the Sixties," *Art in America*, Sept.–Oct. 1967, pp. 26–43.

Gosling, Nigel. "Art," *The Observer* (London), Nov. 5, 1967.

Greenberg, Clement. "Recentness of Sculpture," essay in exhibition catalogue *American Sculpture of the Sixties*, Los Angeles County Museum, 1967, pp. 24–26. Reprinted, *Art International*, April 1967, pp. 19–21.

Hale, Barrie. "Massive Caro, Delicate Caro," *The Telegram* (Toronto), Jan. 21, 1967.

Hefting, P. H. "Twee in een, Paolozzi en Caro in Kroller-Muller," *Museumjournaal* (Otterlo), serie 12/2, 1967, pp. 49–56. English summary, p. 63.

Hudson, Andrew. "The 1967 Pittsburgh International," *Art International*, Christmas 1967, pp. 57–64.

Jouffroy, Alain. "Art de Demi-Brume à Londres," *L'Oeil*, May 1967, pp. 34–41, 84.

Krauss, Rosalind. "On Anthony Caro's Latest Work," *Art International*, Jan. 20, 1967, pp. 26–29.

Kritzwiser, Kay. "Sculptures by Caro," *Globe and Mail* (Toronto), Jan. 21, 1967.

Lynton, Norbert. "Anthony Caro Exhibition," *The Guardian* (London), Nov. 3, 1967.

———. "London Letter," *Art International*, Christmas 1967, pp. 51–56.

Mellow, James R. "The 1967 Guggenheim International," *Art International*, Christmas 1967, pp. 51–56.

Nemser, Cindy. "In the Galleries: Anthony Caro," *Arts Magazine*, Dec. 1966, p. 60.

"News of Art: Anthony Caro's Sculpture," *Horizon*, Winter 1967, pp. 76–77.

Robertson, Bryan. "Mixed Double," *The Spectator*, Nov. 19, 1967.

Russell, John. "Strength Made Visible," *Sunday Times* (London), Nov. 12, 1967.

Russell, Paul. "Caro, Noland at David Mirvish Gallery, Toronto," *Arts Canada*, Jan. 1967, Supplement, p. 6.

Stone, Peter. "Sculpture that Floats with Tension," *Jewish Chronicle* (London), Nov. 3, 1967.

Taylor, W. S. "Anthony Caro," *Sheffield Morning Telegraph*, Nov. 27, 1967.

Thompson, David. "Art," *Queen Magazine* (London), Nov. 7, 1967.

1968

Fried, Michael. "Two Sculptures by Anthony Caro," *Artforum*, Feb. 1968, pp. 24–25. Reprinted, Whelan, 1974.

Greenberg, Clement. "Anne Truitt, an American Artist," *Vogue* (New York), May 1968, pp. 212, 284.

Harrison, Charles. "London Commentary: British Critics and British Sculpture," *Studio International*, Feb. 1968, pp. 86–89.

Kline, Katherine. "Reviews and Previews: Anthony Caro," *Art News*, Dec. 1968, p. 15.

Kramer, Hilton. "Anthony Caro: A Gifted Sculptor within a Tradition," *New York Times*, Nov. 9, 1968.

———. "The Metropolitan Takes Another Step Forward," *New York Times*, May 25, 1968.

Lucie-Smith, Edward. "An Interview with Clement Greenberg," *Studio International*, Jan. 1968, pp. 4–5.

Read, Herbert, and Robertson, Bryan. "New British Painting and Sculpture," dialogue-introduction to exhibition catalogue, University of California at Los Angeles, 1968. Reprinted, *Art International*, Feb. 1968, pp. 26–30.

Rubin, William. "New Acquisitions: Painting and Sculpture—1967–68," *Members Newsletter*, Museum of Modern Art, New York, Oct. 1968, p. 10.

Russell, John. "London," *Art News*, Jan. 1968, pp. 22, 62–63.

Simon, Rita. "In the Museums: Kenneth Noland, Morris Louis and Anthony Caro," *Arts Magazine*, Summer 1968, pp. 56–57.

1969

Annesley, David. "Anthony Caro's Work: A Symposium by Four Sculptors: David Annesley, Roelof Louw, Tim Scott, and William Tucker," *Studio International*, Jan. 1969, pp. 14–20.

Bates, Merete. "The Core of Caro," *The Guardian* (London), Jan. 25, 1969.

Bowling, Frank. "Letter from London: Caro at the Hayward," *Arts Magazine*, Mar. 1969, p. 20.

Brett, Guy. "Elegance of Caro's Sculpture," *The Times* (London), Jan. 27, 1969.

Burr, James. "Mystery in Full Daylight," *Apollo*, Feb. 1969, pp. 147–48.

Caro, Anthony. Statement in *Art Now* (New York), Sept. 1969.

Causey, Andrew. "Art: Shaped in Steel," *Illustrated London News*, Feb. 22, 1969, pp. 20–21.

Cone, Jane Harrison. "Caro in London," *Artforum*, April 1969, pp. 62–66.

Dempsey, Michael. "The Caro Experience," *Art and Artists*, Feb. 1969, pp. 16–19.

Dunlop, Ian. "Caro, New Language of Modern Sculpture," *Evening Standard* (London), Jan. 27, 1969.

———. "Is This Caro's Secret?" *Evening Standard* (London), Feb. 10, 1969.

Fawcett, Anthony. "Sculpture in View: Off the Mark," *Sculpture International* (Oxford), April 1969, pp. 36–39.

Fried, Michael. Introduction to Caro exhibition catalogue, Hayward Gallery, London, 1969.

Giles, Frank. "Groping among the Girders," *Sunday Times* (London), Feb. 16, 1969.

Goldwater, Robert J. *What Is Modern Sculpture?* New York: Museum of Modern Art, 1969, pp. 105, 107, 142.

Gosling, Nigel. "International Father," *The Observer* (London), Jan. 26, 1969.

Gotch, Christopher. "The Measure of a Man's Achievement," *Hampstead and Highgate Express* (London), Mar. 14, 1969.

Harrison, Charles. "Gra-Bretanha: Anthony Caro," in *Catalogo, X Bienal de Sao Paulo*, 1969, pp. 86–89. Text in Portuguese and English.

———. "London Commentary: Anthony Caro's Retrospective Exhibition

at the Hayward Gallery," *Studio International*, Mar. 1969, pp. 130–31.

Kennedy, R. C. "London Letter," *Art International*, Mar. 20, 1969, pp. 46–51.

Krauss, Rosalind. "New York: Anthony Caro at André Emmerich," *Artforum*, Jan. 1969, pp. 53–55.

Lucie-Smith, Edward. *Movements in Art since 1945*. London: Thames and Hudson, 1969. American edition: *Late Modern: The Visual Arts since 1945*. New York: Praeger, 1969, pp. 178, 206, 228–34.

Lynton, Nobert. "Sculpture on the Table," *The Guardian* (London), Feb. 17, 1969.

Melville, Robert. "Turner's Only Rival," *New Statesman*, Feb. 7, 1969.

Mullins, Edwin. "Removing the Barriers," *Sunday Telegraph* (London), Jan. 26, 1969.

Neve, Christopher. "A New Kind of Sculpture: Anthony Caro at the Hayward Gallery," *Country Life*, Jan. 30, 1969.

Niven, Barbara. "Fine Assertion of Space," *Morning Star* (London), Feb. 5, 1969.

Overy, Paul. "Anthony Caro," *Financial Times* (London), Feb. 4, 1969.

Richards, Margaret. "Art: Poetic Engineer," *The Tribune* (London), Feb. 7, 1969.

Robertson, Bryan. "Caro and the Passionate Object," *The Spectator*, Jan. 24, 1969.

Russell, David. "London: Magritte, Caro, Environments," *Arts Magazine*, Mar. 1969, pp. 49–50.

Russell, John. "Anthony Caro," *Sunday Times Magazine* (London), June 15, 1969.

———. "The Triumph of Anthony Caro," *Sunday Times* (London), Jan. 26, 1969.

Salvesen, Christopher. "Anthony Caro's Iron Idylls," *The Listener*, Jan. 30, 1969.

Spencer, Charles. "Caro—Functional Art," *Fashion* (London), Feb. 1969, p. 44.

———. "Private View: Caro and Oiticica, Object and Environment," *Art and Artists*, April 1969, p. 4.

Taylor, W. S. "Caro, Sculptor of the Building Site," *Sheffield Morning Telegraph*, Mar. 3, 1969.

Thompson, David. "Intimately Related to Us?" *New York Times*, Feb. 16, 1969.

Tutin, Frederic. "Brazil Sao Paulo 10," *Arts Magazine*, Nov. 1969, pp. 50–51.

Wilson, Winefride. "This Week in the Arts: Adventure Playground," *Tablet* (London), Feb. 8, 1969.

Wolfram, Eddie. "Anthony Caro," *Arts Review*, Feb. 15, 1969, pp. 79, 87.

1970

Baro, Gene. "Caro," *Vogue* (New York), May 1970, pp. 208–11, 276.

Domingo, Willis. "In the Galleries: Anthony Caro at Emmerich," *Arts Magazine*, May 1970, p. 66.

Fried, Michael. "Caro's Abstractness," *Artforum*, Sept. 1970, pp. 32–34. Reprinted, Whelan, 1974.

Fuchs, R. H. "Omtrent Anthony Caro," *Museumjournaal* (Otterlo), Feb. 1970, pp. 24–30. English summary, p. 55.

Kramer, Hilton. "A Promise of Greatness," *New York Times*, May 17, 1970.

Lynton, Norbert. "British Art Today," *Smithsonian*, Nov. 1970, pp. 38–47.

McLean, Bruce. "Not Even Crimble Crumble," *Studio International*, Oct. 1970, pp. 156–69.

Overy, Paul. "British Sculptors and American Reviewers," *Financial Times* (London), Aug. 21, 1970.

Russell, John. "Closing the Gaps," *Art News*, May 1970, pp. 37–39. Reprinted, Whelan, 1974.

1971

Harrison, Charles. "Virgin Soils and Old Land," *Studio International*, May 1971, pp. 201–05.

Henning, Edward. "Anthony Caro, Wending Back," *Bulletin of the Cleveland Museum of Art*, Oct. 1971, pp. 239–43.

Marshall, W. Neil. "Anthony Caro's 'Clearing': The David Mirvish Gallery," *Arts Canada*, Feb. 1971, p. 61.

———. "Anthony Caro at David Mirvish," *Studio International*, Dec. 1971, pp. 254–55.

Mellow, James. "How Caro Welds Metal and Influences Sculpture," *New York Times*, July 18, 1971.

Spurling, Hilary. "Art," *The Observer* (London), Sept. 26, 1971.

Taylor, Robert. "Contemporary Sculpture," *The New Book of Knowledge Annual*. New York: Grolier, 1971, pp. 100–01.

1972

Bannard, Walter D. "Caro's New Sculpture," *Artforum*, June 1972, pp. 59–64.

Cone, Jane Harrison. "Smith and Caro: Sculptures at Museum," *Baltimore Museum of Art Record*, Nov. 1972, p. 4.

Kritzwiser, Kay. "A High Quality Package of Old & New," *Globe and Mail* (Toronto), Jan. 29, 1972.

———. "Sleek Shapes in the Sculpture Courts," *Globe and Mail* (Toronto), July 22, 1972.

Masheck, Joseph. "A Note on Caro Influence: Five Sculptors from Bennington," *Artforum*, April 1972, pp. 72–75.

Rose, Barbara. "Through Modern Sculpture, from Matisse to Caro," *Vogue* (New York), April 15, 1972, p. 30.

Russell, John. "A Sense of Order," *Sunday Times* (London), Nov. 12, 1972.

Sandler, Irving. "Anthony Caro at Emmerich," *Art in America*, May–June 1972, p. 35.

Shepherd, Michael. "Things Seen," *Sunday Telegraph* (London), Nov. 12, 1972.

Shirey, David. "Caro's Steel Constructions on View," *New York Times*, Feb. 26, 1972.

Siegel, Jeanne. "Reviews and Previews: Anthony Caro," *Art News*, April 1972, p. 12.

Stone, Peter. "Serene and Subtle," *Jewish Chronicle* (London), Nov. 17, 1972.

Tuchman, Phyllis. "An Interview with Anthony Caro," *Artforum*, June 1972, pp. 56–58. Reprinted, Whelan, 1974.

Vaizey, Marina. "Carpets and Caro," *Financial Times* (London), Nov. 30, 1972.

1973

Baker, Kenneth. "Anthony Caro: Meaning in Place," *Arts Magazine*, Sept.–Oct. 1973, pp. 21–27.

———. "How Do You Define a Place?" *Christian Science Monitor*, July 20, 1973.

Carmean, E. A., Jr. "Anthony Caro's 'Night Road,'" *Bulletin of the Hous-*

ton Museum of Fine Arts, Fall 1973, pp. 46-51.

Cork, Richard. "Make Mine a Double Sculpture," *Evening Standard* (London), Dec. 1, 1973.

Elderfield, John. "New Sculpture by Anthony Caro," *Studio International*, Feb. 1973, pp. 71-74.

Frank, Peter. Review of Caro exhibition, Emmerich Gallery, *Art News*, Sept. 1973, pp. 85-86.

Gilbert-Rolfe, Jeremy. "Anthony Caro, André Emmerich Gallery Uptown," *Artforum*, Sept. 1973, pp. 87-88.

Gosling, Nigel. "Painting and Sculpture," *Observer Colour Magazine* (London), Sept. 2, 1973.

Kramer, Hilton. Review of Caro exhibition at Emmerich Gallery, *New York Times*, May 26, 1973.

Wood, Hamilton. "Weighty Sculptures on the Terrace," *Eastern Evening News* (London), Oct. 22, 1973.

1974

"Anthony Caro—Gallery André Emmerich," *Neue Zurcher Zeitung* (Zurich), May 8, 1974.

Blakeston, Oswell. "Anthony Caro," *Art Review*, Sept. 20, 1974, p. 563.

Caro, Anthony. "Some Thoughts after Visiting Florence," *Art International*, May 1974, pp. 22-23.

Cork, Richard. "London Art Review: Sculpture Back on a Pedestal," *Evening Standard* (London), Sept. 19, 1974.

Crichton, Fennella. "London Letter," *Art International*, Nov. 15, 1974, p. 37.

Diamonstein, Barbaralee. "Caro, DeKooning, Indiana, Motherwell, and Nevelson on Picasso's Influence," *Art News*, April 1974, pp. 44-46.

Dienst, Rolf-Gunter. "Anthony Caro," *Das Kunstwerk* (Stuttgart), July 1974, p. 33.

Feaver, William. "Anthony Caro," *Art International*, May 1974, pp. 24-25, 33-34.

————. "Kenwood: Anthony Caro," *Financial Times* (London), Sept. 25, 1974.

Gablik, Suzi. "Anthony Caro at Kenwood," *Art in America*, Nov.-Dec. 1974, p. 126.

Gosling, Nigel. "Art: Two Happy Marriages," *The Observer* (London), Sept. 15, 1974.

Grimley, Terry. "Art: The Evolution of Anthony Caro," *Birmingham Post*, Aug. 3, 1974.

Herrera, Hayden. "Anthony Caro," *Art News*, May 1974, pp. 92-95.

Jacob, John. Introduction to exhibition catalogue *Anthony Caro, Table Top Sculptures 1973-74*, Kenwood House, Hampstead, London, 1974.

Martin, Barry. "New Work: Anthony Caro," *Studio International*, April 1974, pp. 202-03.

Masheck, Joseph. "Reflections on Caro's Englishness," *Studio International*, Sept. 1974, pp. 93-96.

Overy, Paul. "An American Innovator," *The Times* (London), Sept. 17, 1974.

Spencer, Charles. "Five Anglo-Jewish Artists," *Jewish Chronicle* (London), June 7, 1974.

Stone, Peter. "Art: For the Top of the Table," *Jewish Chronicle* (London), Sept. 20, 1974.

Tisdall, Caroline. "Kenwood: Caro," *The Guardian* (London), Sept. 17, 1974.

Walker, F. A. Q. "Anthony Caro in Zurich," *New World Antiquity*, July-Aug. 1974, p. 76.

Whelan, Richard. *Anthony Caro*. Harmondsworth, Middlesex: Penguin, 1974. Additional essays by Michael Fried, Clement Greenberg, John Russell, and Phyllis Tuchman.

Wilkin, Karen. "Sculpture in Steel," introduction to exhibition catalogue, Edmonton Art Gallery, Alberta, Canada, 1974.

1975

Baker, Kenneth. "Morality in Steel," *The Atlantic*, vol. 235, no. 5, May 1975, p. 91.

"Caro im MOMA," *Art International*, June 1975, p. 78.

"Caros späte Deutschland—Premiere," *Der Spiegel*, Nr. 48, Nov. 24, 1975.

Chapman, Hilary. "Anthony Caro's Table Top Sculptures," *Arts Magazine*, Feb. 1975, p. 14.

Close, Roy M. "Remolded self led to Constructed Art," *Minneapolis Star*, Sept. 12, 1975.

Diamonstein, Barbaralee. "The Reluctant Modernist," *Art News*, Summer 1975, p. 40.

Donadio, Emmie. "Anthony Caro," *Arts Magazine*, June 1975, p. 31.

Genauer, Emily. "Art and Artists," *New York Post*, May 3, 1975, p. 32.

Hess, Thomas B. "Monumental Privacy," *New York Magazine*, June 9, 1975, p. 76.

Hughes, Robert. "Caro: Heavy Metal," *Time Magazine*, May 5, 1975.

Kipphoff, Petra. "Anthony Caro," *Die Zeit*, Nr. 51, Dec. 12, 1975.

Kramer, Hilton. "Is Caro Our Best Sculptor?" *New York Times*, May 11, 1975.

Martin, Barry. "On the Occasion of Anthony Caro's Retrospective Exhibition," *Studio International*, May-June 1975, pp. 233-35.

McLean, John. "Table Sculptures by Anthony Caro," *Art Spectrum*, Jan. 1975.

Moser, Charlotte. "Galleries Have Varied Shows with Real Substance," *Houston Chronicle*, Feb. 16, 1975, p. 12.

Nasgaard, Roald. "Simultaneous Activity: The Current Work of Anthony Caro," *Arts Magazine*, Jan. 1975, p. 71.

Ratcliff, Carter. "Anthony Caro," *Art International*, June 1975, p. 102.

Rubin, William. *Anthony Caro*. New York: Museum of Modern Art, and London: Thames & Hudson, 1975.

Ruenitz, Judy. "Anthony Caro," *Vogue Australia*, Aug. 1975.

Russell, John. "Art: Fine Caro Sculpture," *New York Times*, May 3, 1975.

Varnedoe, Kirk. "Intellectual Subtlety in Constructed Steel," *Art News*, Summer 1975, p. 38.

Whelan, Richard. *Anthony Caro*. New York: E. P. Dutton, 1975.

1976

Channon, Noel. Exhibition catalogue for "English Art Today 1960-76," British Council, Comune di Milano, Palazzo Reale, Milan, Feb.-Mar. 1976, pp. 234-39 (edited extract from interview with Caro, Granada TV, Sept. 1974).

Crichton, Fennella. *Art International*, Summer 1976.

Hilton, Tim. "Re-inventing Sculpture," *Times Literary Supplement*, Feb. 1976.

Hoesterey, Ingeborg. "Die plastische Invasion. Ausstellung von Caro und di Suvero," *SZ*. Jan. 17/18, 1976.

McEwen, John. "Steel Pastries," *The Spectator*, May 8, 1976.

Overy, Paul. "Anthony Caro—The Soft Option," *The Times* (London), May 4, 1976.

Winter, Peter. "Anthony Caro," *Das Kunstwerk* (Stuttgart), 1, 1976, p. 60.

Wilkin, Karen. "Anthony Caro and Bernini," *New Lugano Review*, Nov.–Dec. 1976.

1977

Fourcade, Dominique. "Anthony Caro," *Art International*, July–Aug. 1977, pp. 9–13.

Frackman, Noel. "Anthony Caro," *Arts Magazine*, Sept. 1977, p. 16.

Fried, Michael. "Anthony Caro's Table Sculptures," *Arts Magazine*, Mar. 1977.

Fuller, Peter. "Anthony Caro by William Rubin," book review, *Studio International*, Jan. 1977, pp. 70–73.

Glueck, Grace. "The 20th Century Artists Most Admired by Other Artists," *Art News*, Nov. 1977, p. 79.

Kramer, Hilton. "Art: Anthony Caro Adds New Forms," *New York Times*, May 6, 1977.

Kraus, Rosalind. *Passages in Modern Sculpture*. New York: Viking Press, 1977.

Russell, John. *New York Times*, July 27, 1977.

1978

"Anthony Caro, Ben Nicholson; Galerie Andre Emmerich," *Neue Zuricher Zeitung*, April 10, 1978.

Artner, Alan. "Caro Fashions a Show of Sculptural Might," *Chicago Tribune*, June 25, 1978.

"Freigestellte Reliefs," *Tages-Anzeiger*, May 13, 1978.

Haufschild, Lutz. "Conversations with Anthony Caro," *Arts Magazine*, June 1978, p. 30.

Hilton, Tim. *The Observer* (London), Dec. 17, 1978.

Hudson, Andrew. Exhibition catalogue, *Fifteen Sculptors in Steel Around Bennington, 1963–1978*. No. Bennington, Vt.: Park McCullough House Association, 1978.

Nordland, Gerald. *Franklin D. Murphy Sculpture Garden*. Los Angeles: University of California, 1978.

Packer, Bill. *Financial Times* (London), Dec. 19, 1978.

Pischel, Gina. *A World History of Art, Painting, Sculpture, Architecture, and Decorative Arts*. Second Revised Edition, with a new Introduction and new chapter 'Art Since 1940,' by Henry A. LaFarge and Catherine Bernard. New York: Newsweek Books, 1978, pp. 720–21.

"Plastiker Caro in Zurich," *Basler Zeitung*, May 11, 1978.

Spurling, John. *New Statesman*, Dec. 8, 1978.

Taylor, Robert. *Boston Sunday Globe*, Mar. 19, 1978.

1979

"Anthony Caro, Emmerich Gallery," *Art/World*, Nov. 17/Dec. 15, 1979, p. 10.

Beaucamp, Eduard. "Der Bildhauer Caro: Ein Virtuose in Stahl," *FAZ*, Nr. 81, April 5, 1979, p. 23.

Clark, Garth, and Hughto, Margie. *A Century of Ceramics in the United States, 1878–1978*. New York: E. P. Dutton in association with the Everson Museum of Art, Syracuse, New York, 1979.

Corners: Painterly and Sculptural Work; exhibition catalogue. Cambridge, Mass.: Hayden Gallery, Massachusetts Institute of Technology, 1979; essay by Kathy Halbreich.

Fuller, Peter. "Anthony Caro," a discussion with Peter Fuller, *Art Monthly*, Feb. 1979, pp. 6–15.

Russell, John. Review, André Emmerich Gallery, *New York Times*, Nov. 16, 1979.

Saunders, Wade. "Anthony Caro at Emmerich," *Art in America*, Mar.–April 1979, pp. 151–52.

Schilling, Jurgen. "Anthony Caro: Versuch Einer Bestimmung," *Heute-Kunst International Arts Review*, no. 25, June–July 1979, pp. 12–13.

Schilling, Jurgen, and Fried, Michael. *Table and Related Sculptures, 1966–1978*. Kunstverein Braunschweig, 1979.

Spalding, Frances. "The Tate—Between the Acts," *Arts Review*, Vol. XXXI, No. 20, Oct. 12, 1979, p. 549.

Wallworth, Brian. "The Early Sixties—Knoedler Gallery," *Arts Review*, Vol. XXXI, No. 19, Sept. 28, 1979.

1980

Anthony Caro: Bronze Sculpture. New York: Acquavella Contemporary Art, 1980.

Anthony Caro: The York Sculptures; catalogue of exhibition presented by the Museum of Fine Arts, Boston, at the Christian Science Center. Boston: Museum of Fine Arts, 1980.

Deschamps, Madeleine. "La sculpture de fer ou la fuite du centre," *Art Press 35*, Mar. 1980, pp. 5–7.

Feaver, William. "The State of British Art: 'It's a bewilderment,'" *Art News*, Jan. 1980, pp. 62–68.

Fourcade, Dominique. *Gonzalez/Smith/Caro/Scott/Steiner*; exhibition catalogue. Paris: Galérie de France, 1980.

Interview with Christopher Andreae, *Christian Science Monitor*, Aug. 18, 1980.

Kramer, Hilton. Review, Acquavella Contemporary Art, *New York Times*, Dec. 5, 1980.

de Menil, Lois. *L'Amérique aux Indépendants*; exhibition catalogue. Paris: Société des Artistes, Grand Palais, 1980, pp. 37, 62, 65.

Russell, John. "Anthony Caro's Show—'A Historic Event,'" *New York Times*, Sept. 7, 1980.

Taylor, Robert. "A First for sculpture in Boston," *Boston Globe*, Aug. 17, 1980.

Tuchman, Phyllis. "Recent Caro," *Bennington Review*, Sept. 1980, pp. 58–62.

Sculpture at Storm King; preface by J. Carter Brown, photography by David Finn, text by H. Peter Stern and David Collens, New York: Abbeville Press, Inc., 1980, pp. 69, 102.

Whelan, Richard. Review, André Emmerich Gallery, *Art News*, Feb. 1980, p. 196.

Wolff, Theodore F. "Art that speaks for itself: the Caro sculptures," *Christian Science Monitor*, Aug. 21, 1980.

1981

Blume, Dieter. *Anthony Caro; Table and Related Sculptures 1966–1978*. Cologne, Galerie Wentzel, 1981.

———. *Anthony Caro; Bronze Sculptures 1976–1980; Table and Related Sculptures 1979–1980; Miscellaneous Sculptures 1974–1980*. Cologne, Galerie Wentzel, 1981.

———. *Anthony Caro; Steel Sculptures 1960–1980*. Cologne, Galerie Wentzel, 1981.

———. *Anthony Caro; Student Work 1942–1953; Figurative Sculptures 1954–1959*. Cologne, Galerie Wentzel, 1981.

Blumenfeld, Yorick. "A Conversation with Anthony Caro," *Architectural Digest*, Sept. 1981. pp. 64, 72.

Larson, Kay. "The Steel-Plated Theories of Anthony Caro," *New York Magazine*, Sept. 7, 1981, pp. 58–59.

Photo Credits

Acquavella Art Galleries--240, 241, 242, 243
Albright-Knox Gallery--66
André Emmerich Gallery--24, 64, 65, 103, 104, 106, 107, 108, 124, 127, 128, 140, 174, 197, 199, 202, 203, 205, 219, 220, 221, 226
The Barnes Foundation, photograph copyright © 1981--fig. 2
Burton, Valerie--147, 149, 155, 156, 157, 158, 159
Eggman, Verena--137, 138, 139
Floyd Picture Library--9, 13, 30, 38, 39, 47, 54, 61, 67, 100, 191, 192, 195, 196
Frisse, Courtney--209, 210, 274
da Gery, X.--fig. 9
Goldblatt, John--23, 26, 33, 41, 45, 46, 51, 55, 56, 63, 68, 70, 72, 134, 179, 190, 212, 224, 228, 238, 263, 265, 267, 273, 278, 279, 280, 281, 282
Granger, Carlos--17, 19, 78, 118, 141, 144, 165, 168, 169, 171, 180, 181, 182, 183, 184, 185, 186, 193, 194, 214, 215, 217, 218, 225, 236, 239, 245, 246, 256, 257, 258, 259, 260, 262, 269, 272
Harcas Kracow Gallery--150, 151
Kasmin Ltd.--75, 76, 77, 79, 82, 85, 88, 99, 114, 115, 116, 133, 146, 173, 175, 176
Kim, Lim--11, 12, 18
Martin, Guy--71, 73, 74, 80, 83, 84, 102, 105, 111
Noland, William--233, 234
Photo Studios Ltd.--187
Pollitzer, Eric--fig. 4
Rappaport, Ro--10, 58
Scribner, David--97, 98, 122, 123, 161
Tarnay, Matthias--fig. 7
Walker, W. Start--1
Webb, John--28, 40
Wentzel Gallery--81, 86
When, Roy T.--162

Acknowledgment

The publishers gratefully acknowledge the invaluable assistance of Mr. Dieter Blume.

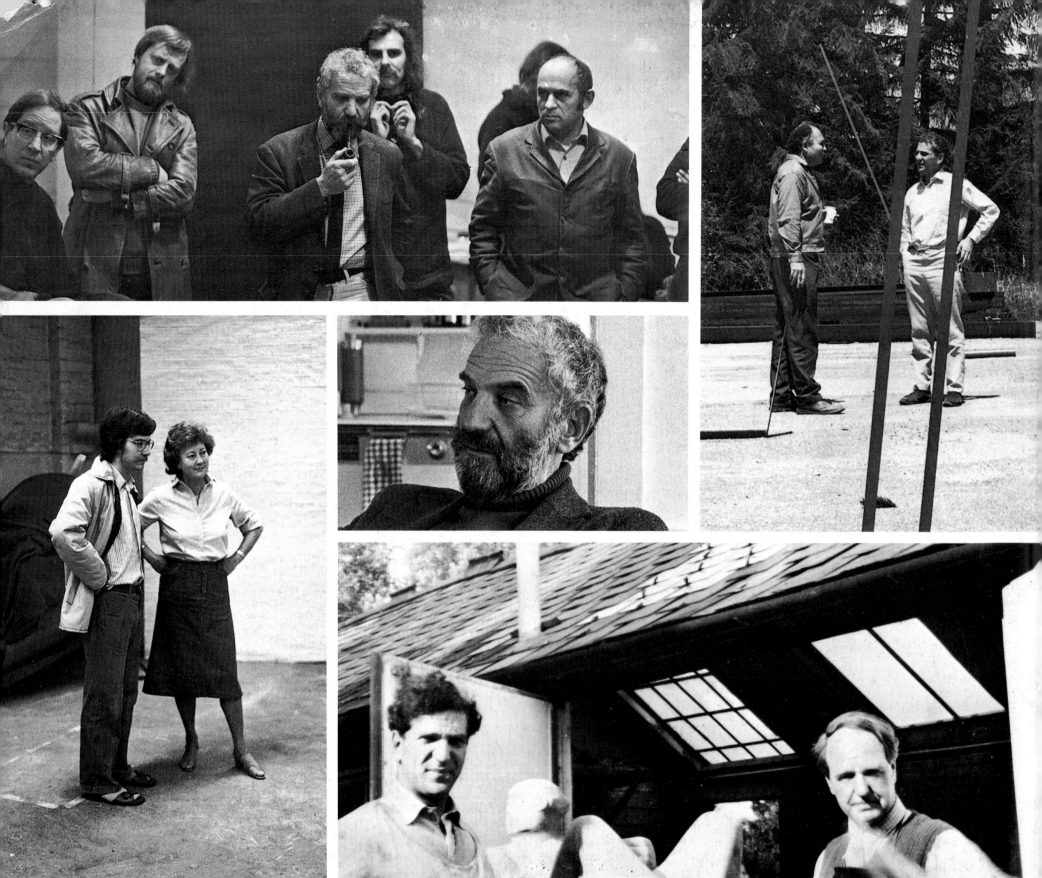

Above left. At St. Martin's School of Art in the 1970s.
L. to r.: Adrian Montford, Tim Scott, Caro,
Alan Gouk, John Nerichoff

Above right. Jules Olitski and Caro at Bennington
College, 1965

Below left. Paul and Sheila Caro

Center. Anthony Caro in a recent photograph

Below right. Caro and Henry Moore at Moore's
studio in the early 1950s